21

FEDERICO

FEDERICO

One Man's Remarkable Journey from Tututepec to L.A.

FEDERICO JIMINEZ CABALLERO

EDITED BY SHELBY TISDALE

THE UNIVERSITY OF
ARIZONA PRESS

TUCSON

The University of Arizona Press
www.uapress.arizona.edu

ISBN-13: 978-0-8165-4078-5 (paper)

Cover design by Leigh McDonald
Cover photo courtesy of Federico Jiménez Caballero
Designed and typeset by Leigh McDonald in Californian FB 10.25/14 and Bleecker WF (display)

Library of Congress Cataloging-in-Publication Data
Names: Jiménez Caballero, Federico, 1941– author. | Tisdale, Shelby Jo-Anne, editor.
Title: Federico : one man's remarkable journey from Tututepec to L.A. / Federico Jiménez Caballero ;
 edited by Shelby Tisdale.
Description: Tucson : University of Arizona Press, 2021. | Includes bibliographical references.
Identifiers: LCCN 2020022311 | ISBN 9780816540785 (paperback)
Subjects: LCSH: Jiménez Caballero, Federico, 1941– | Mestizos—Biography. | Indian jewelers—Biogra-
 phy. | LCGFT: Autobiographies. | Biographies.
Classification: LCC E99.M693 J56 2021 | DDC 739.27092 [B]—dc23
LC record available at https://lccn.loc.gov/2020022311

Printed in the United States of America
♾ This paper meets the requirements of ANSI/NISO Z39.48-1992 (Permanence of Paper).

To my beautiful wife, Ellen Belber, the love of my life

CONTENTS

PREFACE

B Y ANY STANDARD, FEDERICO JIMÉNEZ Caballero is a remark-
able individual. His story is a frank and intimate account of more than
eighty years in the life of a man with deep Indigenous roots, where the
supernatural is blended with the practical in everyday life. It is also a world
where an animal spirit guide is assigned at birth. This animal guide plays an
important role in protecting and guiding the spirit and personality of the
individual throughout his or her life. As a child, Federico faced insurmount-
able challenges that most of us cannot imagine let alone overcome; as an adult
he never stood still but instead depended on his survival skills and sheer will
to become the successful man he is today.

This is the story of the real-life experiences of a man of mixed heritage
who identifies with both his Indigenous Mixtec culture as well as the Indig-
enous and Spanish mixed blood, or mestizo, side of his family. In the United
States, Federico has been able to create an identity that bridges his Mexican
Indigenous heritage with the overall Latino culture of southern California.
Through all his trials and tribulations, he created a successful life for a young
boy, who had grown up in a small coastal Oaxaca, Mexico, town where the
cows and horses had to be chased off the grass landing strip.

I feel blessed that I was the one Federico chose to assist him in telling this
amazing story of survival in a world that was often cruel and unforgiving.
I first met Federico in July 2006. My book, *Fine Indian Jewelry of the Southwest:*

The Millicent Rogers Museum Collection, had just been published in June, and I heard that Federico was going to be one of the artists at the upcoming International Folk Art Market (IFAM) in Santa Fe, New Mexico. At the time, I was the director of the Museum of Indian Arts and Culture/Laboratory of Anthropology on Museum Hill, where the market was to be held, and since I had mentioned Federico in my book, I thought I would give him copies to take home with him. Throughout the years I would see Federico at the annual IFAM as well as the Santa Fe Indian Market, where he also sells his jewelry.

In 2012, I was hired by the Autry National Center (now the Autry Museum of the American West) in Los Angeles, California, where Federico was serving on the board of trustees. I saw Federico periodically and one evening, he and his wife, Ellen, invited me to join them for dinner in Santa Monica. During dinner Federico shared a little bit about his birth and childhood years in Tututepec, Oaxaca, Mexico. I was immediately taken in by his story, and in mid-2015 when I left the Autry and moved back to Santa Fe, Federico and I were able to begin working on his amazing life story.

In early July 2015 I went to Oaxaca with Federico and Ellen, and he showed me all the places he mentions in part 2 of this book. Federico had the first two parts of his manuscript translated from Spanish into English by Pamela Gastelum, and I read them for the first time in September 2015. This draft of the manuscript was rough and disorganized, but in truth I could not put it down. All I could think of was that this is a story that needs to be told.

This is Federico's story as told by him. The editing and fact checking that I did throughout these pages did not change his story in any way. We were collaborators throughout in determining what level of detail was required to inform the reader. Federico uses the *testimonio* narrative style of writing to tell his story. Testimonio is a literary genre that is regarded by many scholars as the truest voice of the oppressed in Latin America and has become a valuable resource for social historians.[1] Among Latin American scholars, Sandra Henderson argues, "Within the realm of cultural studies, the term has developed as a reference to the poor in postcolonial, less-developed countries, especially in terms of subordination based upon gender, illiteracy, and Indigenous

1. Sandra Henderson, "Latin American *Testimonio*: Uncovering the Subaltern's Gender, Race, and Class," *Ex Post Facto* 10 (Spring 2001): 83, https://history.sjsu.edu/sites/default/files/images/2001_Sandra%Henderson.pdf.

status. . . . *Testimonio* thus represents the intersection of the postmodern project of employing nonliterary, unofficial sources and the absence of written historical records among subaltern groups in Latin America."[2]

Using a courtroom analogy of narrator (providing testimony) and juror (reader), John Beverley defines testimonio as a narrative told in the first person by someone who is the "real protagonist or witness of the events he or she recounts." He goes on to say, "The situation of narration in *testimonio* has to involve an urgency to communicate, a problem of repression, poverty, subalternity, imprisonment, struggle to survive, and so on implicated in the act of narration itself. . . . Unlike the novel, *testimonio* promises to be primarily concerned with sincerity rather than literariness."[3] Stories in this form do not necessarily fit well in existing categories of literature, such as autobiography, memoir, or autoethnography.

To guide Federico's story, we divided the book into four parts, with subheadings within each part. We begin with the "Introduction: My Ancestors, My Heritage" to provide some background on Federico's Indigenous heritage, which is so much a part of his life. Part 1 focuses on the circumstances of Federico's birth and growing up in Tututepec, Oaxaca, Mexico. It was an extremely difficult childhood in which Federico was constantly facing poverty, starvation, discrimination, illnesses, and most of all conflicting cultural identities. In part 2 Federico is sent to Oaxaca City at the age of fourteen, where he was literally on his own, with no money and very little hope. Never one to give up, he managed to get through an extremely challenging time through sheer will and his own ingenuity. This is where he comes of age and grows into a young man full of hopes and dreams. Part 3 is when Federico finds his claim to fame as a jewelry designer and entrepreneur in Hollywood and Santa Monica, California, and where he gains recognition as the "Artist to the Stars." It is here we also learn of his philanthropic interests and the establishment of a museum in Oaxaca.

Federico has never forgotten where he came from, and he has used his success to help his sister and brothers obtain their college educations. His sister, Dolores, became a lawyer and judge, Ramon a well-known oncologist, Carlos a dentist, Claudio a radiologist, Francisco a lawyer, and Juan a successful

2. Sandra Henderson, "Latin American *Testimonio*," 83–84.

3. John Beverley, *Subalternity and Representation: Arguments in Cultural Theory* (Durham, NC: Duke University Press, 1999), 65.

businessman. He has supported numerous museums and charities, especially those that help children in Los Angeles; and he has served on museum and nonprofit boards. This he continues to do. Federico and Ellen opened the Belber-Jiménez Museum in Oaxaca to share their vast collection of traditional Mexican costumes; jewelry by William Spratling, Antonio Piñeda, and Matilde Poulat; and pre-Hispanic, Spanish-colonial, and Southwest Native American arts and crafts. The mission of this museum is to educate the people of Oaxaca and visitors from other parts of the world about the rich cultural heritage of Oaxaca and its Indigenous peoples.

At one point I asked Federico why he thought his book should be published, and he replied: "So that young Indigenous kids, both rural and inner city, could possibly see me as a suitable role model, and maybe my story will inspire them to work hard to make their dreams come true. After all nothing in life comes easy. You have to work hard and make things happen."

As one reads through his life story it becomes readily apparent that Federico is a self-made man. He took advantage of opportunities as they came up and found ways to overcome the numerous obstacles he was confronted with. He never gave up, even though at times there seemed to be no way of moving forward. The strength he gained from his mother and grandmother and a strong belief in himself propelled him forward. He didn't have a plan; in many ways life just happened. We take so much for granted that most of us cannot imagine what Federico had to struggle with daily—how to get enough to eat, or medicine, or a place to sleep. Unfortunately, there are young people today facing similar struggles and maybe, just maybe, Federico's story will give them some hope.

I am grateful to have had the opportunity to share this remarkable journey with Federico over the past five years. Our friendship has grown immensely through this experience, and I have the deepest respect and admiration for this extraordinary man.

Shelby J. Tisdale
Editor

ACKNOWLEDGMENTS

A BOOK SUCH AS THIS IS not possible without the help of numerous people. First, I want to thank Shelby Tisdale for making the multiple stories I brought to her make sense to the reader. She was able to string my stream of consciousness into a cohesive narrative, and she filled many blanks and questioned some of my vagueness. Through her efforts my life story has a beginning, middle, and an ending. I say "an" ending because I am still here, and I have a lot to do yet in my life. I also want to thank Pamela Gastelum for her painstaking translation of the stories from my original Spanish manuscript into English. She was able to transcribe these pages so that Shelby could start working on this book. Interestingly, Shelby and I would discuss some points in Spanish so that she could better understand what I was trying to say at times. This has truly been a collaborative effort.

I will be forever grateful for the assistance of Alejandro de Ávila B. in pointing us in the right direction to obtain photographs of my grandmother's textiles, which are part of the collections at the Textile Museum of Oaxaca. I also would very much like to acknowledge and thank Hector Manuel Meneses Lozano, the director of the Textile Museum of Oaxaca, for granting permission to use images of my grandmother Nabora's *posajuanque de gala* and *rebozo de gala* in the museum's collection. These textiles were an important part of my life, and they bring back memories of the time I spent with my

grandmother. To be able to include them in this book was especially import-
ant to me personally, and my dear friend Alejandro made it all possible.

I would also like to thank Allyson Carter, senior editor; Scott de Herrera,
assistant editor; and the staff at the University of Arizona Press for consider-
ing my life story for publication. I also want to thank the reviewers of an early
draft of this manuscript for their questions and valuable comments. These
made me think about parts of my story, and Shelby and I were able to flesh
out more details regarding certain times in my life. The publication of this
book would not be possible without subvention funding from the Arizona
Archaeological and Historical Society. Thank you!

I am deeply grateful for the time that my dear friends took to read earlier
versions of my story, and I appreciate their helpful comments. First, I want
to thank John Gray, former director of the Smithsonian Institution's National
Museum of American History in Washington, DC, and the former president
and CEO of the Autry Museum in Los Angeles. He was the first to read an
early draft of my story, and his comments and answers to our questions
helped to clarify some of my lapses in memory. Another dear friend, Anto-
nia Hernandez, president and CEO of the California Community Founda-
tion, and the former president and general counsel of the Mexican American
Legal Defense and Educational Fund (MALDEF), also read an early draft of
the manuscript. Her comments were heartwarming, and she provided the
encouragement I needed at that point to keep my story alive.

I want to express my gratitude to the Honorable Judge Michael Stern,
Antonia Hernandez's husband, who read a later draft and offered some
badly needed criticism, which helped us to dig deeper and provide miss-
ing information as well as clarification in certain areas. My dear friend Ali
MacGraw also read a draft and told me how much she learned about me by
reading my stories. Even though we have known each for a very long time,
she was not aware of the challenges I had faced growing up. When I had
doubts about telling my story, you all gave me the courage to keep going.
Thank you!

There are others that I especially want to express my gratitude to. They
all helped me in their special ways. If Dr. Adalberto Mendieta hadn't gotten
me out of Tututepec when he did, there is no telling what direction my life
might have taken. Jacob Gutknecht's sponsorship while studying accounting
at the university put me on track to an education and career possibilities I
never dreamed of. I cannot say enough about what Arcelia Yañiz meant to

me during my struggles as a youth in Oaxaca City. She guided me and was truly a spiritual mother to me in so many ways. Most of all I want to recognize Ronald Waterbury, who hired me as a researcher in Oaxaca, where I worked with Ellen, my lovely wife to be. He also made it possible for me to come to the United States. Ronald and his charming wife, Carole Turkenik, have remained close friends to this day. I credit all of them for believing in me and opening doors and providing opportunities that I might otherwise not have been aware of.

I also want to acknowledge and thank my friends and clients whom I got to know through my gallery, Federico's on Montana; my flea markets; and the arts and antique shows, many of whom I mention throughout these pages. I would be remiss if I did not acknowledge Charmay Allred, who introduced me to the world of museums and philanthropy. Charmay, with her sense of humor, big smile, and generous heart, taught me much about giving to museums, social organizations, and nonprofits that do so much to help educate the world about the arts, culture, and social causes. I learned much from Charmay and value her friendship more than she will ever know.

Through my love for Ellen and the joy that I have had with her by my side, a window to the world was opened to me. Ellen and I have traveled throughout the world for over thirty years, and during these times I had to keep pinching myself and asking, "How could a poor Mixtec Indigenous boy from such humble beginnings ever find himself wandering through the magnificent museums of Europe and seeing the works of the masters of art displayed there?" I was able to visit Israel, where I walked the Via Dolorosa asking for forgiveness for the sins of my childhood. We traveled to Spain, Italy, Hungary, Portugal, France, and England. I was introduced to the cultures of such foreign places as Morocco and Turkey. We also traveled throughout Latin America to Argentina, Peru, Chile, Ecuador, Bolivia, and Guatemala, where we visited the ancient ruins of the Inca, Mapuche, Quechua, Aymara, and Maya. We visited Indigenous villages, where we added to our textile and jewelry collections. Our passion for collecting Indigenous art continues to this day as we add significant works to our museum collection. As I cut back on some of my commitments, I plan to spend more time working on our museum in Oaxaca.

I cannot emphasize enough, though, that I would not be the man that I am if not for the love and influences of the women in my life—my mother, Imelda; my grandmother Nabora; and most of all my wife, Ellen Belber. They

all gave me the will to face the challenges that life has presented me with and to not be a victim of my circumstances. I am eternally grateful to them.

Thank you to all who helped me and supported me throughout my life—from my challenging childhood in Tututepec to my achievements and successes in Oaxaca and the United States. It has been quite a journey.

Federico Jiménez Caballero

FEDERICO

INTRODUCTION

My Ancestors, My Heritage

A S I REFLECT ON THE past three quarters of a century and what a true adventure my life has been, I sometimes amaze myself when I think of where my journey has taken me. It has been full of challenges and opportunities, despair and hope, adversity and prosperity, pain and pleasure, along with many adventures along the way. Here, I provide you with a little background on my Indigenous Mixtec ancestral heritage, drawn from the stories I was told growing up, my own memories, and what archaeologists and historians have written about the Mixtec past. Then I begin with my life story. I hope you enjoy this story of a poor little Indigenous boy from a small coastal town in southern Mexico who was determined to make it in this world.

THE TUTUTEPEC I REMEMBER

San Pedro Tututepec, or simply, Tututepec, is the coastal town where I was born and spent my childhood. It is located about eight kilometers from the main highway that stretches along the Pacific coastline in southern Oaxaca, Mexico. The church and some of the residences are built on the same hilltops

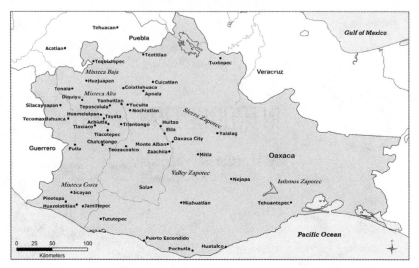

MAP 1. Map of the state of Oaxaca, showing important places of the Mixteca Alta, Baja, and Costa. From Ronald Spores and Andrew K. Balkansky, *The Mixtecs of Oaxaca: Ancient Times to the Present* (Norman: University of Oklahoma Press, 2013), 4.

where Tututepec's pre-Hispanic rulers built their pyramids and temples in the ancient Mixtec kingdom of Yucu Dzaa (Yucudzaa).

The main square of the modern town of Tututepec has a quadrangular shape. The civic-ceremonial core of Yucu Dzaa was a large pre-Hispanic platform on which the colonial-period San Pedro Church sits today. This platform on the north end supported the ruler's palace. At the time of the Spanish conquest, this palace was occupied by Tututepec's cacique (ruler) Coaxintecuhtli.[4] Past the church was another hillside we called the Adoratorio, which was known as a site of worship. Another hill served as the scenic overlook of the Río Verde Valley, the beautiful Laguna de Chacahua, and the Pacific Ocean. Unfortunately, this hill has slowly disappeared over time. The City Hall on the west side of the town square, which sits atop another important ancient temple, has close to thirty murals painted on the interior walls that illustrate the history of Tututepec and the region. It is my

4. See Arthur A. Joyce, Andrew G. Workinger, Byron Hamann, Peter Kroefges, Maxine Oland, and Stacie M. King, "Lord 8 Deer 'Jaguar Claw' and the Land of the Sky: The Archaeology and History of Tututepec," *Latin American Antiquity* 15, no. 3 (2004): 273–97.

understanding that the ancient House of Treasures would have been on the south side, and the school I went to now sits on top of this pyramid. Since a well-maintained paved road was built connecting Tututepec to the main highway and the outside world, it has become a modern town with several large buildings and amenities, including the community museum, Museo Communitario de Yucu Saa.

Tututepec was and continues to be a community of mixed heritage with a well-defined class structure. Since the early Spanish-colonial times, discrimination toward Indigenous people has been rampant throughout the region. The Spanish took hold of the most productive lands and the political offices in the town, and their military forces assumed control of the most strategic sites for their operations. This deprived the Indigenous peoples of their traditional livelihood, and they were moved to inferior dwellings and the least productive lands. When I was growing up, Tututepec was a divided community, where the mestizos (people of mixed Spanish and Indigenous heritage) lived in multiroomed, painted adobe brick houses with tile roofs, while the Indigenous people lived in one-room wattle-and-daub houses with dirt floors and thatched roofs made of palm fronds. To this day, the division between the Indigenous Mixtecs and the mestizos is still visible.

During the Spanish-colonial period, and well into the early decades of the twentieth century, clothing also drew a distinction between the two cultures. Mixtec men wore a handwoven white cotton *calzón* (short pants that either buttoned or wrapped around the waist) held up by a faja (wraparound belt or sash) at the waist. On

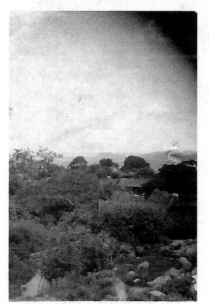

FIGURE 1. Photo of Tututepec. The house with the black door is the one Federico was born in. This house belonged to his grandfather Adrián, who was a high-ranking Mixtec principal. It has a tile roof, while the others have palm thatch roofs, ca. late 1950s. Photo by Federico Jiménez. Jiménez Family Collection.

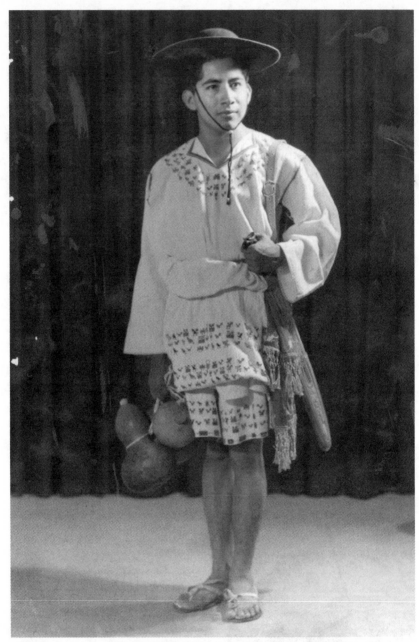

FIGURE 2. Federico wearing a traditional man's outfit representative of the Zacatepec, or Tacuate, Mixtec group in Santa María Zacatepec, Oaxaca, ca. 1960s. Mixtec men wore this type of clothing during the Spanish-colonial period. Photographer unknown. Jiménez Family Collection.

the top, men wore a *cotón* (shirt with three-quarter length or long sleeves), along with sandals and a sombrero. Both shirts and pants were decorated with embroidered animals and other designs in specific colors designating an individual man's status in the Mixtec community. Women either went bare breasted or wore a huipil (an overgarment or simple dress of rectangular strips of handwoven cotton with an embroidered neck and sleeve openings) and a *posahuanque*, also spelled *pozahuanco* (long sarong-like wraparound skirt) with a woven faja around the waist.[5] The mestizos wore industrial-made European-style clothing and spoke only Spanish, which distinguished them from those of Indigenous origin, who wore their traditional clothing and spoke Mixtec.

The neighborhoods in Tututepec were also distinguished from each other. The Indigenous Mixtecs lived on the outskirts of Tututepec, in the beach neighborhood. The entire north end and the center of town were inhabited by the mestizos who were known as the *"gente de razón,"* or the "people of reason" or "rational people." This is a Spanish term used during the postconquest period to differentiate the superior educated European class from those considered to be the inferior Indigenous peoples, who were uneducated, spoke their native language, and continued their traditional pagan religious and cultural practices. Public spaces were clearly identified for use by mestizos or Indigenous populations. For example, there were two cemeteries in Tututepec, one for the Mixtecs and other Indigenous people, and one for the mestizos. We didn't have running water in our houses, and as I recall, the places where one could get water were also segregated. Even in the San Pedro Church the Indigenous men and women sat in the back, behind the mestizos.

Much of the pre-Hispanic sociopolitical structure still existed in Tututepec during my early years, especially in the Mixtec barrio (neighborhood) that I lived in. Even though I am of mixed mestizo and Indigenous heritage, my Mixtec ancestry is deeply rooted in me because of the influence of my paternal grandparents, who taught me some of the Mixtec language and

5. See Susan Drucker-Brown's article, "Cultural Cross-Dressing in Rural Mexico: The Case of Jamiltepec, Oaxaca," *Cambridge Journal of Anthropology* 23, no. 3 (2003): 18–38, for an overview of the type of clothing worn by Indigenous people in rural southern Mexico. Also see an example of the detail of a Mixtec ceremonial posahuanque from Jamiltepec, Oaxaca, Mexico in a chapter by Alejandro de Ávila B., "Bleeding Threads: Cochineal in Mexican Textiles," in *A Red Like No Other: How Cochineal Colored The World*, ed. Carmella Padilla and Barbara Anderson (New York: Skira Rizzoli, 2015), 118–33.

about our cultural traditions and religious practices. It wouldn't be until my adult years that I would gain an appreciation for the Mixtec arts and culture.

In addition to the history of the Mixtecs told through the murals painted on the walls of City Hall, Tututepec's community museum displays some of the archaeological materials recovered from Yucu Dzaa and other ancient sites in the surrounding areas, as well as images of some of the Mixtec codices.[6] Unfortunately, few people living there today seem to be aware of Tututepec's rich cultural heritage as the only Mixtec kingdom in Oaxaca to withstand an Aztec invasion, in the fifteenth century, and that it was still independent at the time of the Spanish conquest in 1522. This may be because less than one percent of the overall population in Tututepec today speak an Indigenous language, and the Mixtec community has been drastically reduced since the mid-twentieth century. Much has changed since I lived there in the 1940s and 1950s.

MY ANCESTORS

My earliest memories of learning about my Mixtec ancestors come from stories told by my grandparents and relatives on my father's side of the family. Over millennia these stories were passed down from one generation to the next through oral traditions, as well as through pictures painted on deer skins coated with white lime, known as the Mixtec codices. My Mixtec grandparents and father were descended from one of the most powerful Indigenous groups in pre-Hispanic Mesoamerica. Today, the Mixtecs can be found in the modern Mexican states of Oaxaca, Guerrero, and Puebla.

The place of my Mixtec ancestors is Yucu Dzaa, which was called "Hill of the Bird" by the Aztecs. We always referred to it as "Bird Mountain." Its location is within the present-day town boundaries of Tututepec and the surrounding hills. Yucu Dzaa is a Mesoamerican site that formed the nucleus of an extensive pre-Hispanic empire during the late postclassic period (A.D. 1100–1522). It was the capital of the Mixtec Empire, which had conquered and controlled most of coastal Oaxaca and several highland communities. It

6. The picture manuscripts from the Mixteca region of Oaxaca are known as the codices Nuttall, Bodley, Selden, Vienna, Colombino, Becker I and II, Sánchez Solis, and others.

was the site of political and economic power and was the region's stronghold against the Aztec invaders.[7]

The Mixtecs evolved over three thousand years from small village life to chiefdoms, then to urban states, and finally the formation of a large empire. These changes paralleled developments elsewhere in Mesoamerica. The Valley Zapotecs and the Mixtecs were the two primary civilizations in Oaxaca, and even though they interacted and occupied nearly the same physical space, they differed in many aspects of their cultural development. The Tututepec Mixtecs formed the nucleus from which Mesoamerican culture originated, flourished, and spread.[8] These were my ancestors.

ARCHAEOLOGICAL AND ETHNOHISTORICAL EVIDENCE

According to the town's historians, Tututepec was founded in the year A.D. 357 by Prince Mazatzin.[9] After leaving his home in the north to seek a new location for his people, Prince Mazatzin climbed a mountain full of seabirds and decided to establish the capital of his small kingdom in this beautiful location, calling it Yucu Dzaa. It had vast bodies of fresh water full of fish and an abundance of wild plants and animals to feed the growing population. It provided natural caves that could be used for religious ceremonies and burials. It was also an ideal defensive location against enemy attacks.

Based on the pre-Hispanic stories recorded in the Mixtec codices, scholars have learned of another important leader in the establishment of Tututepec, Lord 8 Deer "Jaguar Claw."[10] Although most of the codices were destroyed by Spanish priests all over Mexico early in the conquest, eight Oaxaca codices survived, all from the Mixtec region. According to these codices, on the day 8 Deer in the year 12 Reed (A.D. 1063) a renowned noble, known to historians as Lord 8 Deer "Jaguar Claw," was born in the highland town of Tilan-

7. Marc N. Levine, *The Tututepec Archaeological Project (TAP): Residential Excavations at Yucu Dzaa, a Late Postclassic Mixtec Capital on the Coast of Oaxaca, Mexico* (Los Angeles: Foundation for the Advancement of Mesoamerican Studies, 2007), https://famsi.org/reports/05031Levine01.pdf.

8. See Ronald Spores and Andrew K. Balkansky, *The Mixtecs of Oaxaca: Ancient Times to the Present* (Norman: University of Oklahoma Press, 2013).

9. Villa de Tututepec de Melchor Ocampo, *Wikipedia*, last edited September 27, 2019, https://en.wikipedia.org/wiki/Villa_de_Tututepec_de_Melchor_Ocampo.

10. Joyce et al., "Lord 8 Deer 'Jaguar Claw,'" 274.

tongo. He was the son of Lady 11 Water "Blue Parrot" and Lord 5 Alligator "Rain-Sun." Lord 8 Deer would eventually become the ruler of both Tilantongo and Tututepec, even though neither of his parents had ties to either of the ruling families, meaning that Lord 8 Deer did not officially inherit his title as a legitimate ruler.[11] He would eventually be able to claim the title as an official ruler through marriage.

As Monte Albán's power faded in Oaxaca's central valley, the Mixtec city-states to the west and northwest thrived. Early in the postclassic period. the Zapotec region was vulnerable to conquest because of political fragmentation and unrest. Overpopulation, and perhaps pressure from outside forces, compelled ambitious Mixtec nobles to look southward at the fertile lands of Oaxaca's central valley. This set the stage for Mixtec expansion when Lord 8 Deer came of age.

In A.D. 1083 Lord 8 Deer moved quickly, forming alliances and setting his rivals against one another. The lower Río Verde Valley, given its rich agricultural lands and natural resources along the Pacific coast, would have been an attractive location to establish a kingdom for this ambitious royal upstart. Lord 8 Deer led Mixtec armies south from Tilantongo and defeated several Zapotec central valley city-states before arriving in the Río Verde Valley along the coast and founding Tututepec. These actions united the highlands and coastal region. He was able to do this through a strategic alliance with highland groups linked to the Tolteca-Chichimeca and along traditional Mixtec foundation rites. After bringing the entire Mixteca, from the Tehuacan Valley in the north to the coastal stronghold in Tututepec, under his control, Lord 8 Deer embarked on a series of conquests. He founded a coastal Mixteca empire that lasted until the end of the pre-Hispanic era.[12] Tututepec was a major demographic hub on the coast, stretching over twenty square kilometers with an estimated fifteen thousand inhabitants.[13] The Mixtec ability to access exotic goods through long-distance trade networks is demonstrated through the imported materials found at Yucu Dzaa. Obsidian was one of the most common materials recovered, yet no sources of obsidian exist in Oaxaca. The main source for this type of obsidian is in

11. Joyce et al., "Lord 8 Deer 'Jaguar Claw,'" 282.

12. Spores and Balkansky, Mixtecs of Oaxaca, 105

13. Spores and Balkansky, Mixtecs of Oaxaca, 106.

Central Mexico.[14] This corresponds with the codices depicting Lord 8 Deer meeting with important Tolteca-Chichimeca officials and the significance of trading networks throughout Mesoamerica.

Not long after going back north to become the ruler of Tilantongo, Lord 8 Deer was captured and sacrificed in A.D. 1115 at the age of fifty-two. Despite the loss of Lord 8 Deer, the Mixtec nobles continued to rule as an elite minority in Zaachila, Mitla, and other valley city-states. They preserved their dominance of the region through political marriages, especially by taking the daughters of Zapotec nobility as wives. While Tututepec disappears from the codices after the death of Lord 8 Deer, archaeological evidence, as well as early Spanish-colonial documents, show that Tututepec expanded into one of the most important postclassic sites in Mesoamerica as its elite leaders came to dominate a multiethnic empire.

MIXTEC LEGENDS AND STORIES OF TUTUTEPEC

My grandparents told me that one of the most important Mixtec kings of Yucu Dzaa was the brave King Cazandoo (also Casandoo), who managed to kill a great eagle with his arrow. This eagle lived in a mountain cave located near Yucu Dzaa, and when it had chicks, it would set out to hunt and was easily capable of bringing back a human infant to feed on. When the mothers heard the shrill and persistent cries among the fowl in the yard warning of the eagle's presence, they would rush to their huts and cover their babies with a reed basket. Thus, they were able to save their children from the eagle as it glided resolutely along in its search for prey. There is a town not far from Tututepec called Santiago Jamiltepec. It is said that in the past a grieving Mixtec ruler named the town in memory of his infant son, Jamily, who had been carried off by the eagle.

King Cazandoo decided to destroy the eagle and summoned everyone in Tututepec to a meeting to discuss what to do. They all agreed that an infant would have to be sacrificed in order to save the rest of the children. As planned, when the eagle began to fly in circles above the village, all the mothers took their children to a large courtyard. The cries of the children captured the eagle's attention, and when she swooped down and took one of them

14. Levine, *Tututepec Archaeological Project*, 24

in her talons, King Cazandoo shot an arrow through her heart. The eagle dropped the baby, who fell through a leafy tree and got stuck in the branches. The townsfolk quickly placed hammocks underneath the tree, and as some of the men shook the tree, the baby fell safely into one of the hammocks. This magnificent feat bestowed heroic recognition upon King Cazandoo.

In addition to saving the child and killing the eagle, King Cazandoo was greatly admired for his ability to resolve issues within his community, as well as disputes with neighboring groups. His army had the strongest and best organized forces in the Mixtec region. It is said that his spies and traders traveled as far as South America, where they stole some of the secrets pertaining to the metallurgical processes for gold and other precious metals. With this technology the Mixtecs became skilled at, and known for, their artistry in making fine jewelry, figurines, and other objects out of gold and silver.

MIXTEC ARTISANS AND TRADERS

During the postclassic period the Mixtecs were famous for their mastery in the arts, such as metalworking, jewelry, and decorated pottery vessels. Mixtec city-states competed among each other as well as with the Zapotec, as evidenced at Monte Albán, located nine kilometers west of the modern Oaxaca City. Mexican archaeologist Alfonso Caso y Andrade's discovery and analysis of the burial offerings in Tomb 7 at Monte Albán in the 1930s proved that this important classic Zapotec site had been reused by the Mixtecs for the burial of their elite before the Spanish conquest. This burial tomb contained offerings of gold and silver jewelry, elaborately decorated vessels, obsidian earspools, skulls covered with turquoise decorations, and carved jaguar bones. It especially brought to light the rise of metallurgy during this period among the Mixtecs.

Mixtec traders traveled throughout both South and North America in search of gold, silver, turquoise, and spiny oyster shell, which were highly sought after during this period as trade materials for both artistic and religious purposes. Throughout history the Mixtecs have dominated the art of working with precious metals, turquoise, and other gemstones. The gold pieces were created using the lost wax casting technique. They were then finished with the application of different techniques, such as the use of "fake" filigree, a lacelike ornamental work of intertwined wires of gold.

Other finishing techniques consisted of applique, embossing, and the setting of gemstones. They cut jade, shell, pearl, amber, and wood to be used as settings in their gold pieces. Today, the Mixtecs are known as Mexico's masters in their work with precious metals. As a jewelry designer, I have been inspired in my own work by these early traditions and techniques.

Mixtec artisans also applied polychromatic designs to their ceramic works, and stonemasons created delicate mosaics of alabaster. The women wove and decorated beautiful textiles using backstrap looms. They incorporated into their designs the more popular colors obtained from natural dyes, such as indigo for blue, *caracol* for purple (a dye from the liquid of a type of snail that attaches itself to the rocks along the shore of the Bahia de Huatulco), and cochineal for red (a prized rich scarlet dye derived from the female of a small insect, *Dachtylopius coccus*, that feeds off a variety of prickly pear cactus), along with other less popular plant dyes. The Mixtecs were also known for their centers of study that concentrated on religion, astronomy, and medicine. Testimony of this can be found in the ancient codices.

ARRIVAL OF THE SPANISH INVADERS

The encounter between Spain and the Americas had reached Mexico by 1519–20. The Mixtecs were fully involved in the convergence of these two contrasting cultures, that of the European and that of the Indigenous peoples, by the mid-1520s. Despite the warfare and disease brought on by contact with the Spanish, the Mixtecs were not wiped out as a people and their capital was not destroyed as had happened with the Aztec capital of Tenochtitlan. The Mixtecs instead survived as a people by accommodating and adapting to drastically altered circumstances.[15]

At the time of the Spanish arrival in southern Mexico, they recorded that at its maximum extent, Tututepec controlled an empire extending from the modern Oaxaca-Guerrero border east to the Isthmus of Tehuantepec, south to the Pacific Ocean, and north approximately 80 kilometers to towns such as Zacatepec, Juchatengo, and Sochixtepec. Communities as distant as Achiutla, 125 kilometers to the north, and Tehuantepec, 250 kilometers

15. Spores and Balkansky, *Mixtecs of Oaxaca*, 141–42.

east, reported having fought battles with Tututepec.[16] Subject communities were forced to pay tribute to the ruler of Tututepec, which ranged from gold, copper, feathers, textiles, and cacao from the lowlands to cochineal dye and manta (a white cotton cloth) from the highlands.

Not long after Hernán Cortés's conquest of the Aztec capital of Tenochtitlán on August 13, 1521, the wealth and power of Tututepec attracted his attention. Shortly after, Spanish soldiers entered the Valley of Oaxaca and established settlements and initiated commercial activities in various parts of Oaxaca. Spanish towns were established as new settlements, while others were established in existing communities. Tututepec is one community where the Spanish replaced the authority of the Indigenous leaders and set up a town square, or *zócalo*, with streets laid out in a grid pattern based on the Spanish model.[17] For the most part this Spanish town system was laid over the ancient city of Yucu Dzaa.

In January 1522, Cortés dispatched his lieutenant, Pedro de Alvarado, and two hundred Spanish soldiers to the Pacific coast, where they were joined by a Zapotec army from Tehuantepec, Tututepec's enemy to the northeast. Alvarado had conquered Tututepec by March 4, 1522. Palaces and temples were burned, and gold was looted from the House of Treasures. The cacique of Tututepec, the Venerable Lord Serpent King Coaxintecuhtli, was taken prisoner along with his son. As ransom, the Spanish soldiers demanded gold valued at 30,000 reales. The Mixtec people heeded this request and three days later delivered the goods, but Alvarado never kept his side of the bargain and instead demanded more gold. The king's descendants were not able to supply what Alvarado had demanded, and in response he ordered the death by torture of Coaxintecuhtli. Tututepec's last Mixtec ruler died in prison on March 22, 1522. Saddened by the loss of their king, the people of Tututepec buried the Venerable Lord Serpent King Coaxintecuhtli following all the rules of conduct and customs set forth for a man of his stature.

Not ones to give up easily, the people of Tututepec rose up in revolt against the Spaniards in 1523. Alvarado responded with new soldiers and once again fought the Mixtecs, eventually forcing them to surrender. Tututepec was

16. Joyce et al., "Lord 8 Deer 'Jaguar Claw,'" 292; Arthur A. Joyce, "Interregional Interaction and Social Development in the Oaxaca Coast," *Ancient Mesoamerica* 4, no. 1 (1993): 67–84; and Arthur A. Joyce "Formative Period Social Change in the Lower Verde Valley, Oaxaca, Mexico," *Latin American Antiquity*, Vol. 2, No. 2 (Jun 1991), 126–150.

17. Marcus Winter, *Oaxaca: The Archaeological Record* (Mexico City: Editorial Minutiae Mexicana, 1992), 75.

sacked, and thousands of reales in gold and other goods were taken. It was not long before oppression and foreign diseases would radically decimate the coastal population.[18] This defeat paved the way for a new period of Spanish domination and colonization.

After the region was conquered, Cortés ordered Alvarado to establish a town near Tututepec, known as Villa Segura de la Frontera. The town lasted less than a year because the Spanish inhabitants were unhappy with the tropical climate, the mosquitoes, and the high rates of disease. The Spanish settlement was moved to Antequera, which later became Oaxaca City. Even though native technology, economy, social organization, government, and ideology underwent a transformation, and the Mixtecs were increasingly incorporated into the Spanish colonial realm, they did this without fully surrendering their Indigenous identity.

The Mixtec class structure that existed during the pre-Hispanic period included three major social strata: the hereditary rulers (caciques), the hereditary nobles (*principales*), and the commoner class. The ruling class occupied positions of power and had immense wealth and influence. They owned the most productive agricultural lands and received tribute and labor services. They monopolized scarce resources, were entitled to wear exclusive and recognizable clothing and jewelry, and they decorated their bodies in certain ways. Their families ate special foods, used special forms of speech, and were normally in the company of the nobility. The religious cult was sponsored by the rulers, who played a key role in the ritual life of their communities. The power and wealth of the ruling class was usurped by the Spanish during the colonial period.

The Mixtec noble class occupied a position that was between the ruling class and the commoners. They generally resided in capital centers, as well as in dependencies, and organized themselves into large extended families. Their homes were small and simple but larger and better constructed than those of the commoners. The nobility participated in a wide network of interregional interactions that extended outside Mixteca boundaries. The social life of the commoner class was organized around the family and served the ruler and the nobles. The Indigenous population of Tututepec continued to have some remnants of this social structure when I was a child, but for my family it seemed to have disappeared after the death of my Mixtec grandfather.

18. Joyce et al., "Lord 8 Deer 'Jaguar Claw,'" 292–93.

REFLECTIONS

While my homeland remains a region of great beauty with a spectacular history, it was vastly underdeveloped and provided limited opportunities for economic advancement for the Indigenous population. In the 1940s, the time of my early childhood in Tututepec, there was a lack of infrastructure, a shortage of productive lands, and inadequate or antiquated technology. The area was impoverished, and many people, especially the Indigenous Mixtecs, had to seek employment elsewhere as my father did, or emigrate if they could. Even though my family lived on the margins in Tututepec society, we always managed to survive.

This is my life story based on my personal memories. Others may recall things differently, but that is what makes us all human. I hope you find my story interesting, no matter what your age is. But mostly, I wrote this for the young kids who are growing up in the rural areas of Mexico and the United States today. My journey was not easy, but within these pages I hope I demonstrate that dreams can come true. I remember the day when Cesar Chavez shook my hand and said "¡Si se puede!" (Yes, we can!). I took his words very seriously.

PART I

CHILDHOOD

A
S THE DAWN OF A new day was breaking on the horizon, I made my entrance into this world. My first breath filled my lungs with the smoke of burning copal incense, the first sounds I heard were those of the chants and prayers coming from the *curanderos* (traditional healers), and my first sense of touch came from the midwife as she was pulling me from my mother's womb. My next sensation was the soothing waters, infused with special herbs and flowers, as it was poured over me as I was bathed by my female relatives. At the exact moment that my first cry filled the room, my *tona*, my animal spirit that would guide me throughout my life, was determined by the *tonero*, or specialist, who was brought in just for this purpose. At the time, no one could have guessed where my life path would lead me.

I

MY PARENTS

I AM OF MIXED BLOOD. MY father was of Indigenous Mixtec ancestry, and my mother was a mestiza, part Indigenous Zapotec and part Spanish descent from the Valley of Oaxaca. Even though my mother, a devout Catholic, had a strong influence over me, I tend to identify more with my Indigenous heritage. My Mixtec ancestors were a powerful people before, and even for a while after, the Spanish arrived in this part of the world. Many of our customs and traditions have carried us through the centuries, and they are still important in identifying who we are today.

According to my family's historical accounts, I am a twenty-sixth-generation descendant of the Mixtec noble class. My paternal grandparents, Adrián Jiménez and Nabora Pérez, were born in 1880 and 1884 respectively and were descended from the noble Mixtec line. Through oral traditions that passed from one generation to the next, they could trace their roots from the thirteenth century to the Spanish-colonial era, when my family's land titles, homes, and goods were taken from them. Nevertheless, my grandparents continued to uphold their noble status in Tututepec's Mixtec community. They had three sons and a daughter. The oldest son, Toribio, was tasked with maintaining the family lineage, which is passed from father to son(s), but he had two daughters. The second son, David, had four daughters. Since their

only daughter, Ignacia, never married, my grandparents placed their hopes on their youngest son, Juan, to uphold the legacy of the Jiménez-Pérez family.

Among his siblings Juan, my father, was the one who broke away from certain Mixtec traditions and customs. He started wearing commercially made Western-style slacks and button-down shirts, instead of the handwoven traditional Mixtec short pants and shirt (calzón and cotón). Additionally, he found it more useful to communicate in Spanish than in his Indigenous Mixtec language. He spoke Spanish in public and Mixtec at home. At school, he self-identified entirely with his mestizo classmates and participated in the town's most popular sports and games.

At the age of eighteen he was an expert jockey and participated in horse races held in the town square. My father also competed in the lasso roping games, which consisted of taking objects, such as handkerchiefs, rings, perfume bottles, and other items, that were attached to a rope tied between two poles. The riders would grab the objects while their horses ran at top speed. He was a Tututepec cowboy of sorts, in other words, an expert at *charrería*, a competitive event similar to a rodeo. He was highly applauded by the public and had acquired a local celebrity status. In one of these venues he met my mother, Imelda, who came from a local mestizo family.

My maternal grandparents were Pedro Caballero and Juana Crespo. My grandmother Juana died from hydropsy (edema) in the town of Santa Caterina Juquila, popularly known as Juquila, when my mother, Imelda, was three years old. My grandfather Pedro took care of my mother until he died four years later. At age seven, my mother was adopted by her godparents, don Anastasio "Tacho" Silva and doña Dionisia "Nicha" Díaz. They had a daughter named Sarapia, with whom my mother would share her life as part of the Silva-Díaz family. My mother was unhappy with her adoptive parents because, unlike their birth daughter, she was treated like a servant in their home.

The Silva-Díaz's were Juquila's wealthiest and most politically prominent family. Don Tacho Silva was a powerful political official. He had business dealings in Juquila and Juchatengo. In Juchatengo he had an inn, a sugar cane plantation, and a processing plant that produced panela (molded unrefined whole cane sugar). His products were distributed throughout most of the coastal region of Oaxaca, and he had solid political and economic power.

My mother told me about the night that the municipal president and some of the town thugs were gathered around a fire in the town square of

Juchatengo when they were attacked by the Cristeros. The local Cristeros were part of a larger rebellion taking place in Mexico, also known as La Cristiada. The Cristero Rebellion (1926–29) was a widespread struggle in many central-western states against the secularist, anti-Catholic, and anti-clerical policies imposed by the postrevolutionary government under President Plutarco Elias Calles.

After attacking these men in Juchatengo's town square, the Cristeros moved to other parts of town. At one point, they stormed don Tacho's inn, but he was able to escape through a hole that he broke through the roof. He then climbed down an *árbol tabachín* (flame tree), taking only a portable kerosene lamp with him. Barely escaping with his life, don Tacho arrived in Tututepec two days later, where a messenger gave him the grave news that his wife, doña Nicha, had been killed by the blast from dynamite that had been left at the inn by the Cristeros. The Cristeros didn't stop until they killed all the important leaders in Juchatengo and their families. Given her prominent standing in the community, doña Nicha was buried in Juchatengo's town square. After the funeral, don Tacho never returned to Juchatengo again.

This tragic event happened when my mother was twelve, and since she no longer had doña Nicha to care for her, she was sent to live with her stepsister, Sarapia, who was now living in Tututepec. Life went on as usual, and then one day Sarapia decided to open a grocery store. My mother started working in Sarapia's store selling merchandise to the customers. My father would often go there to make purchases and talk to my mother. Back then she was only fourteen years old, but an attraction had already sparked between them. I think this attraction to my father was partly due to her loneliness, but it may also have been because of the competition she had from the other young girls in town who expressed an interest in my father. She would often tell me, "Jealousy and other circumstances drove me to go away with your father."

After being friends for a while, my mother learned that my father was in a romantic relationship with another young mestiza girl. She became quite upset and fraught with jealousy, so when he went to visit her one evening, she asked him to wait by the wall that surrounded the house where she lived. As he waited there, he heard a noise above him, and just as he looked up, she emptied a basket of eggshells on top of his head. This angered my father because in his eyes, what she did was insulting and an act of sheer mockery. That same evening one of Sarapia's children started to feel ill, and my mother

was sent to buy some *ruda* leaves, an ancient herb used to cure different ailments. Sarapia wanted to make a medicinal tea for her son. My father saw this as an opportunity to steal Imelda away. She never returned home with the ruda leaves, and fortunately, Sarapia's son recovered from his ailments and had fully regained his strength by the next day.

The day my father stole my mother away, as was customary in the Mixtec culture, was a fateful June evening. He took her on horseback to his family's ranch, and on arriving, my mother didn't know what she was supposed to do. Being raised in an upper-class mestizo home, she didn't know how to grind corn, make tortillas, or cook over an open fire. Many Mixtec cultural traditions were foreign to her. My father's family expected this young woman to adhere to the traditional roles of Mixtec women, but my mestiza mother didn't know how to follow such Indigenous traditions. My mother's adoptive father, don Tacho, was angry and refused to grant her permission to marry. He was not in favor of her marrying an Indigenous man, and he would tell his friends, "Send her back. I will marry her to one of my soldiers, if marriage is what she wants! I am not in favor of her marrying an Indian." My mother loved my father and stayed with him against don Tacho's wishes.

My grandfather Adrián often sought the company of a very prominent member of the community, don Constantino Bermudez, who was a wealthy businessman. He asked his friend to help him convince don Tacho to consent to the marriage, but to no avail. Clearly, both families were important in their own communities, one mestizo and the other Mixtec. After several meetings and negotiations, they finally came to an agreement. Don Tacho agreed to the marriage under one condition—that the wedding take place at five o'clock in the morning so that nobody in town would know it was happening.

To my mother's disappointment, don Tacho did not attend the wedding and instead sent someone in his behalf, don Marcelino Solis, head of the Tututepec post office. At the end of the ceremony, there were no customary fireworks or music. The only thing provided to the few guests, who were undoubtedly from my father's side of the family, was hot chocolate and egg bread. The following morning, the newlyweds headed to their own *ranchito* (little ranch) in the countryside. Life wasn't very pleasant for my mother, but it gave them privacy and created some distance from the talk around town. They also felt more at ease as they were away from don Tacho's watchful eye, because he constituted the biggest threat to their marriage and future happiness.

It was not only the newlyweds who feared don Tacho's retribution. He was known for implementing an extremely harsh justice system as a political leader in Tututepec. Even though many favored his ways, he had plenty of enemies who did not agree with his hardline approach. Thus, there were many attempts on his life, many of which left him only injured. It was rumored that he had made a pact with the devil who gave him healing dust for his wounds, which tended to heal by the third day. Yet, before the two-year mark of my parent's wedding anniversary, don Tacho was killed one day as he headed toward his ranch. He was ambushed twice that day by his enemies. On the first attempt, he was slightly injured, but they managed to bring him down on the second ambush. Don Tacho was the last major political leader in Tututepec of this era, and his undertakings left a legacy of leadership, both awe inspiring and brutal.

2

STARTING A FAMILY

AT THE TIME OF DON Tacho's death, my mother was pregnant with her first child. Unfortunately, he died a stillbirth. This was looked down upon by my father's family, especially by my paternal grandparents. Nevertheless, things went back to normal when she got pregnant with a second child, whose fate unfortunately followed that of the first. Grandfather Adrián was deeply saddened, while my grandmother Nabora was enraged at the loss of her two grandchildren, both boys who would have been heirs of the Jiménez-Pérez line. My father was extremely worried, and he felt somewhat guilt ridden since he was unable to procreate healthy children. The pressures of machismo customs overwhelmed him. All the while, my mother, being a devout Roman Catholic, left everything to the "Will of God."

After the second stillbirth, my grandmother Nabora and key members of the Mixtec side of the family gathered to determine why the two babies had died. Witchcraft came up as one possibility, along with the evil eye, the phases of the moon, and my mother's health. Yet, none of these possibilities yielded extraordinary findings, so the group concluded that on giving birth, my mother had assumed a sitting position that had suffocated the newborns. They claimed that she was doing this so that no child would be born from the Indigenous side and thus was preventing Indigenous blood from entering the racial mix that would carry on the Mixtec culture and traditions.

These findings from the meeting were relayed to my father, who in turn shared them with his wife. She claimed that those were the most absurd accusations she had ever heard and swore in the name of all the saints in heaven and on earth, and especially imploring the Santo Niño de Atocha (the Holy Infant of Atocha)[19] and the Virgin of Juquila to help her convince her husband's family that she was not someone who would kill babies. My mother insisted that she was just a victim of bad luck and persistently gave them different explanations to try to satisfy them. She argued that it was inconceivable that she could be responsible for the stillbirths; nevertheless, her arguments fell on deaf ears. So, she pleaded with my father, insisting, "Having a child brings unforgettable pain, and that pain creates a greater sense of love for one's children, rather than a desire to kill them as I am being accused of doing. But since your people are Indian, they can't hear the voice of reason."

Finally, my mother complained to her sister, Sarapia, who suggested, "Ime, you must do something to rid their heads of that idea." My mother angrily threatened, "I swear this to you, I am going to offer the next child to the Santo Niño de Atocha." To this Sarapia replied, "Well, tell that to your in-laws." My mother conceded by saying, "I did but it was not good enough. I am sure that if I had said that I would offer my child to the Rain God, they would have thrown a party in my honor. You don't know how these people are. I don't know what I am going to do. Juan tells me to be patient with them; that we should try to have another child. He says that would settle the issue, which is why I ask God to give me a child soon, very soon." Sarapia reminded her, "This is why papa Tacho didn't want you to marry an Indian. They have very strange customs, they think differently, and they are very superstitious." My mother couldn't help but agree and reluctantly replied, "I'll try to bear with this for a couple more months, but if I cannot get used to things, I will come back to live with you. I don't care if I have to make a living selling pan dul-ces [small bread rolls covered with brown sugar glaze]." As my mother was leaving, Sarapia expressed her concerns for her stepsister: "Imelda, you really worry me. Ask God to guide you."

19. The Holy Infant of Atocha, the Roman Catholic image of the Christ Child, is popular among the Hispanic cultures of Spain, Latin America, and the southwestern United States.

AN AUSPICIOUS GATHERING

The family's attitude toward my mother didn't improve over the next couple of months, and they started to distance themselves from her. They couldn't understand how she could lose two babies. As time went by my mother became pregnant for the third time. On hearing this my grandmother Nabora and my aunt Ignacia decided they would take care of her. They constantly consulted my great-grandmother Alejandra Pérez, my father's grandmother, who was also a well-known *curandera*.

On October 16, 1940, during the fifth month of the pregnancy, there was a lunar eclipse. This astronomical event heralds the war between Night and Day, as they battle for power. The Earth must force the Sun and the Moon into equal balance so that the town doesn't perish. As the full moon was about to be darkened as it passed into the earth's shadow, messengers in the town shouted their warnings from door to door. It was imperative that pregnant women, newborns, animals, and plants be protected from the eclipse. This caused great commotion throughout Tututepec, and at home they decided that my mother was to stay in the house for a period of twenty-four hours. As is the Mixtec custom during such frightening events, my great-grandmother Alejandra placed a red cloth on my mother's swollen belly to protect the unborn child.

At the same time, to help the Earth with its efforts to bring about a balance between the Sun and the Moon, the members of the Mixtec barrios made loud cries and banged metal trays or any object at hand while the church bells rang throughout the duration of the battle. Once the eclipse had ended, the entire Mixtec community cheered with joy and sang to celebrate the triumph of the Earth over the Moon and the Sun. I witnessed this dramatic and chaotic activity several times throughout my childhood when there was a lunar eclipse.

Based on predictions stemming from such phenomena, unprotected children and crops would grow with some form of deformity. But according to my great-grandmother Alejandra, I was going to be born without any such condition since she had saved me from that imminent danger by applying the red piece of cloth, so despised by the Moon, to my mother's swollen belly. It had protected me. Afterward, she told my mother, "Imelda, I feel sorry for the people who did not have a red cloth."

Shortly after the lunar eclipse, my grandfather Adrián held another gathering with some important family members and his closest friends to carry out all the steps necessary to prepare for the birth of the third child. My great-grandmother Alejandra had predicted that because of the position of the moon and the size of my mother's belly that the child would be a boy. They all agreed to keep a close watch on my mother right up until her labor started. They summoned the most experienced Indigenous curanderos from the region to help my mother with the long-awaited birth. They also agreed that my mother would not be permitted to visit any mestizo doctors in town. She would be allowed to consult only with my great-grandmother Alejandra through the remaining months of her pregnancy. My grandmother Nabora was also a curandera, but at the time of my birth, she lacked the specific mystic powers to participate in functions of such significance. She would have to await the death of my great-grandmother before gaining recognition as the supreme curandera in the family.

WITCHCRAFT, MAGIC, AND MY ENTRANCE INTO THE WORLD

My mother told me about how I came into this world. This is what I recall from what she shared with me as I was growing up in Tututepec. As the days leading up to my birth approached, curanderos from the surrounding communities of San Miguel Tlacamama, Camotinchán, Tataltepec de Valdés, and Jamiltepec arrived. They were all housed in a large, rather dark open shelter with a thatched roof that belonged to my grandparents. This shelter was the site used for Indigenous rituals and religious ceremonies, and the curanderos didn't leave the shelter except for mealtimes or walks by the ravine, which they used as a privy. Every night they would observe the moon and the position of the stars. They would also place their heads on my mother's belly as she lay back, which enabled them to hear or feel the movements of the baby.

Three days before my mother went into labor, one of the curanderos said that the baby was trapped and that they needed to free it so that it would be born alive. That day, my mother witnessed her first traditional Indigenous healing ceremony. She recalled that they laid her on a petate (woven palm-leaf mat) and rolled it around her like a taco. Then they tied a rope around it and sprayed her with an infusion of aguardiente (brandy) and camphor.

After that, they spun her around several times and then sprayed the infusion over her once again to summon the spirits. Finally, they placed dried corn husks on top of the mat and burned them. Once the fire was extinguished, they untied and unrolled the mat and rubbed my mother's body with the aguardiente and camphor. That night my mother had a good sleep. She claims that it was because of the liquor, but the curanderos say it was because the baby had been released.

The curanderos would meet with my grandmother Nabora in the evenings to keep her updated on the impending birth. They had assured her that everything would go well since the moon was lavish and the swaying of the earth produced good vibrations. They had generously fed the earth corn and cacao beans. At night, the curanderos would light fires to study the shape of the flames and the noises made by the logs as they burned and popped. They would also sprinkle grains of salt on the burning logs to make a series of slight, sharp popping sounds as they hit the flames. As the curanderos consulted with each other, they did not uncover any omens for the days to come.

Just before the stroke of midnight on February 2 my mother felt the first severe pains of labor. The curanderos awoke, left their dark shelter, and took their places on a new mat that my grandfather Adrián had prepared for them. As they gathered, they agreed on the roles that each one would play. My father would be charged with holding my mother by the waist and helping to push me out; one of the curanderos was going to prepare an infusion with different flowers and herbs for my bath; another would sit in prayer holding a tortoise shell and evoking the spirits, so they would guide my birth toward a positive outcome; while another studied the position of the stars and the moon. The most important of all was the tonero, whose objective was to discover my guardian animal spirit, or tona, assigned to every Mixtec child at birth.

At approximately four o'clock in the morning my mother asked my father to summon doña Soledad Solano, a famous midwife among the town's mestizos. Soon after her arrival, doña Soledad established a very amicable rapport with the curanderos. Nevertheless, she chose to ignore their rituals. She knew that the curanderos had good intentions, but she couldn't understand their chants and prayers in the Mixtec language. Chanting and burning copal incense at such an hour made no sense to her.

My mother was very glad to see doña Soledad because now she had someone she could communicate with in Spanish and no longer felt the uneasiness

of not knowing what was being said in Mixtec. The birth was mainly guided by the midwife while my father held my mother and pressed gently down on her belly to help me out at the precise moment. The intensity of the cramps started to increase along with the volume of the chanting announcing the imminent delivery. At about five o'clock that morning my first cry resounded throughout the smoke-filled house. The midwife, aided by one of the curanderos, cut the umbilical cord, and my female relatives proceeded to cleanse my body in the herbal and floral bath that had been prepared in advance.

The chanting ceased, the smoke from the incense started to dissipate, and the identity of my animal spirit guide had been confirmed. They announced to my grandfather, "It's a boy!" February 3, 1941, was a day for celebrating the continuation of the Jiménez-Pérez line. My grandparents expressed their gratitude to the curanderos with hand gestures and other Mixtec cultural expressions. The midwife was also thanked for her expert hand during the delivery, and she happily received the six reales[20] that she charged for her services.

MY TONA

The tonero played one of the most important roles during my birth, as it was his role to discover which animal was to be my spirit guide. His toolkit consisted of a comal (a griddle used for cooking tortillas), two sticks, and a hallucinogenic tea. When my mother's labor pains began, the tonero drank his tea and simultaneously began to trace images of animals, native to the region, in the ashes on the comal with his stick. The animal traced at the precise moment of my first cry would be my tona for the rest of my life.

The tona is the animal that protects the individual; it is an individual's alter ego, a creature that is both real and magical. The tona determines a person's attitude, personality, and status in his or her community. It also plays a vital role in establishing a person's spiritual and physical protection, as well as success in life. When someone in the village is healthy, successful, and strong, everyone in the village assumes that his or her tona is a bobcat, mountain lion, snake, or eagle.

20. In the 1940s the Spanish real was the type of currency still in use among the Indigenous Mixtec in Tututepec. Today the Mexican peso is the currency used.

The individual's tona is a secret that he or she takes to the grave; the only people who are privy to this are his or her Indigenous parents and grandparents. Revealing a tona would be equivalent to committing a mortal sin in Catholicism. It would destroy the individual, and the mystery would cease, thus causing the person's death. If someone becomes ill, it is said that it is because his or her tona has been attacked by other animals, which brings consequences for the person. If he or she does not recover, it means that the tona is dying, and depending on the symptoms, the curandero may attempt to save the individual or not. If death is imminent, it means the person's tona has also died. Therefore, healing rituals for the individual and their tona tend to be spiritual in nature rather than practical.

My grandfather Adrián told me that my tona was a good one, and that he was thankful when the tonero told him that I would someday be highly respected. They did not let my mother know what my tona was because she was a mestiza, and it is considered bad luck for mestizos to know this about you. There was a time when my mother asked about my tona, and my response was somewhat evasive, and we never discussed it again. I think that even though my mother didn't believe in the Mixtec customs, she respected them and periodically would ask about them out of curiosity rather than genuine interest.

THE CELEBRATION OF MY BIRTH

With the announcement of my birth, our closest relatives gathered to celebrate with some hot chocolate and egg bread, as was customary. Our house was situated on a hilltop, and grandfather Adrián yelled in Mixtec that the first male had been born, a child who would one day follow in his footsteps as an important principal in our Mixtec barrio in Tututepec. A few of the neighbors heard him and headed toward the homes of other more distant neighbors to spread the word. By seven o'clock that morning, the stores had opened on the town square, and one of my uncles bought a dozen fireworks. When he returned to our home, he lit them at once, announcing the birth of a son so that the whole community would know.

Throughout the day my family received congratulations from important officials in the community. At the time, my grandfather Adrián was serving as the mayordomo of the Santitos, a group made up of principales who were

responsible for the ceremonies held in the Mixtec barrios that year. He also directed the town's musicians, and they all gathered and played incessantly while drinking aguardiente. My grandfather played the trumpet, which remains in the family for remembrance. It is completely beaten up, and its dents symbolize his drunken escapades. The celebration lasted almost a week, since those who lived in ranches farther away received the news later and came as soon as they could.

The curanderos gave my mother an herbal bath and rubbed her legs to get rid of the cramps. They wrapped the umbilical cord in a piece of cotton cloth woven on a backstrap loom by my grandmother Nabora. They took it to the riverbank, where they buried it so that it would bring forth fertility upon my mother, and she would bear more children. The next morning, I was taken to a hill near our home where the placenta had been buried and presented to the Tatas, the eternal Mixtec gods.

On the third day after my birth, the curanderos met for what would be the last ceremony, referred to as "The feeding of the Earth." I was bathed with water that had been boiled with rose essence and yellow wildflowers, and then dried with a white cotton blanket woven by my grandmother Nabora. Next, they used a sharp knife to cut off my foreskin and then walked toward the riverbank where my umbilical cord had been buried. Mixtec chanting complemented the procession as the curanderos went to bury the foreskin so that I would become "part of the Earth by feeding the Earth." My mother said that I cried a lot, and as the circumcision took place, my grandfather Adrián held me tight so I wouldn't move. After the procedure, they washed me and applied crushed salt to the wound to heal it faster and to prevent infection.

The Mixtec name that my grandparents gave me was 5 Rabbits, which corresponded to my succession in the family line. My grandfather paid the curanderos ten reales each and gave them provisions for their journey home, including chocolate, salt, bread, beans, and other food products. The house was finally at peace, and my mother often said, "I was getting tired of all those brujos [witches]!" My mother's family came to visit with the Galván calendar, which contains information about the different Catholic saints that are celebrated for each day of the year. They looked for the name that corresponded to the saint for February 3, and it was Saint Blas, so they named me Blas Jiménez Caballero. At the time of my baptismal, I was given the name Federico by the Catholic priest at the San Pedro Church.

Most of the women from our Indigenous barrio, whether related or not, would come over every day to wash my diapers. This was a privilege for these women, and it was a way for them to pay their respects to my grandparents. "Those Indian girls would even line up to wash your diapers!" my mother would exclaim in disgust when telling me this story as I got older.

The acceptance of my mother by my father's family continued with little progress. Among the main issues were the household chores. My grandfather Adrián was very patient with my mother because she had given him the grandson that he so dearly desired. As I was growing up, I was the center of attention, as I was charged with the continuity of the family line. Everyone in the family had lofty expectations for me to someday become a political or spiritual leader, among other roles.

3

MY EARLY CHILDHOOD

I REMEMBER TUTUTEPEC AS A SMALL sleepy town located on a breezy hill that could be reached only by foot, horse, or mule. Occasionally, a Jeep might arrive after driving along the dangerous and difficult dirt trail. The climate was tropical and very warm, and most of the people depended on farming and cattle ranching for their livelihood. Corn, sesame, lemons, coconuts, corozo palm nuts, papaya, and hibiscus were some of the produce that was bartered or sold. We walked everywhere or rode a donkey, when we had one. I was fortunate that my grandparents were alive during my early years, and I was able to learn about my Mixtec heritage before they passed away.

THE PASSING OF A GREAT COMMUNITY LEADER

When I was three years old, my grandfather Adrián died, and it seemed like everything changed. He had been the pillar of the family and a revered leader. He represented the family, but more importantly he was a high-ranking Mixtec principal in the Tututepec community. There were twelve Mixtec principales in Tututepec at that time. My grandfather Adrián made critical decisions concerning the welfare of the Mixtec people. He often served as a mayordomo, where he oversaw community property, mandatory community

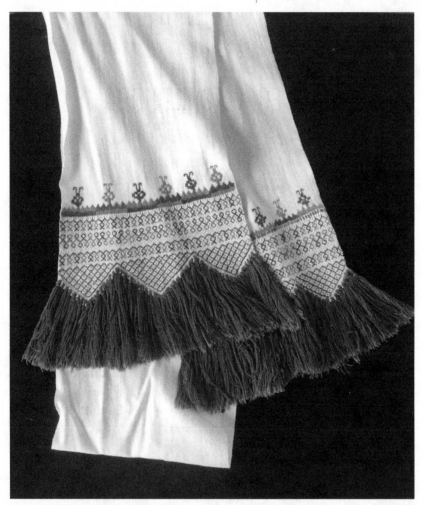

FIGURE 3. Photo of grandfather Adrián's sash with the embroidered design signifying his rank as an important Mixtec principal. This sash has similar designs to the one he was wearing when he was buried. Courtesy of the Belber-Jiménez Museum, Oaxaca, Mexico.

labor, and public works.[21] He also helped in resolving disputes and keeping the peace. It is worth noting here the story of his funeral as my mother recalled it and told it to me.

After the Indigenous peoples of the region found out about my grandfather Adrián's death, our house became the gathering place for representatives of the family, relatives, and friends, all of whom brought "offerings" of items that could prove useful to my grandfather in the "other world, the after world." The ceremony started by dressing my grandfather in his official principale attire. This consisted of a handwoven white cotón with purple stripes dyed with caracol. His handwoven white cotton pants were secured with a wide sash with the ends embroidered with caracol purple and cochineal red. The purple and red designs corresponded with his rank.

At approximately three o'clock in the afternoon, they rolled a petate around him and placed him on a bed made of wood, which was carried to the church by four family members. The procession was headed by other community principales, who carried branches of coconut palm with *zempoalzuchitl* (caléndula or marigold) flowers inserted into the veins of the leaves, creating the particular design that designated my grandfather's rank. The closest family members of the Jimenez-Pérez side followed. As the funeral procession went from the house to the church to the cemetery, people tossed petals from the zempoalzuchitl flowers on the ground so that his soul would find its way back on the annual Día de los Muertos (Day of the Dead, or All Souls Day). He was placed on a bed of soil, so that the earth would take him in. Then four candles were lit to mark the beginning of the wake, which lasted throughout the night and part of the next day.

My grandfather was buried in the area of the cemetery assigned to the Mixtecs, and in his grave, family members placed food and objects that would come in handy in the afterlife. This included clay pots, plates, incense burners, copal incense, and some religious objects. Another group who participated in the procession was tasked with carrying other special grave offerings, including a special tortilla made with ground corn, corozo, and cochineal; beef stew; chocolate; egg bread; and fruit. My grandmother Nabora

21. See Spores and Balkansky, *Mixtecs of Oaxaca*, 111, for a description of the role of principales under Spanish rule during the colonial period, which carried into the twentieth century.

threw in a package containing three changes of clothes she wove so that my grandfather would have something to wear in the afterlife.

Most dramatic was the burial of a live black dog. It is said that the dog had to cross three rivers. The first was a river of milk, the second a river of blood, and the third a river of crystal-clear water that prevented his black coat from being stained by the milk or blood. This was done so that the dog's spirit would not escape, and it could perform the task of guiding my grandfather in the afterlife. Two men took the black dog and pushed him into the grave along with the offerings that had been placed with my grandfather. Once in the grave, the dog cried as he attempted to get out.

At the end, four menacing-looking clay or stone figurines were placed in the grave, each representing one of the four Mixtec deities. Once my grandfather crossed the three rivers on his journey, these sacred deities would carry him to the clouds in the Mixtec Alta, the site of the origins of life. Each of the principales and relatives approached the grave and said goodbye while moving from side to side, soulfully chanting in Mixtec. After the burial, everyone cried, as was customary. It is said that those who do not cry have no regard for the departed.

Afterward, every time my grandmother Nabora saw a black dog in town, she would remember my grandfather's funeral and think about that poor dog that had to be buried alive because of the color of his coat—what an ominous end that was. I was too young to attend the funeral, and many years later, when my mother told me this story, I couldn't decide whether I liked it or not. I felt both anxious and sad. My mother tried to comfort me by saying, "Those are old customs dating back to a time when Indian people were very narrow minded. I wish I could tell you good things about your father's family, but I never quite understood those people. Their customs were different, their language was different, and the way they dressed was different. I always felt very secluded." My mother never could accept these cultural differences, and so she tried her best to prevent her children from learning about their Indigenous heritage.

GRANDFATHER ADRIÁN'S WILL

Soon after my grandfather's passing, my uncles, David and Toribio, went over his will. They weren't pleased with the provisions set forth, especially

since my grandfather had left me a large inheritance. As a result, my aunt Nacha expressed her disappointment in them, but being a woman, her opinion didn't carry much weight. My uncles demanded that my grandmother Nabora nullify the will, to which she finally acquiesced but never did much about it. When my grandmother died two years later, I was five years old, and the issue of the will still hadn't been legally resolved.

As it turned out my grandfather left me the house that I was born in, eight cows, four horses, two young mares, four donkeys, and plots of land that had sugar cane, mango, coconut, and papaya. Most importantly, he left me sixteen ounces of gold that I do not recall ever seeing. My mother told me that when my grandfather got drunk, which was often, he would tell everyone in the neighborhood about those sixteen ounces of gold. He proudly announced to his friends that he had some hidden treasure.

One of the plots of land that I inherited was in the valley close to San Vicente Hill. The adjoining plot on the north belonged to my mother's uncle, and the adjoining plot on the south belonged to her cousin. As I got older and started visiting my plot of land, I noticed that the boundary markers would be in different places, gradually decreasing the size of my plot. This undoubtedly had been done by my mestizo relatives, who after a few years had taken full possession of almost all my land. Neither my father nor my Mixtec uncles fought for it. When I asked why, they both responded very similarly: "Justice did not apply to Indigenous folks back then. Those gente de razón [mestizos] had all the power."

I don't quite recall all the specific details as to what happened to my part of the inheritance because I was so young. The only thing I got to know very well was my little plot of land that I still owned, along with two donkeys that would become an important part of my life. Donkey, land, and child—we were a trinity. As I grew older the blending of these three forces would help me face a harsh rural world and would often have an impact on my family's survival.

GRANDMOTHER'S LESSONS

While my mother held steadfast to her Catholicism, my grandmother Nabora would take me to a hill near our home where she would go to pray. She only prayed on special occasions, such as the beginning of the planting season, or

to ask for rain. She would say, "Let's go talk to the Tatas," taking with her the clay and stone figurines that represented the Mixtec deities. She would wrap these fierce-looking figurines in a piece of woven cloth made specifically for this purpose, and then she would later pray to them while burying them halfway in the ground. Some of the figurines were slanted, and some were placed in a prone position.

My grandmother Nabora would pray in the Mixtec language and remind me that we were at a sacred place where we could talk to the Tatas. While she was praying, she would look down and rock from side to side, like the Orthodox Jews, and she would cover her face with her hands, almost crying. She would tell me that the Tatas where not at peace, that they needed an offering. She would also tell me that when I grew up, I would have to go "talk to the Tatas." They would listen and help me. She would say, "Come as the sun sets, and they will help you as they return from the fields to rest." During the day, we would pass by this same hill to use the privy, and we did not have to do the sign of reverence or even bow our heads because according to my grandmother, the Tatas were not there during the day. The Tatas usually headed toward the fields very early in the morning to protect the harvests and then returned by sunset, whereupon they would receive our offerings.

Other times my grandmother would take a jícara (small gourd bowl) filled with cacao beans and corn grains to perform a ritual. While praying in Mixtec, she would bury the cacao beans and corn grains, stating that they were an offering to the Tatas. Her prayers always ended in whimpers that unveiled her feelings. Her emotions were contagious, and I would end up crying as well, and she would wipe the tears from my eyes with her hand before we would head back home.

My grandmother Nabora wasn't the only one who visited that sacred place; other members of my father's family would go there as well. They usually went in the evening, maybe to avoid being seen by the townspeople, or because, as my grandmother explained, they were just used to going there at that hour. Rosa Maria plants (a type of blooming cactus) were everywhere around the mound, as if someone had deliberately chosen to adorn it with the yellow flowers. I never found out whether the Rosa Maria plant had a specific meaning or just simply served the purpose of keeping the place enclosed.

My mother thought that my grandmother Nabora was irresponsible and her behavior strange. She would often complain, saying, "That Indian grandmother of yours has made you turn away from Christ. But one of these days

when she tests my patience, I will put her in her right place. What she is doing to you isn't right. As a mother, it is my duty to protect you from that witch." My mother would take me to church for Mass, and as she prayed, I could hear her begging Saint Peter to forgive me for going to that place with my grandmother, where the Indigenous people pray. For such a grave sin, she would offer a Ninth Day Prayer dedicated to the Holy Infant of Atocha so that I may be forgiven.

There were countless wood-carved saints in the church, and the one that intrigued me the most was a large Christ hanging from a cross. His eyes were large, and his face was splattered with blood. One time I stood in front of him, and he seemed to follow me with his gaze, which made me laugh out loud in church. My mother pinched me, and even though the pinch was painful and made me cry, I kept on laughing. Of course, my mother was extremely embarrassed by my behavior. As we departed the church, I tried to explain why I had behaved as I did, but she wouldn't have it.

I often found myself confused when I tried to discern my feelings toward my grandmother's beliefs and my mother's religion. On the one hand, I thought that going to the little hill to pray to the Tatas was more pleasant than being in church with my mother. Those Catholic saints scared the hell out of me whenever I looked at them; their facial expressions were so intense! They had a piercing stare, and I felt that they would fly toward me at any moment, demanding that I be punished for praying with my grandmother. I remained conflicted about these religious differences throughout the rest of my childhood.

Several years after my grandparents passed away, my parents made some repairs around the house. As they were removing a wooden post from the ground, they found a gray ceramic pot that contained turquoise and coral beads, along with pre-Hispanic gold pieces. That was probably the gold that my grandfather used to talk about whenever he was drunk and that was left to me in his will. In one corner of the house they also found pre-Hispanic clay figurines. My mother recognized them since they were the same ones that my grandmother Nabora took with her when she prayed to the Tatas. After praying, my grandmother would wrap them in the cloth and return them to the same place in the house. I still have the pre-Hispanic gold and my grandmother's figurines in my private collection. One of the gold pieces is currently on exhibit in the pre-Hispanic jewelry section of the Belber-Jiménez Museum in Oaxaca.

A ROAD TRIP WITH MY MOTHER

When I was about four or five years old, my mother and I took a trip to the Juquila Fair to sell the last of the young mares bequeathed to me. The journey from Tututepec to Juquila was over seventy-five kilometers and took three days. As we left Tututepec, we joined a caravan that was headed in the same direction.

The first day we stopped at Santa Cruz Tututepec, a very old and picturesque village, which is best known for its ceramic household items. I marveled at the sight of most of the houses. They had palm frond roofing, and most of them had two clay pots on top, which I thought were maybe signs or samples of their work. This was the first time I had visited anyplace outside my hometown, and I thought that on my return to Tututepec, I would tell my friends about the places I had visited. I would tell them about those pots on the rooftops that seemed so strange. I didn't know what their purpose was, but it was quite a sight to see them on all the rooftops. A charitable Indigenous couple gave us a place to sleep that night along with a petate to sleep on.

At dawn the next day, we were awakened by the noise and rumble of the caravan leaving, so we hurried to join them on the road to Panixtlahuaca. After a couple of hours, we suddenly lost the path, which was covered with leaves and hard to see. The entire caravan stopped and sent a fellow back to retrace our steps and search for the path. He returned two hours later and guided us back toward it. I felt fearful at the sounds of the different animals. Occasionally I would hear a jaguar or a mountain lion, and all the while the singing of the birds offered us a symphony, as nature revealed the wonders of this tropical forest. Huge bindweeds decorated the trees; moss dressed their tops, while stubborn little agaves clung to branches. Suddenly, a stealthy rattlesnake approached me. I knew that sound and looked at my mother, who told me to stand still so that the rattlesnake wouldn't hurt me. And indeed, it made its way back into the shrubs leaving me intact. I wanted to take a little bit of everything I was seeing and hearing home with me.

By nightfall we had arrived at our next destination along the route. Again, someone provided us with a place to sleep for the night, and while we rested, I could hear young girls passing by with covered containers. I peered out and spoke to one of the girls. I asked, "What do you have there?" She replied, "Pumpkin fruit." I ran to my mother, saying, "Mama Ime, buy me some pumpkin!" "No dear son," she replied, "it's too late for food." But I insisted: "I just

want a little piece." In an act of tenderness, she took out a tightly wrapped bundle and picked out a coin to pay for the pumpkin fruit. Little did I know that hours later, around midnight, I would find myself crawling outside in the dark because of the effects of the pumpkin on my stomach.

When my mother learned that I wasn't feeling well, she started scolding me but then stopped and instead set out to make some guava tea. It felt as though I would end up there in Panixtlahuaca for the rest of my life, had my mother not prepared that tea. Every time I went out to the ravine to use the privy, I could see that a lot of people were in the same condition. I guess I wasn't the only one who had eaten the pumpkin fruit that night.

The road from Panixtlahuaca to Juquila seemed safer and clearer. We had to cross a river quite a few times, and each time my mother carried me at her waist so the current wouldn't carry me away. When we were a few kilometers from Juquila, the entire caravan began to pray and sing. As I recall, the words went something like this: "Oh Maria, Mother of Mine. Oh, comfort of mortal men, protect and guide me, to the kingdom of heaven."

By late morning of the third day, we entered the town of Juquila. I had never seen so many people and such massive quantities of merchandise, including bright clothing, haberdashery, food, candies, and hundreds of toys. I closed my eyes for a moment, and when I opened them, I wanted to run and hug everyone. It was like being in a dream, with so many people and things all gathered in one place. In addition to this being my first trip anywhere outside my town, it was my first experience with the multitude of markets in Oaxaca.

I was a curious child, and I felt free as a bird in that new world that stood before me. I supposed that this was what a bird usually felt like after taking its first flight. I felt independence and self-assurance. Everything was so fascinating! I was so excited and wanted to shout to everyone that I was free. I was also taken aback by the sight of all the candy stands and the smell of food cooking everywhere. I wanted to be taller so I could see everything on the fruit stands. I watched as a man pulled out molars with his tongs without using any anesthetic. I was amazed at those little birds that were trained to pick out a little fortune among a stash of folded strips of paper in an envelope. It is the same state of amazement I have had numerous times throughout my life, particularly when making personal decisions and taking risks that would result in varying consequences, some better than others.

When my mother went to the animal exchange to sell the young mares, she asked someone she knew to watch me for a while. It was taking a long

time, and not knowing when she would return, I approached a lady passing by and said, "I am very thirsty. Do you know where I could get some water?" The lady smiled and responded, "Go to the town's river." I knew there was a river somewhere, as we had crossed it coming into Juquila. I walked for what seemed like hours trying to find the river. At times, I would sit and wait for someone to guide me, but I never found the river, and then on seeing all the rides at the fair, I forgot all about my thirst and wandered around looking at them. I thought the ride that had horses attached to a cylinder in the center and went around in a circle to music was nothing short of sheer wonder. I have since learned that this was a type of merry-go-round like the ones you find at fairs and in amusement parks today.

That evening when my mother arrived at the place where we were staying and asked about me, the lady who was supposed to be watching out for me said that she left me sitting in one place and then suddenly I was gone. My mother almost died from shock and thought of the worst possible scenario, child abduction. She immediately started searching for me, desperately asking everyone she saw if they had seen a young boy wandering around. She gave people my description—short, brown eyes, black hair, and barefoot. Nobody had seen me. People from the coast are known to be very supportive, and most were moved by my mother's crying as she desperately looked for her child, so a crowd formed to help her. Many of them asked for a picture so they would get a better sense of whom they were looking for. There were hundreds of children at the fair, but unfortunately, she didn't have one.

She finally found me after what seemed like hours to her. I was sitting, mesmerized by the merry-go-round, when suddenly she embraced me, pressing me against her chest, saying how glad she was to finally find me. Then, she gave me a tender kiss on the forehead. It was a moment I will never forget. We didn't say anything; she simply took my hand, and we walked around the fair. We stopped at the first shoe stand she saw, and she bought me a pair of shoes. They looked like girls' shoes because of the combination of black and white. Maybe there were no other styles of shoes in my size. We hurried toward a place where we found a photographer, and he took my picture. This would make it easier to find me in case something like this ever happened again. My mother held my hand the whole time as she was not about to lose me a second time.

Afterward we headed toward a church, where my mother thanked the Virgin of Juquila for assistance in finding me. We bought gifts for family and

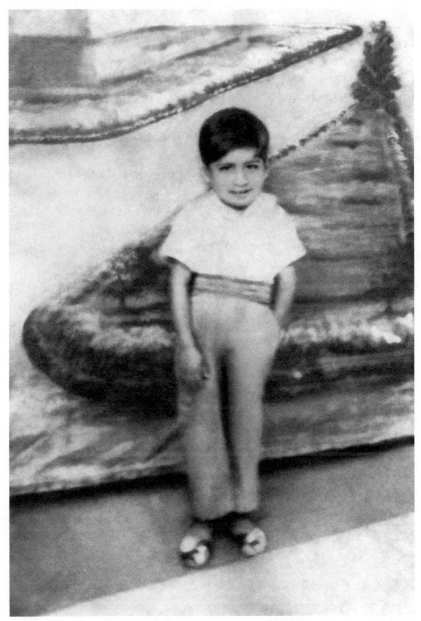

FIGURE 4. Photo of Federico taken when he was four or five years old after being lost at the Juquila Fair while on a trip with his mother. Photographer unknown. Jiménez Family Collection.

friends, and we left Juquila the next day to return to Tututepec. We stopped at the edge of town to wait for the people we had traveled with before so we could all return in a single caravan. That was the safest way for us to travel because we were carrying seventy pesos, and we would have been more vulnerable to attacks by wild beasts or bandits if we traveled alone. We also felt it was safer to travel as a group as it minimized our chances of getting lost.

Three days later we arrived back in Tututepec, tired but with a sense of well-being after such an unforgettable experience. My mother was pleased with the sale of the mares and grateful for finding me. The news that I had been lost had already reached Tututepec, and some thought it was a joke, while others were quick to judge my mother's carelessness. Most of the people were not surprised because they knew that I was quite a restless and curious child. Of course, most of the criticism came from the mestizo side of town.

Despite the differences of opinion in Tututepec regarding marriages between mestizos and Indigenous people, my parents' relationship remained strong because of the intense attraction they had for each other. He loved her dearly, and she was finally accepted by the Jiménez-Pérez family. Nonetheless, there were still ongoing contrasting cultural issues between them. At my father's house, everyone spoke Mixtec, and I liked to speak it too, especially when playing with the other kids in the neighborhood. My mother would get upset with me when I spoke Mixtec, and she'd reprimand me: "Only Indians speak that way, and you are no Indian." One time we were at the market, and I ran into some of my friends from the neighborhood. They asked me to play with them, and I responded in Mixtec. My mother sternly pulled me by my arm and hit me on the head, saying, "Stop, you're acting like an Indian!" She would often say that to me. I wanted to learn Mixtec fluently as my grandparents had wished, but my father always sided with my mother on this issue. Maybe he saw it as a form of racial evolution, "a good change" as he called it. One of the things both sides of the family agreed on was that I should have a formal education. It was when I started going to school that I became much more aware of the cultural differences between the mestizos and the Indigenous people in Tututepec.

4

EARLY SCHOOL DAYS
AND A NAME CHANGE

T O START LEARNING MY FIRST letters in Spanish, my parents sent
me to don Bruno Valladolid's home so I could learn the alphabet using
a spelling book he had. Don Bruno was an old Mixtec principal who
was married to a mestiza. He was quite strict and demanding. At the time
he taught a few other children, both Mixtecs and mestizos, with the help of
his two daughters. Every morning don Bruno would explain the lesson to
us, and a couple of hours later he would test us to see if we could recall his
lessons. If we gave an incorrect answer, he would pull our ears and hair, say-
ing, "Practice your vowels and consonants so that you can memorize them!"
I would respond, frustrated, "I can't memorize them!" and don Bruno would
insist by saying, "Cortando huevos se enseña a capar." In English, teachers
would more politely say "Practice makes perfect." I guess he was right. After
a couple of months, I was ready to start public school.

THE FIRST GRADE

In January 1949, when I was not quite eight years old, my mother introduced
me to the first-grade teacher at the only public school in Tututepec. It was
called the Escuela Federal Progresista (Federal Progressive School). She told

my mestiza teacher from the Valley of Oaxaca, "This is my son. I entrust him to you. Hopefully you can guide him. He's very mischievous, and if he misbehaves please discipline him. You have my permission." Since my education up to this time was with a private teacher, that first day of school was quite exciting. Everything was so new to me. I liked being around other kids, going to the playground for recess, and writing on the blackboard with chalk and then erasing it. Everything sparked my curiosity.

Nevertheless, my joyful days as a student were short lived. Every time the teacher called the roll, she would call my name, "Jiménez Caballero Blas," and everyone would laugh. Some of my mestizo classmates would chant: "A dónde vas, conejo Blas?" (Where are you going, little bunny Blas?). Others yelled, "Blas cara sucia!" (Blas has a dirty face!). They were referring to a story we had been told, "Dirty Faced Blas." It was the story about a boy named Blas who never washed his face, but one time, while crossing the river on his way to school, he slipped on a rock and fell in, and the dirt disappeared from his face. When he saw his reflection in the water, he realized his face was clean, and from then on, he always washed his face before going to school. Understandably, this really got to me, to the point where one day I approached the teacher and asked, "What can I do to change my name?" She replied, "Well, let's see. First you must go to the Town Hall. That is where they keep the registry books."

That afternoon when the school bell rang for dismissal, instead of going home I went straight to the Town Hall. I walked in with my book bag made of calico cloth and took out a slate board with my name "BLAS" written on it. I went into the first office and told the clerk that I wanted to change my name. He told me that I shouldn't be there because I was too young to be in the building, but he sent me to see the registrar anyway. The registrar told me that I was a minor, and that I could not have my name changed by myself; I needed to be accompanied by an adult. He said that the process required the presence of my parents, who would have to fill out the necessary papers, and then there would be a court hearing where the matter would be considered. I didn't understand any of what he told me, but I did tell my parents all about it once I got home.

My parents didn't give it much thought. In fact, changing my name wasn't important to them. Nevertheless, every time I walked by the Town Hall, I would take out my slate board with "FEDERICO" written across it in large capital letters. Standing outside the door, I would yell that I was a very

unhappy child because of the name I was given at birth. I told the mayor's secretary that each time the teacher called the roll, she would emphasize it even more. I also told her that my grandmother Nabora had told me that my grandfather Adrián had been a very prominent Mixtec leader in Tututepec. My arguments merely made the secretary and the clerks smile at me, but after a while they became somewhat inquisitive. Finally, one asked, "What would you like to change your name to?" I responded that when I was baptized in the San Pedro Church, the priest named me Federico. I told her that Federico Jiménez Caballero would be fine.

They must have been satisfied with my answer because the registrar added the name to the record, gave me a copy of my new birth certificate with my new name, and charged me two pesos. Since they realized that I was just a child and assumed that I had no money to pay for the registration of my new name, they waived the fee. When I got home, I told my parents that my name had been changed to Federico, but they didn't act surprised. My father just nodded, and my mother made a gesture that pretty much meant that she didn't care.

The next day I took the birth certificate with my new name to school and showed it to my teacher. I asked her to change my name on the roster and thought that would settle everything. But to my surprise, the next day as she called the roll and got to my name, she said, "Jimenez Caballero Federico Blas." I sprung up from my chair and firmly stated, "I object to that! I gave you my new birth certificate yesterday so that you would correct my name on your list." She responded, "Your name will be Federico Blas for the remainder of the month. Next month you'll hear your new name." For the rest of the month I had to endure the remarks of my classmates that resounded in my head like the banging of a hammer: "A dónde vas, conejo Blas?" and "Blas cara sucia."

NAÏVETÉ AND CONDEMNATION

As a young boy, I was labeled as restless and mischievous. I was a very naïve boy who lived in a town that was extremely conservative and predominantly Roman Catholic, so any act out of the ordinary was considered a sin. Unfortunately, being such a curious boy and yearning to belong, I learned this lesson the hard way. It happened when I was eight years old during the Holy

Thursday Mass, which commemorates a sacred day in Catholicism leading up to Easter Sunday. I heard the church bells ringing, so I decided to go to church to see what was happening. When I arrived and found a seat in one of the pews, I could see that many of the children were dressed in white, and they held a candle decorated with white ribbons and a small book, which was also white. Their parents, relatives, and godparents sat nearby. The church was filled to capacity. During his sermon, the priest said that Jesus had been arrested that night, Holy Thursday, and that we had to pray for him. He also said that Jesus's mother cried because she knew her son was going to be crucified the next day, and that Jesus had to die to save us from our sins. He also said that the Romans were to blame for Jesus's death because they ignored the fact that he was the King of the Heavens.

At the end of the sermon everyone was crying, and some people were bowing their heads. Then the priest pulled out a cup full of hosts (wafers of bread used in the Eucharist) that had come from a small box shaped like a little house. He raised the cup for all the parishioners to see, as they symbolically beat their chests with their right hands. After that, the children lined up, and the priest placed what looked like a tiny tortilla from the cup into their mouths. I thought it was either that or a cookie. I didn't want to be left out, so I lined up, and when it was my turn, the priest placed the tiny wafer in my mouth as he prayed. Suddenly a mestizo boy who knew me shouted, "He did not confess." "It's a sin to take it without confession," added another boy. "Don't swallow it!" cried a third boy. I was overcome with embarrassment and confusion. I didn't know what to do or who to listen to, so I hurriedly spit the host out on the floor of the church.

The expressions of shock and word of what I had done spread among the parishioners. Everyone was distraught, and they all got up to see how the priest was going to respond. When he realized what had happened, he headed toward the spot where I had spat the host out, knelt, and said some phrases in Latin while picking up the host with a towel. Once he had done this, he added, "Forgive him, Lord, for he knows not what he has done." He then returned to the main altar to conclude the day's mass. All the while I wondered what was going to happen because of what I did.

The church incident became the talk of the town, and everyone pointed their fingers at me, making me feel like a worm. I rushed home, and by the time I arrived, my father had already heard. As soon as I entered the house, I felt the first hit of his belt across my back, and then many more hits followed.

I don't know how many; all I know is that my back indeed looked like holy Jesus's back. The beating had been so severe that I couldn't sleep that night. My mother placed some banana leaves on my petate so that I could lay on them and finally get some rest. Apparently, my father felt satisfied with the way he had responded to the news; it was a reaction that would pass muster among everyone in town, or so he thought.

After that, whenever my mother sent me out to get something, I would hear people's shouts directed at me. "Wretched boy, wretched boy, you'll be excommunicated for five generations." Those words really struck a nerve, and I no longer wanted to go out or run errands for my mother. I didn't want people to see me, I felt so sad and troubled. At one point, I approached my mother and asked, "What does it mean to be excommunicated for five generations?" She told me, "It means your children, and your children's children until the fifth generation will not have forgiveness. Only the Holy Father [the pope] can forgive you." So, I asked her, "What if I write a little letter to the Holy Father?" And she replied, "No son, it must be in person. You need to go to Rome to receive the blessing. He will send you on your way to the Holy Land, and you will have to walk the Via Dolorosa and stop at each station of the cross and ask for forgiveness, cry, and repent for what you have done, then you have to start again, on and on."

Obviously, this worried my mother as well, so she paid a visit to the priest. Per his instructions, she paid for a special mass which the entire family attended. During the mass, the priest stated that I had to fast for four days. I was allowed to only eat fish, no meat. I also had to pray three Holy Father and three Hail Mary prayers for forty days. After doing this I thought I had paid for my sins and been forgiven, and supposedly everything had returned to normal, but people continued to point their fingers at me any chance they got. This is when I started to learn how unforgiving and discriminatory the citizens of Tututepec could be and how complex the relationships were between the mestizos and the Indigenous people.

5

THE GROWING JIMÉNEZ FAMILY

M Y MOTHER KEPT HAVING BABIES, one after another. She blamed the curanderos for this. She said that they had buried my umbilical cord by the river so she would be more fertile. By then, Ramon and Carlos had been born, along with others who died at birth. With each passing day, my sister, Dolores, who was three years younger than me, and I were entrusted with more and more responsibilities. We had to watch our younger siblings, which included feeding them, entertaining them, and putting them to sleep. We would take turns rocking them in a hammock, singing, "Sleep now dear child, sleep now or else . . . the cat will come to eat you up." After singing this nursery rhyme twenty times and realizing that they were still awake, Dolores and I would take the bottle of brandy and put a dab of it on their mouths. This would put them to sleep right away. When Ramon and Carlos were still very young, my mother would get up to warm their milk and make them some atole, a hot gruel made with ground corn. She would warm up the atole in a pewter cup placed over the flame of a candle. I would help sometimes and would start to fall asleep doing this until the heat of the flame started to burn my fingers.

My mother was always exhausted from working so hard. She'd spend all day making corn tortillas to sell. At night, she did other people's laundry and made beaded garments to sell. Other times she would decorate camisas

(blouses) that she called *lomillo de tumbagones* and *camisa de letilla*. Some had embroidered flowers, and others had cross-stitched embroidery. She knitted and crocheted pillow covers and made embroidered napkins. I never saw my mother rest. She was always doing something to provide income for the household. When she finished a blouse or tortillas or anything that could be sold, she would immediately wrap the goods, place them in a basket, and tell Dolores and I to "go sell this for whatever they'll give you."

My sister, Dolores, and I were quite close, and when not caring for our younger siblings or running errands for my mother, we played even though we didn't have any toys. Dolores had a triangular-shaped stone that she named Tomasa. She used to wrap the stone in her shawl, and Tomasa became her doll. I had a little bull made of black clay that my parents had bought at one of the coast fairs. A lady who sold clothes in town gave Dolores a little plastic doll that could close and open its eyes. The two of us made a little hammock, where we would place the doll at night so she could sleep. One morning, on waking up, we realized that the doll was nowhere to be found. We figured the mice had stolen the doll; they must have taken her to their nest. My sister cried inconsolably, and ever since she has hated mice. She said that God named them *ratones* because they share the same word as "robber." And this is how the days of our childhood went by.

LEARNING FROM MY FATHER

I learned to work in the fields by the age of nine. My father tried to teach me everything related to agriculture and caring for the animals, starting with how to handle a donkey, and how to get on a horse without a saddle. He always wished that I would be more like him, but I never did meet his expectations. Maybe this was because he started teaching me too late in my childhood. By this time, my mother had gotten me used to doing the common chores in town that I helped her with. She would often say to me, "You and I shall face the storm together because your father doesn't seem to care much about us." There was a clear divide in the family. Dolores was dad's favorite, and I was my mother's favorite. At least that's how I saw things.

I'll never forget one day when my father took me to the countryside. He was hired to brand cattle for some neighboring ranchers and would get paid two pesos for each branding. As we were heading to one of the ranches, we

got to a place where he sat me on a branch in a large tree right in the middle of the tropical forest. He said, "Stay here and don't be afraid. The pumas will not get you because they can't climb trees, and neither can any other dangerous animal." I replied skeptically, "I'll be here waiting for you, Papa."

Hours ticked by, and my father hadn't returned. The sun was setting, and the wild animals and birds seemed to howl and sing all around me. I thought some of the cries of the animals sounded joyful at the opportunity to hunt and then eat me. When my father returned, I was crying, and he helped me come down from the tree and then held me tight. We walked to the river-bank, where he tied a cow to a tree and dug a small hole in the sand right under the cow's udders. He placed a large leaf in the hole to create a sort of bowl and started to milk the cow until the small bowl had filled. He then threw in pieces of hard tortillas and said, "Eat until you've had your fill and then we'll head back to town." I thought those hard tortillas dipped in milk were amazingly tasty.

It was during this time that my father taught me how to strap a saddle on a horse and how to mount. Once I could do it flawlessly, he started taking me out in the wild to hunt and to visit other ranches to brand cattle. My father knew the tropical forest like the palm of his hand. Every time we went hunt-ing, we would take only hard tortillas with us. The wilderness would provide the rest. If we got thirsty, we'd drink from a river, and if there was no river in sight, my father knew how to tell water reeds from other types of reeds. He would cut them and squeeze their juice in my mouth. Although the juice wasn't particularly flavorful, it at least took care of my thirst.

One time we got lost in the tropical forest, and we couldn't make it out of there before sunset and night fell upon us. We couldn't find our way back, and my father kept cutting weeds with his machete to create a path for the horses to follow. At last we found a small clearing where we could see the moon and the stars that would guide us back to town. But as we entered the clearing, we heard what sounded like a crashing noise, and the horses started getting rest-less. There seemed to be something on the ground that was disturbing them. My father took a lantern out of his satchel, and when he lit it, we could see the ground beneath us, and to our surprise, thousands of tarantulas had gathered there to breed. We hurried out of there, and we finally found a path that led us back to town. Life in the tropical forest is full of surprises.

My father and I visited all the important places and ranches around Tutute-pec that I needed to know about. Some of the places we visited were around

Pastoría. One was called Hierba Santa, where my father helped plant and harvest some of the crops that belonged to doña Gudelia Barete. He would receive half of the harvest in exchange for helping her with her crops. We also went to other ranches: El Faisan, owned by the Bermudez family, who were distant relatives of my mother; Camalotillo, owned by the Soriano-Reyes family; Yugué, a small ranch inhabited by blacks; Chacalapa Ranch, though I never knew who the owner was; and San Miguel, owned by the Juarez family.

Another place we visited was Charco Redondo, a village to the west along the Río Verde that was the first to be inhabited by blacks who were the descendants of African slaves brought by the Spanish in the early 1500s. Some of the people in this village were my parents' godsons and goddaughters. We went there once when one of my parents' godsons had been shot to death. My mother and I went for his funeral, and I don't know what I ate, but it gave me the worst stomachache. I had to stay close to the river, where I would constantly submerge myself to soothe the bouts of pain.

I recall that the houses and furniture were different from what we had. They were similar to what you would see in Africa. Given its location by the river, the community members of Charco Redondo used canoes for fishing, and during celebrations, they turned the canoes over and danced on top of them. To make the dance more dramatic, they would make a hole in the sand on one end of the overturned canoe so that a drumming sound would come out. I remember on these visits that we would observe many cultural practices that were part of their African heritage. When they brought smoked fish to sell at the fair in Tututepec, they stayed at our house. Like the Mixtecs, they were also discriminated against by the mestizos in town.

These places that we visited were in the middle of the tropical forest that houses thousands of species of plants and animals. Despite the natural beauty of the area, after these experiences with nature, I decided that the wilderness simply was not for me. During these travels through the forest with my father, I really didn't know what was expected of me, but I did know one thing for certain—that nature and I would be both friend and foe for some time.

CHANGING RESPONSIBILITIES

When I was ten years old, my father decided to take part in the campaign to combat hoof-and-mouth disease that had infected the country's livestock. He

wanted to help vaccinate the cattle to prevent further spread and death from the disease. Not able to make ends meet working on the ranches, he decided he would have to leave home and work to improve the family's economic situation. He promised to send us money while saving part of it so he could eventually buy another horse. He wanted to be like his mestizo friends that he drank with at the cantina in town. And so, he signed up to be part of a group that was going to be working mostly around the coastal regions of Oaxaca and Guerrero.

We didn't see my father for months at a time, and whenever he visited us, my mother would once again be expecting another baby. She loved him dearly, and when my father returned, my mother would tell him how much she missed him when he was gone. In response, he would whisper sweet words in her ear and hand her his hard-earned pesos to appease her. Sometimes he didn't bother to write or send us any money, which made my mother very sad. She would dictate countless letters to me, and after I wrote them, I would take them to the post office to be mailed to my father. Some of her letters were very affectionate, while the tone of others, more demanding.

Neither approach seemed to work, so my mother got a novena prayer book, and we would kneel on our brick floor and pray to the Holy Infant of Atocha every night. When we reached the part of the prayer that involved petitions, my mother would start praying quietly. She would ask for good health for my father and abstinence when it came to his squandering of our money on other women or getting drunk. She would ask for God's protection for my father and for his prompt return, or at least a telegram from him.

My mother's list of requests of the Holy Infant of Atocha was very long. Some nights she would cry while praying, and on seeing this, I would end up crying as well. On the last day of the novena prayers, I was usually glad because it was the last night that we'd have to pray. Praying can be exhausting, especially if you kneel on a brick floor every night for a long time. The next day I noticed that my mother was thoughtful, and that night she said, "Let's start another nine days of novena prayers because the Holy Infant of Atocha apparently didn't hear my other prayers." I secretly felt guilty because I would ask the Holy Infant to keep my father from returning soon, since every time he came back, it would be to make another baby.

My mother's longed-for miracle was for my father's return or at least a cash remittance to help his family. I think my father left to get a break from his

family responsibilities. That left the entire task of seeing the family through each day as my responsibility as well as my mother's. It is sad to think that a child so young would be tasked with so many obligations because he is the eldest among his siblings. My father never once considered my mother's situation of caring for so many children, and my mother would not abstain from having more children either. She would often say, "God sends these children to me, and I will obey his command."

That seemed to be her typical explanation for always being pregnant. Even if the baby died, she would get pregnant again a couple of months later. When I was eleven, my sister Zoila Clementina was born, and I noticed that my mother had a very sad look in her eyes. She said that the moon had eaten part of my sister's throat. By this time, we could no longer count on my father for anything; he wasn't sending money, and all we could buy was a prayer candle that we lit for Zoila Clementina during the day.

On the day that Zoila Clementina died, we had to wait until nightfall to take my baby sister to the cemetery and bury her. My mother didn't want people to notice that we were burying my baby sister without a coffin. We didn't have enough money to buy a little wooden casket lined with wrinkled paper, so my mother wrapped Zoila Clementina in her rebozo (shawl), and we carried her to the cemetery. It was a short walk from our house. We could see the cemetery from the kitchen window, which was just beyond a ravine and a little stream we called El Vergel.

The night was dark and gloomy; fireflies buzzed around as though they were announcing Zoila Clementina's death. As we headed to the cemetery, my mother asked us to be quiet out of respect for our baby sister. We crossed the ravine and walked up a path that led to the cemetery. When we arrived my mother's cousin Gustavo had already dug a grave large enough to bury my sister's tiny body. My mother asked us to kneel by the grave and beg for forgiveness for not getting Zoila Clementina a wooden coffin lined with white paper. White is the color for such an innocent child. We also asked for forgiveness for not buying Zoila Clementina a little doll, like the ones that open and close their eyes, to be buried with her. After praying for some time, we kissed the ground by the grave, and my mother said goodbye. She promised my baby sister that she would return with flowers and candles and that in nine days we would be back for the rosary prayer, so that God may allow her to enter the heavens in the form of a little angel. We then returned home on the same path that had brought us to the cemetery, and as we crossed

the ravine, we were startled by the hoot of an owl. "He's announcing Zoila Clementina's death," explained my mother.

My baby sister's death deeply affected my mother, and she fell into a state of depression and didn't utter a word for three days. She stayed in bed the whole time. When we ran out of tortillas, she made a tremendous effort to get out of bed. She ground some corn and made tortillas to feed us. For many days, she would lament the fact that my sister would still be alive if the moon had not taken part of her throat. She wondered whether someone had invoked the evil eye on her. Zoila Clementina actually died from anemia. My mother wasn't eating enough to breastfeed her, and the atole Zoila Clementina was given three times a day lacked the nutrients necessary for the survival of a newborn.

TRYING TO MAKE ENDS MEET

On seeing my mother's suffering and observing my father's lack of responsibility for our family, I decided to stop going to school and went to work on the land that my grandfather Adrián had bequeathed to me. Every morning around five o'clock, I would go out to the fields with my donkey to cut some hay. Sometimes I would come up with twenty bundles, and sometimes thirty, depending on how long it would take to cut and gather the hay and make the bundles. The donkey was much taller than I was, so I would have to find a rock or ground high enough to stand on so that I could load the bundles on his back. Then I would take my bundles to town, where I would sell them as animal feed on the town square. I would carefully place the bundles of hay on display as if they were flowers, and as a street hawker, I would loudly announce my product to passersby. If I overheard that the competition was selling at a lower price, I immediately lowered the price of mine, as I was determined to sell all my bundles. There was no way I could return to the fields with them because I had other chores to do during the day.

It was a daily challenge to get to my land where the hay pasture was. First, I had to cross the river that flowed through both Miguel Aguirre's ranch and Pedro Chamboles's land. Then I would come to the land that was divided between my uncle David and my father. The river was not as deep there, but crossing it still made me nervous. You could see little smooth stones and small fish, as well as some type of large shrimp everyone called *endocos*.

Crossing the river three times to get to my land scared me, especially when it rained, because the flow would increase along with the risk posed by the strong current. I was always afraid that the river would take hold of my donkey and all the bundles, or that it would pull me in.

Even though I had tried, I didn't really know how to swim. My land was the only one where the river formed a large pond, large enough to swim in. My father tried to teach me to swim by throwing me in the deep part. If I was having a tough time, he would throw in a banana plant or a rope to pull me to the shallower water. This method clearly did not work for me. When I told my mother about these fears, she gave me this advice: "Every time you are afraid, say the Lord's Prayer and ask God to protect you. Do not forget that He will take care of you. Everything works well when you do it with devotion." Following my mother's advice, I recited the Lord's Prayer more than once, along with other prayers that she had taught me. I mainly asked that my donkey not be killed by lightning; he was all we had, and without him starvation was a certainty.

Whenever there was a storm, the rain and thunder seemed to last forever. All the elements obeyed the will of the Rain Gods. The rain always started with thunder and lightning, and if it struck close to me, I could smell sulfur, which has a peculiar odor. According to the rumors that circulated in town, lightning had killed many people and cattle. They said that lightning struck at the tongue, so whenever the intensity of a rainstorm increased, I placed a muzzle around my donkey's mouth so that he wouldn't be able to open it during the thunderstorm. I prayed in silence, wondering whether I was being heard by God or not. After two hours of rain and lightning, an almost spiritual tranquility would follow, with semiclear skies and an enormous rainbow.

One day as I was going out to my land to cut some hay, I ran into one of the sons from a neighboring ranch, who told me that his father found pre-Hispanic Mixtec gold pieces in one of the rivers that I crossed to get to my land. He said that they were gold eagle heads. I later heard that the owner of a large store in Tututepec bought them and then sold them. No one in Tututepec ever saw them, but almost sixty years later, I was approached by an antique dealer in the United States who had them and asked me if I was interested in acquiring them. There were six pieces altogether, and I did buy them around 2009. They are now in the collection of the Belber-Jiménez Museum in Oaxaca.

Some months were more difficult than others, like the time when the rain swelled up the river and the current dragged my bundles of hay away. Those that remained ended up soaked with mud, so I had to wash the hay. If I didn't do this, the mud would increase the weight of the bundles, and the donkey would have a tough time carrying them, and they would be more difficult to sell. Even though getting to my land could be difficult at times, I was able to make enough money selling my hay to buy corn and beans. Eating meat was a luxury for us. Sometimes my mother would have enough money from all her odd jobs to buy an iguana. She liked to cook it with *pitiona* (lemon verbena) and make tamales. They were so good! Especially the ones made from green iguanas that included the eggs, which was much like caviar.

Every year we excitedly looked forward to June 24, the day we celebrated San Juan (Saint John) Day in Tututepec. This was also the day that the *chicatanas* (large winged ants) would come out from their hollows and lose their wings. Dolores, Ramon, and I would pick them all up and place them in a gourd. Once we filled the gourd, we would take it home, and my mother would toast the chicatanas on a comal. She then placed them in the *chirmolera*, a clay mortar, with avocado leaves, salt, and dried chile peppers, making a sort of paste that we spread on our tortillas. We thought this was a delicious way to eat them.

FINDING ENOUGH FOOD

Whenever my father returned from his work for a while, we went out to live on our ranchito in the countryside. My father would hunt iguanas, armadillos, wild birds, or *chachalaca* (wild chickens), and if he was lucky, he would find a deer. In addition, we would eat vegetables with the meat that would be enhanced with flavorful herbs from the leaves and stems of various plants, such as *hierba mora, chepiles,* and *guias de calabaza.* Every time my father went hunting, my mother would light a prayer candle for the patron saints of hunters and fishermen. She would say, "Hopefully one of these saints will help him find us something to eat." My father liked to hunt with a breech-loading rifle, and when luck was on his side, he would bring us something to eat. But most of the time, he would return empty handed. The saints didn't help him much.

We had a dog named Capulina. Dolores used to say that Capulina was our best friend because she would go everywhere with us. If we bathed in the

river, she'd do the same; if we sang, she'd howl along; and if we cried, she'd lick our face and ears. What most impressed me about Capulina was her instinct for hunting. Sometimes she was gone all day long and would come home late with something to cook, like an iguana or a chachalaca. Sometimes she'd bring home doves or a hare. She didn't do that often, but I could almost ascertain when she would sense our condition of scarcity. Capulina would set off on her pursuits when she noticed that we were most afflicted and suffering from hunger. One time, Capulina was gone for two days, and on the third day we heard noises and barking near our house. Capulina had found an injured deer and was herding it back home. My father killed the deer and butchered it, and my mother salted the meat and hung it to dry in the sun. The banquet it yielded lasted for several weeks.

My family faced countless challenges, as well as the solitude that living in the wilderness created. We had to fend off wild beasts, and at the same time we were amazed by the beautiful fields and forest, which offered such a variety of trees, bushes, and flowers. Such beautiful colors! And the unparalleled fragrances! All accompanied by the singing of birds, which could be very loud at times. Parrots would fly from tree to tree, as though announcing that we were in their territory. Despite being surrounded by this natural beauty, I never liked living in the countryside. Even though I preferred being in town, given my family's situation, I had no other choice other than to embrace nature and make amends with it.

Our country home was along the Yutañaña River. The area resembled a small canyon flanking the river. Sometimes we could hear the echoes of hunters lost in the tropical forest, and my parents would yell back to inform them that they were not alone. The sounds echoed back and forth on the canyon walls, along with the sounds of the rushing crystalline water. Our land was covered in grasses that we turned into hay bundles for animal feed. There were also many papaya and plantain trees, a mango tree, as well as many coconut palms and sugar cane. This was clearly not enough to feed our family, so we had to bring our staple food items from town. Now and then my mother would bring in a bunch of green bananas that she would boil and then mix with corn dough to make tortillas. When we could sell our hay, we had enough money to buy some of our provisions in town and bring them with us when we returned home.

Life in the countryside was boring and quite monotonous. Once the sun set, there was nothing to do. Everything was quiet except for the sound of

birds and insects in the depths of the darkness. The only fun we had was when we played for hours in the pond, and I would try to swim. It was a wonderful place to bathe. Many families would visit us because they too enjoyed swimming and bathing in the pond. There were various kinds of fish, especially the *popollote*, a large fish that can be very tasty when prepared correctly. We would keep busy with these activities every day until my parents would decide to return to our home in town.

For the most part, life in town was not much better than in the countryside, but at least I had other children to play with. The reason we would occasionally move back to town was that my father would be called back to work on the vaccination campaign. As always when my father was gone, everything was more difficult for us. We frequently suffered from hunger, which is one of the worst health foes that one can withstand. Our diet usually consisted of tortillas with salt. My mother used to add the salt to water and then sprinkled some of it on the tortillas. Then she would roll the tortillas like a taco and give them to us, saying, "If anyone asks what you're eating, say it's a meat taco. And remember, hunger might bring us down, but together we stand tall."

Homes in our barrio were located very close to each other, and it was easy to see what our neighbors were doing. To have some privacy, my mother would light up a log so the smoke would cloud the kitchen. People would assume she was cooking a meal, but in reality, the tortillas were all she could give us to eat. One day one of my uncles came to visit and saw us eating tacos with salt. My mother told him, "I made some meat tacos for my children . . . that's what they are eating." Right away Dolores unrolled her tortilla and asked her, "Where is my meat?" My mother was so embarrassed that she struck her on the head, saying, "shush."

I recall that one year during Día de los Muertos, one of my mother's fellow godmothers brought her a red hen as a present, which we received joyously. We became very fond of the hen and were not planning to ever sell her. She laid an egg every day, and both my sister and I would take turns looking under the only bed in the house to check whether she had laid the egg yet. We were so happy to hear her cluck, because that is how she would let us know when she laid an egg. My mother would have a pot of water boiling, ready to add the egg along with tiny pieces of dried chile pepper and salt. Then she'd serve us a bowl of that soup and hard tortillas that filled us up for a while. Sometimes the hen wouldn't lay an egg, and my mother would say, "even chickens take the day off on Tuesdays."

6

AN ENTERPRISING YOUTH

THAT IS HOW LIFE WENT on throughout my childhood. Years went by and suddenly I realized I was no longer a little boy. My childhood was in the past, and now I was tasked with different duties as the eldest son. I must have been around twelve years old when I was told that I was expected to work even harder to contribute more to the household. The bulk of my duties increased because of our dire circumstances. It seemed that there was nothing I couldn't do. I could easily be spotted selling baked goods from doña Adelina Galindo's bakery, or the handmade soap that doña Casimira made. I sold coconut candy made by Gudelia Barete. On weekends, I shined shoes at the only barber shop in town, and when large fairs were held in town, I helped merchants sell clothes and other goods.

Often, I was tasked with carrying large gourds full of boiled corn to the local mill. Sometimes I would end up arguing with some of the ladies to keep them from stealing the corn dough from me when it was my turn. I also witnessed quite a few accidents at the mill. The most horrifying one was when a woman with long hair was distracted as she bent over to pick up her tray and her hair got caught in the belt and jerked her toward the motor. Her injuries were fatal, and the entire place was soaked in blood, with trays of corn strewn everywhere.

I continued to go out to my land to cut hay to sell in the town square. During times of drought in the region, hay was scarce; there wasn't enough to make even small bundles. One alternative was to go out to the grass landing strip when the planes arrived to see if I could transport some of the supplies into town and deliver them to the various merchants who sold the goods in their stores. Tututepec was far from any major economic center, so pretty much everything had to be flown in or brought in on pack mules.

When I knew a plane was arriving, I would head over to the landing strip with my donkey. There were no roads at the time, only a small pathway that was just big enough for the two of us. It usually took me about thirty minutes to travel to the landing strip, sometimes forty if my donkey wasn't walking very fast. I profited by charging two pesos per load of whatever the donkey could carry. Some of the staples we would transport included sugar, petroleum, rice, cookies, clothes, and other types of merchandise.

At other times, I was fortunate enough to assist traveling salesmen who arrived by plane to sell merchandise through a catalog. I would carry their luggage, as well as their briefcases and samples. During one of these numerous treks, a salesman gave me his luggage to carry to the hotel. I believe his name was don Alvaro. He was a very tall, hefty man with blond hair. The Hotel Cortés was the only hotel in town, and when we arrived, don Alvaro headed directly to the outhouse. The hotel had one wooden outhouse perched on the edge of a hill. All the waste ran down the hillside into the ravine, where pigs and dogs hung out. Don Alvaro opened the door, went inside, and sat down. Moments later, the tiny structure began to shake, and the beams that held it together started to crack. The structure started to collapse and slide down the hill, just missing a group of pigs that had gathered there. Don Alvaro cried for help, fearing that the outhouse would fall to the bottom of the ravine, when at last two men helped him out of the structure. He was covered in waste and furious, cursing at the lack of decent sanitary facilities in the town.

It was quite a sight, and all the boys who had gathered there and witnessed the incident laughed out loud. I was trying not to laugh because after all, I was still waiting to get paid my two pesos for carrying his luggage, along with twenty centavos for my tip. Whenever any of the boys told the story of don Alvaro's outhouse incident, including me, we exaggerated and added more to the story. Some would say that he had fallen on the pigs below; others said he broke two ribs. To this day, the story of don Alvaro is still recalled at local parties.

CONTINUING MY EDUCATION

It was not easy getting an education given my ongoing childhood illnesses, taking care of my siblings, and having to work during my father's absences. After I finished the first grade, even without high grades, I was glad to learn that I would not have to repeat it. I was twelve on the day that I went to enroll in the second grade. My mother came along as I walked to school from the countryside, where we were living at the time. As we walked toward the school, she gave me some words of advice. She told me to behave well and not to do any mischief. She also said that I should listen to the teacher, but mainly she reminded me not to behave like an "Indian." She told me not to speak Mixtec, and if anyone called me an Indian, I should answer, "I might be an Indian, but at least I'm no idiot." She told me that if any of the boys picked a fight with me, I should kick him "right in the balls." It was the best place to strike, and it would show my bravery. When we finally arrived at school, several children were already there with their parents, and the air was festive. My mother whispered something in the teacher's ear, and then they both looked at each other and smiled. The teacher, senorita Edelmira, then showed me to my desk. She was a young Zapotec woman from the Valley of Oaxaca.

As señorita Edelmira read the roll on the first day of class, which started in January, she noted that my birthday was coming up in a couple of weeks. She asked me how I planned to celebrate my birthday, and I told her that I had never had a birthday party. To my surprise and amazement, a couple of days before my birthday, I arrived at school and saw a huge papier-mâché piñata filled with candy hanging from a tree. She brought this to school so I could celebrate my birthday with my classmates. She gave me a pole and blindfolded me. I swung at the piñata until it broke, and the candy fell out. It certainly was a special birthday indeed.

Señorita Edelmira excitedly imparted her lessons with such eloquence and charisma that the students were immediately engaged because of her almost theatrical demeanor. The first class was about the history of Mexico. On the board, she hung a sort of lithograph of Hernán Cortés and his soldiers burning Cuauhtémoc's feet to force him to reveal where his peoples' treasures were hidden. But Cuauhtémoc didn't immediately succumb to the torture, so the Spanish soldiers continued to add more wood to the fire. Our teacher narrated these events with such passion and emotion that her voice cracked. I felt the tears roll down my cheeks as I could only imagine the pain that

Cuauhtémoc suffered. In my mind, I compared my father's beatings with the blade of his machete to the burning of the flames and decided that the latter was more painful. I realized that Cuauhtémoc's suffering surpassed mine by far. Some of my other classmates were crying as well, and on noticing this, even the teacher began to cry. Just then, another teacher walked by our class-room and asked, "Why are you crying?" My teacher answered, "Because my students' crying really got to me. My lesson has saddened them a great deal."

I personally loved the way señorita Edelmira taught us every lesson. She also taught us songs. I can still remember some verses. One I remember went like this: "My parents and grandparents were never able to reap much, that heartless landlord of theirs would charge them half their pay.... Such pain suffered by the poor, for the rich man had them working just like beasts." I learned other songs as well. I don't remember the words, but they were very similar in their message.

Many years later I ran into señorita Edelmira, and I asked her why she had taught us those songs. She said she was very fond of them because they were part of the agrarian changes after the Mexican Revolution. I also took advan-tage of the occasion to thank her for healing a head wound I had sustained one day. This happened when a hill next to the school was being leveled, and a rock came flying down and hit me on the head, knocking me out. When señorita Edelmira saw what had happened, she carried me to her home and washed my wounds with peroxide, then added an iodine solution. I was out for nearly three days. When I regained consciousness, the first thing I saw was my mother crying. The news had made it all the way to her in the coun-tryside. She now had to slowly take me back out to our country home so I could continue my recovery. Being outside of town offered more access to herbs that would help with the healing process.

CHILDHOOD ILLNESSES AND THEIR CURES

I was not a very healthy child. I suffered from numerous diseases, some tropical and others the result of my physical weaknesses and malnutrition. Malaria was one of the diseases that I often suffered from. There were thou-sands of mosquitoes, and I had a very weak immune system. Thus, I used to get high fevers quite frequently. I still had to keep working in the fields whether I had a fever or not. I had no choice but to work. I would strap the

saddle on my donkey early in the morning, mount it, and head toward our land. Whenever I had a fever, I had to search for something fresh to lie on, and the perfect place for that was the shade that the plantain trees offered. After sweating off my fever, I'd continue with my chores.

One time I complained to my mother that I was exhausted and ill from a high fever. I told her that the fieldwork was becoming harder and harder each day. My mother consulted doña Locha, who owned the only pharmacy in town. Doña Locha was originally from Jamiltepec, but she had been in town for quite some time. She regularly gave injections or prescribed medications, even though she was not officially trained as a nurse. Doña Locha advised my mother to give me an Aralen (chloroquine) pill every other day before breakfast to fight the malaria. For some strange reason, that pill would only make me feel weaker. Nonetheless, it did seem to work at controlling the fever. Sometimes I would have to skip my dose because I didn't have the sixty centavos needed to buy it. Needless to say, it would take me a long time to get over my spells of malaria.

I can clearly recall the time when my fever was so high that my mother had no choice but to take me to see doña Locha again. She gave me a shot of an antibiotic of some sort; I can still recall the pain from the injection. Two weeks later, the entire area around the injection became infected. Maybe the needle was dirty. Nevertheless, one of my buttocks just kept growing, and it was becoming extremely painful to sit. When we went to see doña Locha again with this new malady, rather than admitting to a possible mistake on her part, she scolded my mother and asked her what she had fed me. My mother proceeded to list all the foods I had eaten, which wasn't much other than tortillas and beans, so doña Locha couldn't determine the cause. Then she continued asking my mother more questions, and my mother added, "Oh yes, and corn tamales." According to doña Locha, those tamales had been the culprit. She had me lie face down, took out a sharp knife, and made an incision on my buttock to drain the pus and the blood. At this point I lost consciousness.

I still have the scar from the hands of that brutal woman! Whenever I fill out any legal documents or forms that require that I list any distinctive marks or scars, I am reminded of doña Locha, but I tend to write "none." One time, when I had to go to the American embassy in Mexico City to get a thorough physical exam, the doctor asked me why I didn't include the scar on the questionnaire. I told him that people would laugh at me if they knew. Years have

passed, and my pants have never quite fit. My mother used to say that it was because doña Locha cut one of my buttocks off. Nevertheless, doña Locha always insisted that the infection was a result of my mother's corn tamales. I suffered from a host of other maladies during my youth, and apparently, doña Locha was never able to cure them either.

School was the best place for the exchange of infections and all sorts of illnesses from the New and the Old World. Chickenpox and I became good friends. The Spaniards, our conquerors, bequeathed this to us. There was also measles, which was quite common among children; and then there was the evil eye, which most Indigenous children got. Dysentery was known to strike all Indigenous and impoverished children. Many suffered from tungiasis, an inflammatory skin disease caused when the nigua flea burrowed into people's toes and sometimes fingers. Anemia, due to our ongoing hunger and lack of proper nutrition, as well as bedbug bites were among the deadly ones. I came down with all these maladies, some with greater intensity than others.

Sometimes my mother would apply mud compresses on my forehead to decrease a high fever. When I had tonsillitis, she applied the mud all over my neck. I don't remember if it worked, but as was customary, I believed in its healing power. Most maladies were treated with what little remedies we could acquire in town. If some of these illnesses kept me in bed, my mother and I would pray to God to send a cure. The remedy I hated the most was the one for stomach ailments. They called it *empacho*. My mother used to make me drink castor oil with urine, black coffee, and ruda leaves. The taste was disgusting, so to make me swallow it, my father used a corn stalk or a piece of wood to keep my mouth open as they poured the substance down my throat. I could not throw up because if I did, my father would hit me with his belt or his machete, and the entire process would have to take place again the next day.

Ringworm got the best of me as well, partly from a lack of proper hygiene and partly due to the close contact with infected kids at school or in the neighborhood. I had white scabs on my scalp that would cause bald spots. Ringworm is quite contagious and difficult to cure, but my mother thought she could control it. Her naïve solution consisted of applying an herbal remedy from the negrito fiddlewood plant. She used to apply it on my head at night, and I would be embarrassed to go to school the next day. Some of the girls would notice my scalp and call me names. They would call me "mole head," "*tlacuache* [opossum] head," and "mangy head." Some called me "vulture

shit head" because of the white texture of the infection, which resembled bird excrement. Luckily, I saved two pesos and fifty centavos to buy myself a cap, which could cover my head when I went to school. The scabs remained on my scalp for some time, and I didn't completely get rid of the ringworm until I moved to the city years later.

Just as there were mestizos who would inject or prescribe drugs, there were the traditional Mixtec curanderos. Some were more famous than others, and if we couldn't find the right curandero for an illness, it was customary to go to adjacent towns, particularly those located in the southern coastal areas, to find one. Once I was walking with my mother through the town square when we ran into a curandera who told my mother, "Your child is very thin, pale and has a very gloomy look. Bring him to my home and I will heal him." My mother asked if there was anything the curandera needed to perform the healing. She also asked how much it would cost. The curandera told her what was required: "I need two candles, a bottle of *alcanforado* [camphor dissolved in alcohol], a bit of ruda plant, and petals from seven different colored flowers. It will be ten pesos for the healing session."

The next day, my mother had everything the curandera had asked for. She sent me off to the curandera's house, which wasn't far from where we lived. When I arrived, the curandera had already placed a petate on the floor for me to lie on. She used a piece of charred wood to trace a cross on my hands and feet, and then she covered my body with a sheet. All the while she had a clay pot heating over an open fire. The curandera placed the candles in the clay pot, and they slowly started to melt. She added the melted candles to a different pot that was filled with cold water. Afterward, she covered that pot and began chanting in Mixtec, summoning the spirits. She concluded the chanting after a while and then proceeded to uncover the pot with the melted candles and water. The candle wax had hardened into an array of different shapes. The curandera began analyzing the shapes and grasping their meaning. With a shocked expression, she said, "*muerte!*" (death) and showed me a shape that resembled a cemetery. We could also make out the town, rivers, ravines, and the tropical forest.

This process had to be done a total of seven times, and every time she repeated it, she would disperse the multicolored flower petals. The curandera concluded that everything revolved around a great scare that I had as I was crossing the deepest part of the river when I was going to my land years before. She said that since I hadn't known how to swim at the time, I had

started to drown, and that is when my tona, my animal spirit, had helped me find my way out of the water. Nevertheless, my tona had remained there in that place. She said that we needed to go to that spot the next day so that we could retrieve my tona. My mother came along, and we brought bunches of ruda plant with fresh leaves, which we used as fans that we waved toward the sky. When we arrived at the place indicated by the candle shapes, the curandera asked me to lie on the ground. She started doing gargles with the alcanforado and then sprayed it out of her mouth onto my face. She circled around the place where I had been frightened and performed a cleansing ritual of the area that I pointed out to her. Afterward we headed back to town. When we got home, the curandera repeated the process of spraying the alcanforado on my face, thus concluding the healing ritual. My mother paid her, and that night I slept like a baby.

Growing up, I never went to a doctor. In the first place, we didn't have any money, and second, we didn't have a doctor in town. When I was twelve Tututepec finally got a full-time doctor, Adalberto Mendieta. Even when we finally did have a doctor, there were people in town who continued to prescribe drugs haphazardly. Some of the sick would recover, some would worsen, and some would die without blaming anyone but God for the ailment.

7

HOME LIFE

M Y MOTHER WAS NOT VERY sociable. Now and then she would visit relatives on her mother's side of the family, including the Crespos, the Bermudezes, and the Silvas. They were all prominent mestizo families in town, both socially and economically. They never approved of the fact that my mother had married an Indigenous man, but they tolerated it. I rarely saw her paying visits to our Mixtec neighbors, even though their houses were right next to ours. On those occasions when she did have to visit one of our neighbors, she would usually go at night, and it had to be for a compelling reason.

She didn't like to host guests either, especially if they were not part of the family. Maybe she was ashamed of the poverty we lived in or the fact that she was always alone because my father was away on his usual escapades, or as he liked to call it, "work." The neighbors who did dare to pay my mother a visit would make it a very short one. Upon parting, they would say to her, "Your husband might have left you, but he gave you a big house made of adobe, that is painted white and has brick floors." This was the house that had belonged to my grandfather Adrián and had been inherited by me. He had a different type of house than his neighbors because of his status as a principal. Even though we didn't have much, many of our neighbors were jealous of what we did have, and after our guests would leave, my mother would mock their words: "He left you such a large house. I wonder if it's good enough to eat!"

MY FATHER RETURNS

Finally, we heard that the hoof-and-mouth disease was under control. I think this disease affected the whole country, and we suffered greatly because cattle fell to a host of other diseases as well and died in large numbers. Sadly, a lot of people blamed it on the vaccines that were being used through what they referred to as that "damned program." We knew that it wouldn't be long before my father would return.

One morning, a bird that we called Guicho kept singing atop a tree by our house. My mother said, "I bet your father will arrive today or maybe we'll get a letter from him, that's what Guicho is announcing." The bird continued singing until he got tired and then flew off to the south. "He is going south, right where your father has been for many months." That afternoon I saw my father in the distance as he headed toward our house. Dolores and I ran to greet him. He hugged us tight, and my mother was as happy as ever to have him back home. He turned to her and placed something in her hand, saying, "Ime, here is a pair of gold earrings that I bought for you in Ometepec [Guerrero]." My mother immediately put them on and showed my father, looking at him with love and forgiveness. It was as if all her hardships and sadness, while he was away, were forgotten.

Knowing how much my mother had suffered during my father's absences, I had the urge to ask him why he hadn't responded to our novena prayers to the Holy Infant of Atocha, and my mother's constant whimpers whenever we reached the page that said "petition." In my mind, there was no excuse for his behavior. I felt confused and frustrated, but I never did share my thoughts and feelings out loud. I wanted to ask him how many times he had gotten drunk and spent the money that he had earned on himself and other women, instead of sending it home to his family. I felt like asking him how many women he had been with. Why did he abandon us? I also wanted to let him know that I had worked extremely hard in his absence. On the other hand, I saw how happy my mother was, how she showed tenderness and love toward my father, as if he were the only thing that ever mattered to her.

The relationships between me and my mother and father started to become more and more strained with each passing day. The day of my father's arrival marked the start of my deep-seated resentment toward him. I never confronted him man to man to tell him everything I felt. I wanted to tell him to be more considerate and to appreciate everything that I had done in his

absence. I never did tell him what I thought, and life went on as it had in the past.

Shortly after his arrival, we moved to the countryside once again, which must have pleased my mother, because now she would have no competition from the other women in town. She would have my father all to herself, as she had entirely devoted herself to him. When we lived in town, my father liked to go to cantinas and parties, where he was quite popular with his friends and the ladies. These distractions would be out of reach once we were back in the countryside. I didn't object to this move because at least there would be two men doing whatever needed to be done to support the family, a family that was continuing to grow.

With the return of my father, I could go back to school to continue the second grade. I continued to cut hay to sell in town before going to school. I had to be at school by nine o'clock in the morning. After school, I would buy items such as brown sugar, beans, and lard, and if I had any extra money, I would buy my father a pack of Faros Cigarettes, before returning to our home in the countryside. He said that the cigarette smoke helped get rid of the mosquitoes. During one of those treks back and forth between our home in the countryside and town, I had the misfortune of losing my donkey. I left him tied to a coconut palm tree in the town square. He was quite a restless little creature, especially when he saw a female donkey. I left some hay for him to eat while I was in school, but to my dismay he was nowhere to be found when I returned to get him. He must have pulled with great strength and torn the rope as he took off on the chase to who knows where.

I went back home without my donkey. I explained everything to my father and told him that it wasn't my fault, but he blamed me for losing my donkey and took out his machete and started hitting me with the blade. My mother tried to intervene and ended up being beaten as well. According to my father, she shouldn't have stood up for me because it was my fault, and no one else was to blame. Each blow threw me to the ground, and I thought the beating would never stop. At school, they asked me why my arms were bruised, and I said that I fell out of a tree while trying to catch a squirrel.

The donkey finally turned up close to a coastal village without saddle, ropes, or bridle. Apparently, a group of ranchers had discovered him among their herd. Although I must admit I was mad at him at the time, I didn't hate him. That donkey was like a friend and partner to me; I spent most of my time with him. I would constantly talk to him through the long hours of the day

or at night when we crossed the dark tropical forest. I would talk out loud to the donkey, hoping that the wild animals would think that I wasn't alone.

My mother seemed to always have something philosophical to say no matter what, such as, "we might be poor, but we are united." She was referring to the fact that my father was at her side. I think she loved him more than he loved her. When my father came home drunk, she wouldn't greet him kindly, but the look in her eyes would change as he sang coastal songs to her until he fell asleep. Despite my father's transgressions, our family stayed together.

THE GREAT DROUGHT AND FLOOD

I remember that not long after my father returned for good, we had a drought throughout the region, and to make matters worse, a locust infestation hit as well. This devastated all the crops and started a wave of starvation. Everyone in town was frantically trying to get by, and the president of the municipality, whose post had been held by mestizos since colonization, asked the merchants to lower the price of flour. That way, flour tortillas could be more accessible, but this only benefited the mestizo population, because Indigenous people ate only corn tortillas. The situation became even more vexing for my family, as corn provisions were being rationed in Indigenous communities. Those who had corn to harvest and sell started shipping only quarter crates instead of whole ones. Corn was measured based on a whole crate, half crate, or quarter crate. A quarter crate was not enough to feed a family of our size.

One day with the ringing of the church bells, everyone in town was summoned to the church to find a solution together. Everyone agreed to conduct a procession in honor of San Pedro (Saint Peter). This ceremony was organized by the town's Indigenous people, but everyone, including the mestizos, could participate in the procession, even though they didn't observe ancient traditions. The Mixtec principales met each Sunday behind our house, in the same large structure where my grandfather Adrián had held his meetings before his death. According to my mother, everyone sat on petates and discussed issues surrounding the weather, the moon, and the planting season. They must have had a Mixtec calendar because they would often consult documents that were placed in a boxlike basket made from woven palm leaves. They had been charged with setting the date for the San Pedro ceremony. San Pedro is the patron saint of Tututepec.

When the specific morning arrived, they met and prayed in Mixtec while hitting the ground with coconut palm leaves as they paved the way for the procession. The chanting and prayers echoed throughout the town as well as the ravines, hills, fields, and tropical forest. If I remember correctly, it went something like this: "As you guard the heavens, Oh Mystical Key, Shadow of Saint Peter, Lay your Pity on Me. May your songs of worship fervently resonate. May the Lord bless us with a peaceful parting in death." Once the procession had reached the boulder on the crest of the hill marking the pre-Hispanic site of the Mixtec's ancient ancestors, Yucu Dzaa, the men carrying the statue of San Pedro carefully lifted it through a series of scaffolds. They placed it facing the sea.

Everyone prayed and chanted, and some of the most pious worshipers cried as they pleaded for rain. The invocations went on for a long time. At the end of the ceremony, just like a scene in a movie, the sky became cloudy and rain started to pour down. Everyone ran to the nearest shelter to stay dry. They placed the statue of San Pedro in a small niche and covered it with a blanket that they had brought with them in anticipation of just this type of natural phenomenon. If it hadn't rained, the whole procession would have taken place again a couple of weeks later. Fortunately, we didn't have to repeat it thanks to the intense fervor of the chanting, prayers, pleas, and cries of the people.

As I recall it rained for about seven days straight. Night and day, it didn't stop. So, we spent our time around a wood fire telling stories and recounting the history of our town. After the third day of rain, four Indigenous principales from Tataltepec de Valdés paid us a visit. They spoke to my father discreetly for what seemed a long time. I heard them mention the name of my grandmother Nabora and grandfather Adrián. They thought that my grandparents were still alive. In the end, they deferentially gestured their goodbyes and headed to the home of another important Indigenous man in town who was an expert in the healing arts and witchcraft. When my father returned, he said that those men wanted to ask for my grandmother Nabora's permission to allow the tona belonging to one of those men to pass through our town. My grandmother had the authority to allow such a thing if she so desired.

According to these visitors, this man's tona, which was a serpent animal spirit, had grown immense and was in a pond. The problem was that it could no longer remain there; the pond was much too small for it. The tona

was beginning to upset everyone in the village since it was devouring all the smaller animals that would come and drink from the pond. My father pointed out that this was a very serious matter. He said the rain was not going to stop soon and that the Tataltepec de Valdés curanderos didn't know whether to expel the tona from the pond through wind or through water. If they opted for wind, they would have to produce a very intense tempest to pull this tona out of the pond and carry it out to the ocean. If they opted for water, they would have to extract this tona from the pond and guide it toward the Río Verde, which would then take it out to the ocean.

The intensity of the rain increased, along with the wind, thunder, and lightning, and I saw a funnel cloud forming along the ocean. This was the first time I saw fish flying through the air and landing on rooftops, thrown by the force of the wind and rain. All the kids were saying that these flying fish were a sign that the world was coming to an end. The world didn't end, and the only thing the fish brought was a putrid smell all over town.

As rumor had it, the day before the rain stopped, some people saw a serpent's head peering out of the water as it headed down the river toward the sea. The fact is that the rain was to blame for the flooding of the rivers, especially the Río Verde, which empties into the ocean at the Laguna de Chacahua. All along its path it dragged cattle, horses, donkeys, and everything that had been along the riverbank. People would say that the river tore entire houses from their foundations, taking them along with dogs, chickens, and other animals that had taken shelter on the rooftops. Most of them ended up in the ocean as well. The flooding wreaked havoc, and people still talk about it today with much sadness. After this horrifying experience, the same four men who had come to town asking for permission for the tona to pass through showed up with forty of their fellow villagers, all ready to offer a week's worth of *tequio*, or collective work, toward the betterment of the community. They helped fix the town's buildings and roads, thus making up for the disaster caused by the passing of the tona.

SEARCHING FOR WORK

My father didn't have a permanent full-time job. He studied up to the third grade at the Escuela Federal Progresista, the same school that I went to. This was as far as he could go because the school didn't offer anything beyond the

third grade. His lack of schooling kept him from getting an office job in town, and being Indigenous didn't help either, since preference was given to mestizos to fill those types of positions. Nevertheless, he sought better opportunities driven partly by his youthfulness, and because he had so many children. He searched for jobs that paid more than the average day laborer's wages.

I remember the time that a tradesman from town referred him to a position as a foreman at a ranch over by Pastoría. The ranch belonged to a Spaniard by the name of don José. A date was finally set for don José to interview my father at his ranch. My father agreed to take me with him, and the entire way, he tried to educate me on proper etiquette. He said they were probably going to serve us dinner at the ranch. Good, I thought. I was starving! He was very clear in his instructions: "Look, son, leave a little bit of food on each of the plates you get. Don't eat everything on your plate. That would not be polite. Do you hear me?" And I replied, "Yes, Papa." He said, "Do not talk unless spoken to, and do not fall asleep either, that is considered rude." I nodded and answered, "Yes, Papa." He added, "Don't chew with your mouth open either." To which I agreed and said, "Yes, Papa." And finally, he reminded me to say, "Thank you always, even to the maid." And of course I said, "Yes, Papa."

By the time my father had concluded his instructions, we had arrived at our destination. We were invited to take a seat, and our host offered my father a glass of sherry. I was given some Pepsi. Then we headed toward the dining room, and when they brought the vegetable soup, per my father's instructions, I didn't finish it. Then came the main dish of rice and chicken, and I didn't finish that either. I wanted to eat all of it, of course, but I was afraid to contradict my father's warning. When the maid asked me if I had finished, I said, "yes."

Don José looked at our plates, which still had food on them, and he told my father in his strong Andalusian accent, "Hell, eat your food, eat it! If you don't eat all of it, you'll shit foam. You should clean your plates; food does not come cheap, c'mon." So we cleaned our plates, which made me very happy. Don José then told my father about all the duties that he would have to carry out at the ranch. He also mentioned that there were other candidates for the job. He said he would contact my father if he decided to hire him.

After dinner, don José offered to drive us home in his Jeep, but he had difficulty seeing the road in the dark. As we drove along, we suddenly felt something pull the Jeep back. It turned out the wheels were stuck in the mud. My father and I tried to push the Jeep forward but couldn't get it to budge. Don

José lost his patience and started to take some tools out of his Jeep, and to our surprise, started hitting the vehicle with an axe, yelling, "Bloody Christ, Holy Mother and all of the saints. I'll shit on all of you." Luckily, my father found two pieces of lumber that he placed under the wheels, and on our next attempt to push, we were able to get the Jeep out of the mud. After we resumed our trip, don José kept saying, "Thank God and the Holy Mother for getting this damn car out of the mud." When we arrived home, we told my mother everything about the evening, and then she said to me, "You didn't hear anything. Everything that man said was sinful."

My parents would take me to the seven o'clock Mass on Sunday morning, and I was always reminded of the Jeep incident whenever I spotted don José sitting in the first row. He always sat in a specific spot where the priest could see him. He prayed and took communion every Sunday. He would beat his chest at prayer, and whenever he did that I thought of the blows of the axe and all the blasphemy he uttered as we pulled the Jeep out of the mud. I concluded that all the saints had forgiven him because he was a very rich Spaniard who gave a lot of money to the church.

My father never heard from don José again, that Spaniard who would shit on all the saints. Yet, that was the best thing that could have happened to my father, because he was about to start the career of his life. My father finally found work at a ranch called Palma Sola. This ranch was in the valley and belonged to Adalberto Mendieta, the town's doctor. Dr. Mendieta had graduated from a university in Mexico City and landed a social service residency in our town. He liked Tututepec so much that he returned to set up his medical practice there. Dr. Mendieta was a good-looking fellow. He was young, intelligent, and had a friendly personality. His ancestors were from Spain. All these qualities raised much interest among all the young women in town, but he wasn't interested in them. He lived instead with a young woman who was a childhood friend of my mother.

Dr. Mendieta liked the way my father worked and made him administrator of his ranch. But it was more than a ranch: it was a coconut palm plantation where copra, the dried meat of the coconut, was used to make coconut oil. They also planted sesame, cotton, and corn. My father's position was well paid, and our family was finally improving economically and socially. My father was respected by his boss and friends. The fact that he finally landed a respectable job reinforced his self-esteem. Things were finally going well for my family.

8
A CHRISTMAS TO REMEMBER

A S THE MONTH OF DECEMBER 1954 approached, and Christmas was just around the corner, choir practice was starting. An all-female church committee had been formed that included choir and catechism teachers. One of the ladies came to our house and asked my mother if I could be part of the children's choir. My mother told the lady, "My son is quite restless. He doesn't behave well, like all the other children . . . he's too wild." But the lady responded, "We'll take care of him and then bring him home after the Midnight Mass. While you think about it, please allow him to go to rehearsal and get him an outfit for the event." This convinced my mother to let me rehearse every evening with the other children. As I recall, the words to the first Christmas carol went something like this: "Let us go, shepherds, let us go to Bethlehem. Let's go to see the Child, to whom Glory shall be given." In addition to the carols, we all had to learn a short poem related to the story of the birth of Jesus. They gave me my part, and I really liked it, so I practiced it every day to memorize it.

I went to the Posada celebrations for the nine days leading up to Christmas. My favorite part was getting candies and animal cookies. The festivities centered around the birth of the Baby Jesus, and every year a patroness was chosen. That year a girl named Angelita was the lucky one selected to be the *madrina* (Mother Mary). She lived in Cruz Grande, a wealthy mestizo

neighborhood. Angelita's parents had assumed the responsibility of financing the event to honor the birth of the Baby Jesus on Christmas Eve.

A TRAGIC CHRISTMAS EVE

Christmas Eve day finally came, and the first to arrive at the home of the event's patroness were the musicians followed by the invited guests. After breakfast, everyone who had been at Angelita's house went to the ten o'clock Mass. Angelita carried a silver tray with plush little pillows for the statue of the Baby Jesus that she would carry back to her house after the Mass. Many of the young men carried branches adorned with multicolored paper chains as they paraded through the streets to the church.

The priest waited at the threshold of the church with a container of holy water that he used to receive the patroness and guide her to a special seat in the church. Angelita sat there for the duration of the Mass. Afterward the Baby Jesus was handed to Angelita, and she proceeded to carry him on the silver tray back to her house, where she placed the statue in the special altar they had prepared. The altar was adorned with old artifacts from the church and antique toys that belonged to some of the oldest families in town. Punched-paper adornments had been placed both inside and outside the home, and several gas lamps illuminated the guest's faces. Christmas music played in the background, and the energy was electric, as a large crowd of people gathered to celebrate this important event. It was a scene of joy and brightness everywhere.

It appeared as though everybody in town was at Angelita's house. It was like some of the Mixtec celebrations that were held in my barrio, but on a much larger scale. They had heaps of sweet fritters, about fifty bowls filled with breads, sweets, cookies, flavored water, mole, soup, and the list goes on. They had invested quite a considerable sum of money in the feast. All the boys and girls in the choir were dressed up either as little shepherds or in special outfits. I was wearing red slacks, a yellow shirt, yellow socks, huaraches, and a yellow hat. My sister, Dolores, was also in the choir, and she wore a red skirt with a yellow apron, yellow blouse, and a hat like mine. We both held staffs with rattles on the end, like the shepherd's staffs.

After a while one of the church organizers gave us our cue: it was time for the children to sing and recite our praises for Baby Jesus. First, we sang,

"In the town of Bethlehem, A child will be born at midnight. Rejoice little shepherds, because that child will be our Lord. Play your tambourines and play them to announce that the prophecy came true." Then we recited our assigned lines and played our parts. One of the boys recited his part, music played, and then came my turn. I said, "I am a poor little shepherd, who hails from Galicia. I have no gold, but I bring this fine linen to make a shirt for you." Then I placed a piece of fabric on the altar that was wrapped as a present. I used Dolores's dress for the gift, but nobody noticed because I had wrapped it with rice paper and sealed it with homemade glue. After placing the offering on the altar, I returned to my place. The rest of the children recited their lines, the music played on, and afterward Angelita had the church ladies pass out sparklers. Only the mestizo children were given the sparklers. I didn't get one, and this saddened me. As the children began to light their sparklers, you could hear their excited chatter. They laughed and squealed with joy, and it felt as though we had reached the most memorable part of the celebration, yet I didn't have a sparkler to celebrate with.

One of the mestizo boys approached me and said, "You've got a basket on your head," a phrase that means you are unfortunate, or you don't count. It's like saying that people can see right through you. It was one of the bullying tactics used to hurt and demean others like me. All the children were happily playing with their sparklers, waving them at each other and toward the altar where the Baby Jesus had been placed. I thought those sparklers were magical when I saw that their sparkles didn't hurt if they landed on the arm. It was the strangest phenomenon I had ever seen. I wondered where these children had learned to handle the sparklers with such skill. The whole thing was utterly new to me, and I wanted to know what it felt like to hold one and to raise it up to show the Baby Jesus that I was just like the rest of the boys and girls. I wanted to show him that even though I was an Indigenous boy, I also adored him like all the mestizo children.

I gathered enough courage and determination to ask the boy to my right if he would let me hold his sparkler, just for a few seconds. He completely ignored me and turned his back to me, so that he could protect his sparkler, which had already burnt halfway down. Standing to the left of me was a girl dressed like an angel. Her wings were made from light blue rice paper, and she wore a blue sash across her chest. She was the perfect candidate for my request to hold her sparkler. When I asked, she refused and pulled the sparkler away from me. Upset, I thought about hitting her on the arm, thinking

that she would drop it, and then I could pick it up, even for just a second or two. But before I could do this, her wings caught on fire, and she threw the burning sparkler on the floor. Forgetting about the sparkler, my first instinct was to grab the burning wings off her back and throw them on the floor. I never did see where the sparkler landed. Within an instant the green-painted sawdust on the floor caught on fire and then spread to the altar, engulfing it in flames.

As the fire started to grow out of control, we all panicked and ran toward the exit as fast as we could. You could see fear and desperation in everyone's face. Some people uttered, "Oh Lord, please forgive us, have mercy on us, and save us, dear Lord." "Fire! Fire! Fire!" they shouted. Children cried, and people nearly trampled each other as they were fleeing from the fire. Some of the guests threw pitchers of hibiscus and rice-flavored water at the flames, but to no avail. Moments later, some people started to fetch buckets of water to try to extinguish the flames. Women sat outside without their rebozos; children stood barefoot.

In less than two minutes the whole house was in flames, and the size and intensity of the fire grew and reached the next house, and then the one next to it, and so on until sixteen houses had burned. The whole neighborhood was trying to combat the fire with machetes, sticks, dirt, and anything else they could find. As the altar burned, I could hear the noise of breaking mirrors. They had been placed there to represent lakes in the nativity set, next to the sheep and the shepherds. In my head, I could hear the Baby Jesus cry, as people shouted, "Save Baby Jesus, Save Baby Jesus." A woman exclaimed, "Isn't there a man with enough balls to save the Baby Jesus?" As the flames kept growing, someone indeed had the courage to go into the house to rescue the Baby Jesus. I think it was a man named Damasio who climbed on a chair and amid the flames reached for the tray, which was scorching hot, and threw some lemonade on it. Little did he know that his actions that night would make him the most heroic man in town. People said he had burned his hands and arms, but that the Baby Jesus promptly healed him, and he didn't have one single scar from the burn. Thus, Damasio acquired a saintly status in town.

Uncertainty and fear took hold as everyone started to gather after the flames were extinguished. All that remained were ashes. The people whose homes had burned stood there in utter shock. They couldn't believe that in a matter of ten minutes, the fire had destroyed the place that had witnessed

the birth of their grandparents as well as their children. It was a scene of desolation and sadness. They wanted a response, an explanation, while their close friends tried to bring solace to them. Their relatives firmly bowed their heads in solidarity, saying, "God took it from you, but He will help you build a new one."

I fled the fire alongside the other children. Finally, someone headed toward us and told us to line up and go to the church. We walked to the church, led by Angelita at the front of the line. She was holding the scorched Baby Jesus tightly in her arms. Tears ran down her face, and I could see the deep sadness that struck her after such a horrible experience. Every bell in town announced the tragedy, and people started coming out of their homes with their torches. It was dark, and there was no electricity, so it was easy to see them coming from every direction, adding to the commotion. Some people were wearing their pajamas, yet they were curious about what had happened.

When we made our way to the main street, I could see people standing on both sides of the street while we headed toward the town square and the church. More and more people joined the procession as we traveled up the street. Once we reached the town square, I could see that many people in the crowd were concerned. Some were kneeling, others prayed, and others made the sign of the cross when the patroness walked by with the Baby Jesus. Everybody wanted to know what was going on, asking, "What happened?" They were told, "The Baby Jesus was burned." Then they asked, "Who burned him?" I was shocked when I heard someone say, "It was Federico, the son of Juan Jiménez. The son of Juan Jiménez did it." Deep down inside, I knew this was wrong and that I could not accept this accusation. I knew that the girl had thrown her sparkler on the floor after her wings caught on fire and that her burning wings and sparkler had ignited the sawdust and started the fire. I was only trying to save her from catching on fire. Nonetheless, it was too late; they were already pointing their fingers at me and condemning me for something quite serious that I didn't do.

Finally, we got to the church where the ringing of the bells continued to announce the tragedy that had just occurred. The priest was at the entrance waiting for Angelita, who was carrying the Baby Jesus. She approached the church crying; then the priest said something to her in Latin and blessed her with holy water. He looked upset, which I am sure had to do with the statue of Baby Jesus being scorched. And so began the Christmas Eve Midnight Mass, and the part of the sermon arrived where the priest acknowledged

that the Baby Jesus had been accidentally burned. He said he lamented this incidence and asked that everyone in town pray so that peace and harmony may reign once again. He announced that the Baby Jesus was going to be placed in the main altar of the church for those who wished to see him. People stared at me with hatred and disgust, and I didn't understand why. Once the Mass concluded, one of the church committee ladies walked me home without uttering a single word. Looking back, the whole event was surreal.

Early the next day, my parents learned all the details about the previous night's event. My father woke me up to punish me. He took out his machete, and I felt the blade fall on my back like a giant stone. Each blow would hurt more than the last, and so he kept on beating me until I wet my pants. I don't know if it was from pain or fear. I begged him, "Papa, forgive me, I promise I won't do it again. Forgive me, please!" I knelt with my hands in prayer and pleaded over and over. My father ignored my pleadings and went on beating me until he decided it was enough. My mother didn't say anything. Maybe she was afraid of my father, but then again, maybe she thought I deserved the beating.

I later found out that my father was under a lot of pressure from community members. They demanded that I be punished, but he didn't know how to go about it. Many people wanted to see me behind bars. My father might have gone along with this idea had I been old enough for sentencing, but I wasn't; I was still too young. I felt like the son who had shamed his father, his mother, and maybe the entire family. Unfortunately, I was never given the opportunity to defend myself and tell my side of the story. I was considered guilty by both my family and the community.

AN ENDURING PUNISHMENT

After several days, my wounds from the beating began to heal, the pain decreased, and I was ready to resume my chores and to go buy some food items for my mother as usual. My mother had asked me to buy beans, eggs, and other food items for the family. There was no public market, so I usually went to specific homes to purchase these items. As I approached the first house, before even reaching the pathway to the door, I heard a voice coming from inside, "I have nothing for you. Get out of my yard before you curse it." Then I headed to the next home and heard, "If I was his mother,

I would hang him on the wall" meaning that I should be crucified. Then a woman passing by looked at me with disdain from head to toe and said, "What you deserve is to be burned over green logs," meaning that it would be a very long and slow burn. Then when I went to another house, the woman said, "Get away from my house. Wretched boy. Damned boy." This was devastating to me, and I didn't want to be seen by anyone else in town, so I went straight home.

When I arrived home empty handed, I told my mother that I couldn't find any of the items she was looking for. I never told her about the insults that had been thrown my way. I felt quite sad, and deep down inside I didn't want to be there anymore. I didn't understand everyone's harsh rejection of me. Since that Christmas Eve, my hometown had become a place where compassion didn't exist, nor forgiveness for that matter. On the contrary, the town folk condemned me, along with my family, without knowing what really happened that night. They couldn't bear the sight of me or my family, because according to them, we were damned, condemned forever.

After the Christmas festivities came New Year's Day, Three Kings Day, and the beginning of school in January. My mother enrolled me in the third grade. My teacher's name was Hortencia, but everyone called her Tencha. My mother had a long talk with my teacher, and then I heard her say, "If he misbehaves, discipline him, use a tamarind branch if you have to." The tamarind tree has thorns, and it would be extremely painful to be hit with one of its branches.

When school started the next day, I got there right on time. It was nine o'clock in the morning, and I didn't want to be punished for being late. The punishment for being late consisted of holding a brick on the back of each hand while standing in a white circle that had been traced on the ground with chalk. The punishment lasted at least a half hour. I greeted my teacher and headed toward my worktable, which had enough room for ten students. When I took the place that the teacher had assigned to me, all the students sprung out of their seats and moved to a different table. Those who didn't find empty chairs opted to sit on the floor, leaving me by myself at the large worktable. When the teacher asked, "What is going on here?," one of the students said, "We don't want to sit by that wretched boy. He is a sinner." "He burned the Baby Jesus!" yelled out another student. The teacher didn't say anything and proceeded to begin the lesson as always. During recess, nobody wanted to be with me, and this went on for weeks.

All the while I would think about my grandmother Nabora and the times she took me to the hill to pray. She never mentioned a God of forgiveness in the Mixtec words she spoke. She explained to me, "Bad people, those who do terrible things and those who kill are sent south. That was the worst punishment because they could no longer see their family, and they could not adapt in another village, thus they would die of sadness." I wanted to die of sadness in my own town, along with my tona. I wanted to be buried next to my grandparents, and to have a black dog next to me so he could guide me in the afterlife. Just like my grandfather Adrián. I dug out the little statues that my grandmother Nabora had buried, and I prayed to all of them, even though I didn't know which one was the one who could grant me the forgiveness I so desired. I would then bury them again, because leaving them exposed was considered taboo in the Mixtec culture.

More weeks went by, and people knew that my presence in Tututepec had become a burden, mainly for my parents. Whenever my father decided to go drink at the cantina and didn't come home to sleep, my mother would ask me to go look for him and convince him to come home. That way she could deter him from spending a whole week's pay on liquor. Other times when my father had one too many, he'd come home drunk and proceed to beat me and my mother, and then he would throw us out of the house.

One day, as I was about to enter the cantina, I looked through the crack of the double swinging door, and I saw that my father was arguing with another man who was also drinking. He yelled at my father, "Your son burned the Baby Jesus. You should thank God he is not old enough, otherwise I'd beat the hell out of him." When I heard this, I ran home as fast as I could. I lied to my mother and said that I couldn't find my father. Eventually he came home smelling of brandy, after having spent half his week's pay at the cantina. It turns out he had been buying drinks for that man who had said that he'd beat me up. He sat on the hammock and began to cry. When I asked my mother why he was crying, she said, "Because he is drunk." Then he held Dolores and said, "You are my dear daughter. I love you so much. I love you from here to the heavens."

My father's sobs were the product of the shame that he felt because of me. He couldn't bear my wrongdoing toward the Baby Jesus. He also regarded it as a grave sin. Everyone in the region was utterly conservative; they turned their back on reason and lived submerged in condemnation and gullibility, which gave way to manipulation. That is what drove my father to resort to

liquor. It helped him forget about his worries and his disappointing son. And all the while I felt guilty; I felt everything had been my fault.

I felt that I was to blame for my father's drinking so much, and that I was the reason that he chased us in a rage intending to beat us. At times, we had to run out of the house with our blankets and head to our neighbors' homes, where we would hide and escape from his violent attacks. Our neighbors would fortunately let us stay the night. I know they felt sorry for us. If my father caught me when he chased us, he would strike me with his belt. He hit me more than the others. Every time I saw him heading in my direction, I knew I had to prepare for another beating. He would take off his belt and hit me until I was down on my knees. Other times he would beat me with his machete blade, and several times the neighbors had to intervene and beg him to stop. They would free me from the beating and take me to their homes.

Around that time, my mother didn't leave the house during the day. She was afraid of what people might say or do. Some people would look at her with compassion, while others would say, "What did you do, woman? What is your sin? Why did God send you such a wretched son?" My mother would lower her head and not answer. She'd just cover her head with her rebozo and turn away without saying a word. Once, as she was heading home after doing some errands, a woman told her, "Your son is growing like a crooked tree, not even God can straighten him." Poor mother of mine! She had to tolerate all the reproaches, like knowing that her son had been excommunicated from the church for the second time, and that only the Holy Father in Rome could forgive him. I didn't know where Rome was, but I was surely hopeful that someday I would join a pilgrimage headed to where the Holy Father lived. I intended to walk all the way there, and on seeing him, I would ask that he pardon this sentence, which had inevitably befallen on me.

I heard that the Baby Jesus had blisters all over his body from being burned. I felt very sad about this and wanted to see the Baby Jesus for myself. So, one day I went to the church very early in the morning and confirmed that the Baby Jesus did indeed have blisters all over. I hoped with all my heart that they would go away, along with my feelings of guilt. So I asked him for forgiveness and told him that it was not my fault. He knew the truth. Deep down inside, I knew my soul had been absolved. I never understood how the Baby Jesus got those blisters until years later, when I learned that chemical substances from the paint and the gesso form bubbles upon exposure to heat.

I needed someone who could help me solve my problems. I needed a "savior," an "angel," or an "archangel." So, I prayed with my mother every night. As usual we prayed to the Holy Infant of Atocha, and when we got to the place for petitions, my mother would lower her head, imploring this Holy Infant, "Father of mine, Miraculous Child, you have fed the prisoners; may my children never suffer from hunger. Give them their daily bread and keep my husband from the perils of drinking. Bring salvation unto my son Federico. Forgive him and help him change his ways." My mother prayed constantly to the Holy Infant of Atocha. I think he started getting tired of all the pleadings, and finally he performed his miracle.

BANISHMENT: THE FINAL HUMILIATION

Not long after the Christmas Eve fire, Dr. Mendieta most likely had become aware of my parents' situation, including the pressure of keeping everyone in town at bay, and the risk of my staying in town past the age of eighteen. Shortly after my fourteenth birthday, Dr. Mendieta, a man of extraordinary vision and a huge heart, set forth a proposal my parents could not resist. When Dr. Mendieta showed up at our house one evening, my parents asked my sister and me to go outside so we wouldn't hear their conversation. But kids will be kids, and we went outside and stayed close enough to listen to the adults. We could hear that they were talking about me. Dolores whispered, "They are going to send you away." "I don't want to go anywhere," I answered. She replied, "Don't be afraid, dear brother, I'll go with you." And I said, "I think they said Oaxaca, and that it should be soon." After they finished talking, Dr. Mendieta said goodbye to my parents, and he lit his lamp and headed home. Dolores and I went back in the house, pretending we hadn't heard anything, and went straight to bed on our respective petates and fell asleep. Our parents didn't say anything that night.

The next morning my father approached me and said, "We are sending you to Oaxaca. Dr. Mendieta has a sister there, and she is going to get you a scholarship so you can go to a boarding school there. You will live there and will have access to everything you need, but you must stick to their rules; they are very strict. I must warn you. You must stay away from our town for many years, until people forget about you a little bit. You'll have to try your best to get used to life in Oaxaca." I was completely taken

aback by my father's words. I was also frightened by his determination. Apparently, he was content with this plan, but to me it seemed a bittersweet punishment.

Very humbly I responded, "Papa, people say that it gets really cold in Oaxaca. I don't know that I will ever get used to that. I'm afraid to go. I don't want to be far from all of you. I promise that I will help you by doing more farm work. I will help you in the cornfields. We can plant jicama, melons, and lots of green beans. We can sell all those crops and make a lot of money. I will pay more attention to the fieldwork. I'll do everything you do. I've been practicing how to climb a coconut palm tree with no ropes since last week and—" "No, Fede," my father interrupted, "you are going. It's the best thing you can do for the family. My peers no longer respect me because of you. Many people look down upon me. That is why I'm never considered for any vacancies in our Town Hall. The highest post I've had was as councilman for road works. If you stay here, I will never gain a seat as trustee." I continued to make my case and thought I had made a reasonable suggestion: "Papa Juan, why don't we all just move to the countryside? We can work the cornfields. Let's move to Hierba Santa; it's far from town, and we could live better." But he wouldn't hear of it and replied, "No, son. Don't you understand? I want to become the mayordomo of Tututepec, and then maybe I could even become president of the municipality. Those are the two highest seats in town."

I wasn't going to give up and kept trying to convince him that I would not be able to survive in Oaxaca. "Papa, they say that the food in Oaxaca isn't good. They eat horse meat and say that it's cow meat." But my father was set on my going. "No, no. You'll get used to it. My friend Maria Pérez sent her son off to Oaxaca, and he got used to it. They say he has gotten a fine education. Same thing with my friend Dario Rosas's son, he's fine. Manuel Narvaez sent his son as well. . . . There's no way around it, son, you're going." My last argument was to point out the difference between these young men and me: "Papa, they are all mestizos. I'm an Indian. It's very different. They don't like Indians in town, and they don't like them in the city either."

There was no persuading my father, and he finally said, "Look, son, you could use a great deal of discipline. Dr. Mendieta told me that the boarding school where you'll be placed is where the children of military families go. This is the opportunity of a lifetime. Do you know how lucky you are?" All I could say was, "That's fine, Papa, I see that you no longer want me here. I'll go and try my luck there." He tried to convince me that it was for my own

benefit: "No, Fede, don't you get it? You'll go to school so that you can be somebody and not just a farm boy like me."

As I started to think about it, I asked, "Can I come back during the summer vacations?" But he sadly replied, "No son, I think that we will have to wait several years before you can come back. During your time off you can work so you can buy yourself some clothes. You know that we don't have any money to send to you." So, my last tactic was to ask, "Papa, what does mother think about this?" And to my surprise, he told me, "She agreed. It's a sacrifice we are making that will change your future. She is more excited about this than me." I felt betrayed and cried out, "How can she say that she loves me yet won't let me stay here in town?" His only response was, "It's for your own good, son." According to my parents, they had found the best solution for their eldest child—to be sent away and enrolled in a military-style boarding school so that I could get an education and "straighten my ways." All this so that one day I could return and regain the family's dignity, maybe with a title or degree.

After our conversation, my father took his hat, left the house, and went to the place where they sold plane tickets. My father requested a one-way ticket to Oaxaca City. He had no trouble coming up with the thirty-six pesos for my one-way ticket, since we had sold a pig, two pots of *hoja pintada*, and a beaded blouse that my mother had made. Nobody knew I was leaving town other than my family and the doctor. My mother washed my clothes and packed them in a cardboard box as the day of my flight was approaching. Then one morning, my father said, "Say goodbye to your sister, Dolores, and your brothers, Claudio, Carlos, and Ramon. Say goodbye to your mother. I'm taking you to catch your plane."

As I was leaving, my mother gave me the following advice: "Don't bring me more shame. Don't come back soon. Bear with it. Behave well. Study and write often." And I replied, "Yes, Mama Ime, I swear I will write often. I love you very much!" And she said, "I love you too. I will not let a day go by without praying for you. You are the child that has helped me the most, the child in which I place all my hope for the betterment of the whole family. We have fought many battles together. God willing I will go visit you whenever I can, and hopefully someday soon we will all be together again."

Dolores held me tight and cried out loud because she didn't want me to move to Oaxaca. My mother pinched her because she didn't want anyone to find out about my leaving Tututepec. Ramon silently cried and hugged me

tight. He was quite young then. Then my mother said to me, "I will pray for you, so that God may protect you, take good care of you, and give you the courage to excel. And once again, don't forget to write, so we know how you are doing."

She held me in her arms, and I saw that she was crying. At that moment, I thought about all the experiences we had shared, of the times when my father had left the two of us with the responsibility of supporting the whole family, and the times when that red hen would lay an egg under the bed that we used for our soup. I thought about all the times I had cut hay to sell in town. I used to cut wildflowers to sell to doña Queta Sanchez, and with the money she gave me, I would buy candies and lollipops for my siblings. I thought about the times I sold candy, fried plantain, or bread for doña Adelina Galindo, and when I sold soap for Aunt Casimira. I recalled the times I sold coconut candy called *jamoncillo* for Gudelia Barete, or flavored water for the Holy Friday procession. I thought about the Candelaria Fair, when I worked for don Tobón pushing the merry-go-round for five centavos per round. I recalled the time I sold bread balls with the brown sugar glaze.

I thought about the time that I sold water from jugs I had drawn from the river. I would fill up the jugs and secure them on each side of my donkey with a huge net. I would then tie myself onto my saddle to keep balanced while riding him. This one time my donkey saw a female donkey and started to mount her. She kept kicking at him and trying to get away, and he kept chasing after her. During the whole episode of my donkey seeking his own pleasure, it was too dangerous for me to try jumping off, so I remained tied to my saddle, hanging on for dear life. The jugs broke during the chase, and I lost all the water, and everybody burst out laughing. They found the whole scene to be hilarious. I had to get new jugs and go back to the river for more water and start all over again.

I remembered going to the soldier's quarters to ask if anyone needed their laundry done. My mother used to charge two pesos per uniform. Then there was the time she sent me to Barrio Grande to sell the only pair of gold earrings she had. These were the earrings that my father had given her when he'd come back from Guerrero. My mother also sent me to Barrio Grande to sell the cross-stitch blouses she had made or to sell tiny dresses for little girls.

Amid my memories, the question lingered as to whether my mother was as concerned about my leaving as I was. We just looked at each other. Finally, I said, "Goodbye, Mama Ime. Goodbye, Mama Ime." And she finally said,

"Goodbye, son. Dearest son of mine, may the Holy Infant of Atocha bless your path. Goodbye, son." Just then a boy passed by our house and saw me saying goodbye to my mother and to my siblings. He took off running and announced at the top of his lungs, "Federico is leaving by plane! Federico is leaving by plane!"

My father and I got on our horses and we rode toward the Tututepec landing strip. When we got to the edge of town, a crowd of women and children had gathered. When they saw me, they shouted, "Goodbye, wretched boy! Goodbye, damned child!" "The Devil is leaving! The Devil is leaving!" The yelling started to annoy my father, so he whipped his horse to pick up the pace, and off we rode, away from the shouts of the crowd. I could still hear the humming of children's voices, saying, "Goodbye, wretched boy. So long, you heathen."

I tried to etch in my mind every detail of the landscape that I was leaving behind because I loved my town, the place where I was born. The sorrow of leaving my family behind weighed heavily on my soul. I felt a lump in my throat, but I suppressed the tears since I thought that men shouldn't cry. It was difficult not to cry, being only fourteen years old, poor, and Indigenous. I had no idea what was ahead of me.

Shortly after we arrived at the landing strip, we saw my plane in the sky as it headed toward us. My father cleaned my shoes with his red handkerchief, and then he held me tightly in his arms. I couldn't remember the last time he had done that. It felt great, but at the same time, I was overcome with sadness. Did this gesture symbolize the pressure he felt from his peers after everything that had happened? Maybe he was trying to tell me that he was sorry. With tears in his eyes, he said, "Be good. Study and follow the rules, do you hear me?" I replied, "Yes, Papa, I'll be good." He also reminded me, "Don't rush back; don't come back soon. Do you hear me?" And I sadly responded, "Yes, Papa." I then boarded the plane for Oaxaca City.

As I took my seat, I looked out the window and saw my father raising his hand. I couldn't tell whether he was saying "goodbye" or "don't rush back; don't come back soon." The plane's propellers started to rotate, and as the plane started to move forward, the tears gushed out of me like a river. I cried as though someone had died. As the plane took off, my father's image began to disappear in the distance, but his words remained, causing distress in my mind and sadness in my heart. "Don't come back soon. Don't come back soon. Do you hear me? Don't come back soon."

PART II

COMING OF AGE

9

TRAVELING TO THE BIG CITY

THE PLANE I BOARDED WAS small, with a seating capacity for eighteen passengers. It came from Acapulco, and after making several stops in different towns, dropping off and picking up passengers and supplies, it arrived in Tututepec. I never imagined that I would travel in one of those giant silver flying objects I had seen in the sky. As I took my seat, I realized that I had no idea what was ahead of me, but most of all I felt a deep sadness. I felt as though a part of me was staying behind. As I looked out the window, I thought, "I'll be back someday, and things will be different."

When all the passengers had taken their seats, a man on horseback raced across the landing strip, chasing away the animals so the plane could take off. The pilot told us that he didn't like using this landing strip because it was too short, but with God's will, the plane would take off without any difficulties. Some of the passengers prayed in silence, and when the plane started to move, everyone made the sign of the cross, that is, everyone but me. A lady sitting next to me quietly said, "Do the sign of the cross, young man," and I politely followed her request. The lady was señora Maria Narváez, who had a food stand on the town square. Every time I walked by it, I could smell lard and garlic, which always made my mouth water. Señora Narváez covered her head with her rebozo, and we didn't speak to each other for the rest of the flight.

Early in the flight I noticed the other passengers whispering something among themselves. As I was trying to hear what all the fuss was about, somebody whispered in my ear, "Pray for our salvation because we have a priest on this plane, and some people say it is a sign of bad luck, and the plane could crash. It has happened plenty of times." Everyone prayed except the priest. I knew that for a fact because he was sitting right behind me, and every time I turned around, he'd just look at me and smile. After a couple of times, he gave me a blessing by making the sign of the cross. I wasn't sure if I should feel cursed or blessed, since we were all concerned about the consequences of having a priest on the flight.

The flight seemed to be going along smoothly, or so I thought, until I saw the pilot immersed in some sort of comic book. Then it occurred to me that no one was flying the plane. I thought for sure we were doomed to crash. After a while he told us that in approximately thirty-five minutes, we would be reaching our destination, the great City of Oaxaca. I had always thought of our state capital as an immense, endless metropolis, as opposed to my small yet intimate town. My marvelous and beloved hometown of Tututepec, which was now so far behind me.

As I looked out the window, the roads leading back to Tututepec had disappeared into the mountains by the sea. I thought about the hills around our town and was reminded of the evening when my grandmother Nabora had told me that I would "someday be a great man, a principal." Even though I was very young, I recalled the times when she had taken me out to the little hill to pray to the Tatas while carrying a torch with pitch on the end. When we arrived at the little hill, she would light her torch from the fire that was always kept going there and then point it to the setting sun and recite her prayers in the Mixtec language. Unfortunately, I had no time to visit the little hill to say goodbye to the *Tatas* before leaving.

I also thought about all those Roman Catholic saints in the San Pedro Church who used to frighten me. I thought about God, whom I was sure had forgiven me for my sins of burning the statue of the Baby Jesus and for taking communion without first confessing. As I looked out the window to the horizon, I felt atoned way up there in the sky, and at that moment I felt closer to God. My mother told me that God was in the heavens; that is probably why I felt close to him. On the other hand, my grandmother Nabora taught me about the importance of the sun in our Mixtec religion. Even though the Indigenous practices of my grandmother were viewed as pagan

by my mother and the other mestizos in town, I found them to be especially moving, and they resonated with me on a deep spiritual level. For this reason, I have always felt a strong affinity for the sun, and now being so close to it I was able to draw some comfort and strength from it. Nevertheless, my sadness increased as the distance between me and my hometown grew, and I kept thinking, "I'll be back some day, and it will be different, I promise you that, grandmother Nabora."

As I left the sea and mountain ranges, my thoughts were suddenly interrupted by the sight of the grand valleys of Oaxaca. The plane was getting closer to the great city. The plane finally landed on a dirt road that served as a landing strip for the Oaxaca airport. Flanked by cornfields, the airport was in an area that is now known as the Colonia Reforma neighborhood.

AN INTRODUCTION TO MY NEW HOME

Shortly after landing, I was handed my cardboard box by the flight attendant. All my belongings were inside that cardboard box tied with henequen rope. This was all I had in addition to the twenty pesos that I kept secured in the pocket of my pants. After all the passengers got their luggage, I joined a group of them, and together we got into a *collectivo* (taxi shuttle van). We each had to pay two pesos for our fare. The collectivo made its way along cornfields for the short trip into the great city. As I looked out the window, I got the impression that only rich people lived in Oaxaca, as I didn't see one single house made with palm roofing or that had gates like the one at my grandparent's house. All the homes looked like palaces with gardens full of different types of flowers. They reminded me of pictures I had seen in my school textbooks.

Oh! I especially remember Juárez Avenue, where we passed by the El Llano Park. This is a magnificent park, now officially known as Paseo Juárez El Llano. At the time, it had golden lion statues at each entrance and beautiful fountains with abundant streams of water flowing from them. The benches were made of concrete and marble with pre-Hispanic designs, complemented by the art deco style from the time of the presidency of Porfirio Díaz. There was also a large monumental statue of the famous Zapotec governor of Oaxaca and later president of Mexico Benito Juárez. Little did I know that a few years later I would be standing before a sizable crowd on the park's central

stage, passionately and eloquently exalting this incredible man, the most important Indigenous Mexican leader in the history of our country, and a distinguished hero of the Indigenous people of all Latin America.

On seeing dozens of churches and cathedrals, I thought, "What a Catholic city this is." They had huge bell towers and great atriums surrounded by wrought iron gates. The streets were divided into small squares, like the ones on game boards, and I was thinking that it was not going to be easy finding my way around these city streets. After a couple of minutes, our collectivo turned onto a smaller cobblestone street, flanked with regal palm trees, named Gurrion. We stopped in front of a house with the number three. "This is Gurrion 3, it'll be two pesos please," said the driver. I got out and just stood there holding my cardboard box. I hesitated for a moment as I looked at the house. Then as I headed toward the door, I stopped again, feeling lost and overcome with immense uncertainty. After a minute or two, I finally mustered up enough courage to walk up to the front door at Gurrion 3. Señora Sara Mendieta de Franco, a light-skinned and very refined

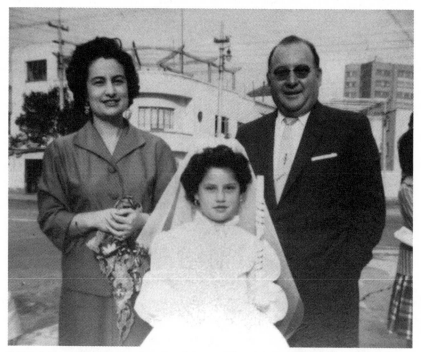

FIGURE 5. Photo of the Franco Family celebrating the Holy Communion of their daughter, Tere, ca. 1956–57. Photographer unknown. Jiménez Family Collection.

lady opened the door. When I saw her, I immediately felt the cultural and social divide between us and nervously blurted out, "I'm Federico, son of Juan Jiménez, a friend of your brother, the doctor in Tututepec."

She looked at me for a moment without saying a word, adding to my uncertainty. I didn't know whether her gaze held pity or curiosity. But then she said, "Come in. In a little while I'll take you to the Ignacio Mejía Boarding School." We left not long after and walked toward the boarding school. After walking a couple of blocks, we crossed the huge El Llano Park, and in no time, we were standing in front of the school building located next to Our Lady of Guadalupe Church. The school was enormous. Señora Mendieta de Franco was a friend of the school principal, and he took her into his office right away. I took a seat and waited in the hallway. They spoke in private for quite a while, and then they said goodbye to each other. She then turned to me and said, "This will be your home now. Behave well. I will tell my brother that I've made all the necessary arrangements."

MY FIRST WEEKS AT THE BOARDING SCHOOL

The school principal gave me a card with the number 452 on it. I soon learned that I would no longer be known as Federico. Whenever I heard the number 452 called out, I would have to respond, "present." They gave me a bed, a pillow, and a laundry sack with the number 452 written on them. I felt so insignificant with that damn number. I couldn't believe that the number 452 had replaced my name. At the age of fourteen I couldn't help but think about what I had gone through to have my name changed to Federico back in Tututepec only to lose it once I entered a boarding school in Oaxaca City.

Every morning at five o'clock, a loud bugle played a military tune announcing that it was time to get up, wash up, dress, and line up to march across town. My school was like every other military school; we had all the rules, uniforms, and discipline expected of official military quarters and training. At six o'clock we would depart from the school carrying rifles as old as time and march to the Ixcotel section of Oaxaca, which was a military installation in the city. We walked about five kilometers one way. I could have sworn that my rifle was heavier than the cross Jesus had to bear. To this day, I don't know how we managed to do all the different hand maneuvers with those old rifles. But then, my friendship with my rifle was fleeting.

Two weeks after being enrolled in the boarding school, the school doc-tor summoned me to his office. I had to undergo a full physical exam. After conducting his exam, the doctor was very angry as he told me the results. He had found a whole array of health maladies and ordered that I be kept away from the other students immediately. I was to avoid any and all contact with them. I didn't take what the doctor said very well as his diagnosis seemed to point to my imminent death, or at least that is what his reaction seemed to indicate. I couldn't help but think, "What if I die here in Oaxaca?" I wouldn't receive a proper burial because nobody knew me. I thought they would burn my remains along with the few belongings I had in my little cardboard box. I immediately thought about the stories my mother used to tell us about Aunt Elpidia's death from typhoid fever. They had incinerated her along with all her belongings. Afterward, they set her house on fire. To this day nobody dares to cross the land where her house once stood, much less build on it. I asked myself, "Did I inherit that disease from Aunt Elpidia?"

Neither the doctor nor the nurse said a word for the longest time. They just looked at each other with revulsion, and I was too scared to ask for details about what I should do. Finally, the nurse turned to me and said, "Wait here, don't move." She disappeared and came back with the cardboard box that held my belongings. "Follow me," she said. We walked to the school's main entrance, and I was left in the custody of the guard. He turned to me and said, "You are now dismissed. I can't let you back in under any circumstances unless I receive special orders." Having nowhere to go, I sat on a curb by the school for what seemed like an eternity. Hours later, one of the school nurses who was heading home recognized me. She looked at me sadly and suggested that I go see my "guardian."

I thought about that but was reluctant to bother señora Mendieta de Franco, as she had already helped me get into the school. Finally, realizing that I didn't have any alternative, I took my box and headed to Gurrion 3. I knocked on the door, and when señora Mendieta de Franco opened it, I explained everything to her. She was not pleased at all and said, "Unfortunately there isn't any room here. I can't keep you here. I have three young children and would not like them to catch anything from you." "But I can't go back to my hometown," I insisted. She replied, "Here's what I can do. Come by every day. and I will feed you while you get better, but you need to find a place in a neighborhood where they'll let you stay overnight." She said she would also speak to the school principal to find out the reason I had been so hastily dismissed.

ON MY OWN IN THE BIG CITY

So, there I was, alone in the streets with my cardboard box after having arrived just two weeks earlier. I walked toward the zócalo, Oaxaca's main square, maybe instinctively, maybe because I wanted to be surrounded by people. I arrived at the park known as Alameda de Leon and sat on a bench, box beside me, thinking about what to do. By then I was very hungry; it had been hours since I'd had anything to eat. I wanted to return to my home-town, but that was wishful thinking, since I didn't have enough money for a plane ticket. I thought about finding a path that would lead me back home, but I didn't know where to begin. Besides, it would be incredibly difficult. I thought about all the wild animals I would possibly encounter along the way. The walk home from Juquila used to take three days, and I wondered how many days it would take to get to Juquila from the city. I also knew deep down that I would not be welcomed if I went home. My mind stopped wondering about how I could get home to Tututepec and returned to the reality of finding a place to stay in the city.

I looked up, and there was a photographer right in front of me with all his gear, including an old tripod and camera. I was reminded of what they had told me at the boarding school, that I needed a photo ID. The worn-out state of his equipment made no difference to me; all I wanted was a set of photo-graphs so I could have them handy in case anyone requested one. I couldn't have picked a sadder moment to have my picture taken. Every time I see it now, I think of the sorrow that weighed down my heart at that time in my life.

I had no idea where I was going to spend the night. I sat on a bench looking at the statue of Antonio de Leon. He was a local hero, who stood valiantly hold-ing a sword at his side. I knew he was important, but I didn't know exactly

FIGURE 6. Photo of Federico taken on the zócalo in Oaxaca City in February 1955. Photographer unknown. Jiménez Family Collection.

why. I spoke to him and asked, "Who are you? What were you able to achieve that put you on such a high pedestal? Was your family rich and famous, with large fields, farm animals, homes with plenty of food and comfortable beds to sleep on? Did you have your own bed? Your own room? Never mind, you can't talk back to me, even though your eyes seem to be saying something—so say it!" My thoughts were interrupted by a loud cry, "Circuito, Panteon," from a bus that was passing by, announcing its next stops. As the bus momentarily stopped in front of the cathedral, people ran across the street to board it. They passed right by the four pedestals that held bronze statues, each representing a different season.

My prior conversation with Antonio de Leon didn't matter at this point; what mattered now was finding a place to stay that night. I couldn't just sleep on the zócalo next to don Antonio's statue, or any other part of the city, for that matter. I had been warned to be careful and to watch out for thugs. People used to say that a lot of muggings went on in the city and that "thugs can steal your socks without ever removing your shoes." People said it was especially dangerous for an Indigenous child to roam the streets alone; only the more experienced street orphans could do that. Suddenly, I felt the little piece of paper in my pocket that had the address of a couple who were fabric merchants. I had made their acquaintance at the Candelaria Fair, which is one of the largest fairs held in Tututepec. They had given me their address without putting much thought into what might transpire in the future. And then an idea just hit me: "I'll pay them a visit!" I rushed past the statue of Antonio de Leon, saying goodbye and promising to continue our conversation some other day so that he could share the secret of his success with me. For now, though, my main objective was to find the home of this couple.

As I started to walk toward the Juárez Market, I looked at the street name written on the little piece of paper again. It said Aldama 22. I asked people where Aldama Street was, and when I had reached my destination, I walked in and realized that I was in some sort of a communal housing complex. I looked for the unit belonging to the fabric merchants. On my unannounced arrival, they seemed surprised, and I wondered if their reaction was out of joy or just the result of an awkward situation. I didn't have any choice but to ask them if I could stay there and said it would be temporary. They said that all they could offer me was a tiny room full of tools, merchandise, and portable shelves they used at the markets. I told them that was fine and reminded

them that back home I slept on a petate on the floor, so sleeping among these things would be no sacrifice. At this point I was desperate, and even though it wasn't great, I at least had a place to sleep for now.

The Aldama communal housing complex was on a very loud street. In fact, it was one of the loudest streets in the city. The street was lined with dozens of taverns and prostitutes. The sound of jukeboxes echoed as they played the latest hits, such as "La Mujer Paseada," by Ramón Ayala, and "Ya No Estas a Mi Lado Corazon," by Los Panchos. There were also hotels, motels, and two eateries on Aldama Street, which began at the Juárez Market, the largest in the city, and went east to Mier y Terán. The smell of urine, cheap cigarettes, and manure from the horses and mules permeated throughout. No one cleaned up after their animals whenever they passed down Aldama Street, carrying loads of merchandise to the market. On Saturdays, which was, and continues to be, the traditional market day in Oaxaca, the street would be lined with stands selling vegetables, bread, and pottery. And of course, there were always the tiny fortune-telling birds. I would pay ten centavos a week to get my fortune told, and the little bird would always pick a strip of paper that said I would soon fall for a very pretty rich woman, that my luck was about to change, and that love and fortune were at my doorstep.

A family of bakers lived in one of the housing units, so the smell of freshly baked bread helped to cover up the foul odors somewhat. There was also a dressmaker who worked long hours to send her daughter to a private school she called La Corregidora. There was another lady who had a coal stand, and she always looked like a clown with all the soot on her face. A small convenience store stood on the corner with a sign at the entrance that said, "NO SALES ON CREDIT TODAY, MAYBE TOMORROW." Across the street was a pottery factory. Some of the pieces they sold had oriental designs, which is probably why the neighborhood was referred to as Chinatown.

I felt relieved and thankful because at least I had a place to sleep. The noise in the street didn't matter, nor did the street walkers, taverns, or awful smells. I wasn't concerned about sharing my sleeping quarters with a bunch of tools and shelving. Those were the least of my worries. After a couple of days had passed, señora Mendieta de Franco told me that I had been diagnosed with ringworm, which was an extremely contagious disease among children. There was hope that I would be able to return to the boarding school, but I had to get better as soon as possible. From that moment on regaining my health became my primary mission.

10

THE CURE!

SEÑORA MENDIETA DE FRANCO SPOKE TO the boarding school
principal, who granted her a special favor. I could go back to the board-
ing school, but only during regular school hours. I couldn't live there
with the other students. During the week, I attended the boarding school
during the day and took fourth-grade-level classes. The students called me
"*el pelon*" (baldy), refused to play with me, and sat as far from me as they could
because of my contagious illness. During recess they refused to socialize with
me, which reminded me of the way things were back home, where my class-
mates didn't want to be associated with a sinner. But this time I didn't care.
I knew that as soon as I regained my health and recovered from this case of
ringworm, they would talk to me and play with me. I thought, that's when I
will tell them about the important political ranks that my grandfather held in
the town and that I came from a line of noble people who spoke to the Mixtec
gods as the sun set. I would also tell them that I was born in Tututepec, the
pre-Hispanic capital of the Mixtec in the coastal region of Oaxaca. I will tell
them that I was very proud of my Indigenous roots. Nonetheless, I thought it
would probably be best to leave out the part where I had been banished from
my hometown, even though God's forgiveness had washed away my sins. In
my mind, however, I was convinced that it was thanks to my grandmother
Nabora's prayers to the Tatas that my sins had been forgiven and not so much
from the constant novena prayers of my mother.

EXPERIMENTAL CURES

To rid myself of this miserable disease, I started looking for home remedies, such as the "black man's herb" that my mother used to grind up and apply to my head. Unfortunately, I was never able to find that remedy. The local herbalists in the market would laugh every time I asked for it. One herb merchant told me, "I don't have black man's herbs, or white man's herbs!" She said she only had medicinal herbs. Another remedy that someone suggested was sandalwood oil. I found it at the Merced Pharmacy and applied it every night and then tied a red handkerchief around my head. Unfortunately, I later realized those efforts had been futile.

Little by little I learned about different remedies for ringworm, and every time someone suggested a home remedy, I would try it at once. Sergio Franco, my guardian's husband, took an interest in helping me find a cure. He knew a lot about medicine because his parents had once owned a pharmacy in the city. He gave me a treatment that consisted of vitamins and granules that tasted like dried orange. One day he applied DDT to my head, which caused a very strong burning sensation, but I tolerated it since I was told that it was part of my treatment. I was so eager to find a cure that I subjected myself to incredible barbaric measures.

The barber who cut my hair suggested a sulfur remedy, but he warned me that it could be harmful to my hair. Boy, was he ever right. The day after he applied the sulfur, my hair fell out by the handful! It rolled down my face. I ran to the mirror, and on seeing myself, I nearly cried out—my head looked like a baby chayote, and I got really scared. I don't recall ever being that upset. I didn't know hair loss could cause such strong negative emotions, especially when you are a fourteen-year-old. I had about thirty strings of hair on one side of my head and four on the other, so I bought a cap to cover my head. The most embarrassing thing was when I had to take my cap off. The students at school were curious and wanted to see what new remedy I had applied to my head this time. When they saw that I had just a few strings of hair left on my head, they suggested that I apply more sulfur on what little hair I had left to even everything out and become entirely bald. They told me I should forget about my hair ever growing back, and I told them that back home I used to cut hay, and whenever the fields burned, the hay would grow back again in no time and that my hair would do the same thing. That made my classmates burst out laughing.

Finally, the day came when the doctor gave me a clean bill of health. Next, he had to decide whether I was ready to be reenrolled full time at the boarding school. I had prayed to the Holy Father and recited three Hail Mary's, which is what my mother had told me I should do in a letter she had written. So, when the day came for another physical exam, I sat in the infirmary early that morning waiting for the doctor. When he walked in, I felt extremely anxious since my return to school full time depended on his diagnosis. He examined my mouth, eyes, testicles, and finally my head. Then he said, "I see that you are quite healthy, but you cannot return to the boarding school full time yet. I want to keep you under observation for another three months to make sure that the infection does not come back." I thought that the reason behind this observation period was the horrible appearance of my head, so now I needed money for a different type of treatment, one that would help my hair grow back faster. I wanted to be just like the other students at school, without any peculiar characteristics distinguishing me from the others whatsoever.

The doctor said that I was recovered from the ringworm, but now I had to invest some money on counteracting the side effects from the remedies that had been used. But where would I get the money? Somebody told me that I could sell newspapers in the morning before nine o'clock, which would earn me a few centavos while still allowing me to get to school on time. I went to the building where the newspaper *El Imparcial* was located, and an older man asked me to return at five o'clock the next morning so he could write my name down on the list of newspaper boys. As custom had it, the first names on the list got to cry out, "The news, the news, *El Imparcial*."

I didn't sleep well that night as I was concerned about waking up early the next morning. I didn't have a watch or an alarm clock, but I managed to wake up and return to the newspaper building quite early the next morning and got my name on the list. I think I was one of the first five on the list. When my turn came up, the man in charge said that since I was new, he could only give me twenty-five newspapers, costing twenty-five centavos each. I had to sell them for thirty centavos, which would earn me five centavos per newspaper. After two weeks, I was given fifty newspapers, which would give me a profit of two pesos and fifty centavos. It turned out that selling fifty newspapers per day was easy for me. I had come up with the idea of asking a prison guard to let me sell my newspapers to the inmates. Back then, the prison was in the building that is now the Camino Real Hotel. Whatever I didn't sell at the prison, I would sell in the streets.

By nine o'clock every morning I was at school. I made a point of never being late or missing school, not one single day. After saving up my proceeds from selling newspapers, I had enough money to buy the treatment needed to grow my hair back. I continued with my treatments, but I don't know which was worse, the disease or the cure, which again consisted mainly of herbs that I bought in the market. I must have used all the different concoctions and combinations that the herbalists sold. I religiously followed all the directions and applied countless remedies to my head. I started seeing some progress, although not quite as rapid as I had hoped, so each morning I continued to take the granules that señor Franco had given me. They tasted horrible, but I would take them patiently and sometimes with much eagerness since all I wanted was to regain my health entirely.

My parents wrote often, telling me to behave and saying that my mother always prayed for me. They suggested that if I had some extra money, I should buy a votive candle for the Holy Infant of Atocha so that things would go well for me. They would also mention in the letters that my sister, Dolores, missed me a lot, that young Ramon was sick, and that God had given them the gift of another child, since my mother was pregnant once again.

One day I received a letter I found utterly shocking after all my efforts to survive in the city and to get an education. It said:

Fede,

We are hoping you are in good health, and that God may light your path each day with his blessings, and that he may protect you. Everything is well here, thank God. And after this brief greeting, I would like to tell you that your mother and I are very much ashamed because rumors are spreading in town saying that you are not going to school. People are saying that you are a paper boy just roaming the streets of Oaxaca. They say they have never seen you carrying a book, that all you ever have are newspapers. Fede, please tell us the truth, don't lie to us like in the past. What we have done for you has been of much sacrifice to us and that is no way to thank us. We always proudly talk about how you are attending a boarding school where there is much discipline, we tell everyone that you will mend your ways and become someone new. In the future you will be able to return to town once people are aware that you have straightened your path. We ask God with much devotion that you succeed in Oaxaca. As of now, you know it is impossible for you to return to town, but your mother would like you to send some onions and

*jalapeno peppers, garlic, apples, and peanuts since they don't sell any of that
here. Please as soon as you can, tell us how you are doing, and bear in mind
that your mother is pregnant with another child and she must avoid getting
very upset. She constantly prays to the Holy Infant of Atocha so that he may
protect and guide your ways. That is all for now. We send our blessings and
we love you a lot.*

Your Papa

I was happy to hear from my family, but I found this letter more upset-
ting than comforting. I felt resentment, and even hatred, towards the towns-
people. I felt as though I was still being persecuted with rumors and gossip
even though I was far away in the city. Were they not satisfied at having me
banished? It felt as though everyone in town refused to lose sight of me. It was
as though they needed to know exactly where I was and what I was doing
all the time. I guess I was officially the town's sinner, that wretched boy, the
exile and the outcast. Everyone wanted to be kept abreast of my daily life.
When someone from Tututepec traveled to the city, everyone would hassle
them with questions on their return, among them the latest news about me!
They would ask, "What is he doing? Has he gotten into great trouble once
again? Is there anything juicy to share?"

This letter was very depressing for me. I had nobody to turn to in the city.
There was no one I could talk to about my sorrows. I had to ask myself, "Had
I turned those sorrows into something bigger than they really were?" Maybe
I did because I was a small-town boy. Even though my first days in Oaxaca
were spent wandering the streets and wondering how I was going to survive,
I couldn't help but be reminded of my father's last words to me: "Don't come
back soon." What helped me the most was thinking about my grandmother
Nabora's words: "You will be a great man one day, and you will remember
what I say, my grandson." Of course, my grandmother was referring to my
being a principal or a mayordomo in Tututepec someday, which now seemed
an extremely remote possibility. Nevertheless, my grandmother's words
comforted me and assured me that everything was temporary. They helped
me to accept my current situation as a poor kid in the big city and to believe
that things would change for the better someday.

My hair continued to be my most important concern, and every morning I
would look in the mirror and count each new strand that grew. When there

were only six strands of hair, I would count them over and over. I would angle
the mirror sideways to see if there were any new strands of hair I had missed.
Two months had passed, or possibly three, before I gained the courage to visit
the doctor at the boarding school. Again, I anticipated my visit with several
prayers to the Holy Father and three Hail Mary's. The doctor examined me
and said I could reenroll in the boarding school and fully participate in all the
academic activities. I was ecstatic when I left the infirmary. I headed straight
to the Basilica de Nuestra Señora de la Soledad to thank the saints for healing
me. I told the Holy Virgin of Soledad, the patron saint of Oaxaca, that as soon
as I had money, I would ask some artist to do an ex-voto painting of a boy
with no hair next to another boy with a full head of hair and between them
the Holy Virgin with her gaze set on the boy with the hair. I promised this
to her for granting me the miracle of growing my hair back.

That night in the candlelight, I wrote a letter to my parents informing
them that I had been reenrolled full time at the boarding school. I asked them
not to worry anymore because I would no longer be "roaming the streets
of Oaxaca." I was going to be studying full time and living at the boarding
school, where discipline was just as they had hoped. They probably thought
it was the best thing for such a mischievous boy who was also restless and
filled with ambition. At times, I wondered if I was doing everything just to
satisfy my parents, whom I had apparently offended and embarrassed with
my past behavior. I was caught between two religions and two cultures and
now forging a new path on my own.

BACK IN BOARDING SCHOOL

At the time there were twenty-seven boarding schools in the country, thanks
to the efforts of General Lazaro Cardenas's administration. Children of ser-
vicemen were given priority in the state's efforts to promote public educa-
tion. Next came the children of rural and Indigenous families that could not
make ends meet to pursue a private education. There were students from all
parts of the country and the recognizable regions of Oaxaca in my board-
ing school. If they came from the mountains, we called them Serranos; the
Indigenous Mixes came from the east; the Costeños came from the coast; the
Tehuanos came from the region that encompasses the Isthmus of Tehuante-
pec; and so on.

Gradually I became more engaged at the boarding school. I wasn't one of the brightest students in my classes, nor was I falling behind either. There were Indigenous students who had difficulty speaking Spanish, students with rooted dialects and expressions. The mestizo kids from the city would make fun of us, and they would try to imitate us. I enjoyed listening to the Zapotecs of the Isthmus of Tehuantepec sing and converse in their native language. I learned a song in the Zapotec language, and whenever I'd sing it, the students would clap for me, even though I didn't understand the words to the song. Several years later at a bus terminal in Tehuantepec, there were many bored Tehuanos waiting for the Oaxaca-bound bus, and I suddenly felt the urge to sing the only Zapotec song I knew. I gather it was quite a popular song, as minutes later I had a large audience singing along.

The boarding school gave me a sense of security. I felt safe there with my Indigenous classmates from rural villages like me. Some were younger, and others were older. We were all glad to be able to get an education. I felt as though I had everything I needed, but at the same time, it lacked certain things. For example, the food was delicious though limited. Breakfast consisted of a bread roll, coffee, milk, and cereal; for lunch we'd have a bread roll or a tortilla and some stew; and for dinner we would be given a bread roll, coffee, and milk. I was always hungry and never quite satisfied after a meal. I missed the food we ate back home. I'm not sure why since we never really had enough to eat, but I still missed it anyway. I especially missed my mother's handmade corn tortillas.

As I had experienced before, shortly after the loud wakeup call of the bugle in the morning, I lined up in a military-style formation with the other students. We would leave for Ixcotel carrying our timeworn rifles. Our teacher would train us in military exercises, and it felt as though we were being prepared for war. When we returned to the boarding school at around eight o'clock, we had a few minutes to wash up and then line up in formation near the dining hall for breakfast. After breakfast, we lined up again to march to our classrooms. The blaring of the bugle declared our daily activities, whether on or off the premises.

The boarding school was based on discipline. If any student stepped out of line, he faced a severe punishment. These punishments were cruel. One form of punishment was called the "bridge," where you had to place your toes on the side railing of one bed frame and stretch until your fingertips reached the side railing of the bed frame across from you. Once there, you had to hold that position hanging in midair for at least half an hour, sometimes a full hour. The

bridge was under the category of those punishments that took place at night; morning and afternoon punishments were much worse.

The level of punishment depended on the student's infraction. If you made a foolish mistake or didn't follow the rules during the day, you might be faced with cleaning the toilets, which were used by five hundred students. The toilets were so dirty that whenever I was given this form of punishment, I would beg my teachers to let me do the bridge instead. I found cleaning the toilets to be absolutely repulsive. These messy toilets stunk in their tiny doorless stalls, and they were often clogged. We poured buckets of water down them in an attempt to unclog the drain but sometimes they would overflow, drenching the floor all the way to the courtyard.

There was another punishment, one which I found to be the most dreadful. It was called "the arrest," which consisted of staying at school on Saturday and Sunday. Weekends were important to me because I worked for an apple vendor in the city's main market. I was responsible for cleaning and selling the apples. Several students had families in the city and would go home on the weekends, while others who lived far away would stay at the boarding school. I would sleep in my shed on Aldama Street. One time when I committed an infraction and was going to have to stay at school over the weekend, I spoke to the principal, our highest authority, pleading for clemency, as we liked to call it. Unfortunately, he responded with a stern voice, saying, "No! And if you ask me again, I'll give you a smack not even your own father has dared to give you." This straightforward response left me with little desire to go anywhere near the principal's office ever again if I could avoid it.

The school custodian's name was don Chepe, but all the boys called him Atilla. He would proudly boast about his battle wounds and show us his scars from bullet entries on both legs. According to don Chepe, he had been shot during the Mexican Revolution. He would speak of how brave he was. He had fought in favor of the Revolution and said that he had killed a dozen people who didn't agree with his ideas. Don Chepe recalled how he encountered both courageous and cowardly folk and would have soldiers on their knees pleading for mercy, to which he simply responded with bullets. The students listened with close attention and fear as he told those stories.

Every Monday we held a ceremony in the school's courtyard where each teacher spoke of patriotism or some other educational topic. After half an hour of standing in the sun, we would get bored, and one way to hasten the teachers' speeches along was to clap loudly for a long time. Three waves of claps were needed before profesor Canseco would conclude his speeches.

Profesora Gloria Alvarez was a gorgeous young lady who looked like a model. When it was her turn to speak, we would hold off on our applause because we didn't want to shorten her speech. Being teenage boys, we especially enjoyed hearing her talk, while admiring her beauty.

EXTRACURRICULAR ACTIVITIES

The main objective of the boarding school consisted of imparting a basic course of studies with the added feature of cultural and sports activities. National events took place yearly in the cities that accepted an invitation to host the program; these events were called Las Jornadas Culturales y Deportivas (Cultural and Sports Events). Every boarding school competed in athletics, music, singing, poetry, and dance activities.

I had no experience with athletics but liked the idea of participating in the program. When the week for tryouts came around, we started with soccer. Unfortunately, I was disqualified less than five minutes into a game when the instructor told me I had no idea what soccer was. Next, I joined the volleyball team and again was disqualified. This time around, the instructor was nicer; he informed me that I was too short and that the team was looking for taller students. The javelin throw was a sport I had never seen before, and once again, I failed miserably while attempting a throw. After several attempts to qualify in different team sports, I finally agreed to run the hundred-meter dash, thanks in part to my experience running in the hills back home. But this sport didn't interest me either. Quite frankly, I couldn't see what the point was.

That's when I decided to steer my efforts instead toward cultural programs. I requested a meeting with the choir teacher, but she told me that she was going to visit every classroom to listen to students sing, and she would listen to me then. When she came to my classroom, I was prepared to sing a salute to the national flag. My confidence stemmed from my loud singing back home, but unfortunately, my previous experience didn't help. When I started singing the part that goes, "Long live and prosper my flag, my tricolored flag," the teacher covered her ears and frowned. She expressed her disapproval by saying, "No, no, no," and using a very sweet tone of voice, she said, "next." From that moment on I disliked this teacher and took delight in causing mischief during our singing lessons. I'd make sure that when singing my D, C, E, F, G, and A notes that they were heard above the sound of my

teacher's piano playing. If she caught me doing this, she would hit the palms of my hands with a wooden ruler.

Regardless of a few bumps in the road, my search to further develop my underlying artistic talents continued. After all, my grandfather was a musician who played the lead trumpet in the town's band, so I must have inherited some of that talent, right? But I didn't. Finally, I did find something that captivated my interest—reciting poetry. When I first tried out, the teacher said that I had big lungs and that declamation was suitable for me. In fact, she said I was good at reciting "epic and patriotic" poetry. I'd practice body language and gestures every afternoon, including hand movements, enunciation, and general body language. All these elements would in turn be incorporated into my poetry recitals.

Weekends were something I looked forward to because on Fridays after school, I'd head for Aldama 22 to sleep and prepare for my Saturday and Sunday newspaper sales in the early morning, and then apple sales in the market the rest of the day. I thought the market was extraordinary; it was a place where I could eat anything, from local food dishes made for the working folk to extraordinary delights. The market food was cheap and abundant. For the most part, when I was in the market, I was a kid lost in a fantasy created by none other than myself. I stood immersing myself in the smells emanating from the portable stoves grilling jerked beef and tripe over charcoal, with a meat-filled tortilla in each hand and enjoying every bite. I knew I wouldn't eat like this again until the following weekend. That would mark the end of my Sunday afternoons, when it was time to return to the boarding school and continue the weekly routine.

The school year ended in November, and I had completed the fourth year of basic studies. Unlike the other students, I wasn't able to return home because my parents would not permit it. They preferred that I stay in the city and earn enough money to buy myself some clothes and simple necessities. They continued to write, asking that I send them packages of fruits and vegetables. Throughout the school break, I sold newspapers in the morning and apples at the market while sleeping at Aldama 22.

BACK TO SCHOOL

In January of the following year, 1956, I returned to the boarding school for the fifth year of basic studies. During the first week of school I was told that

my peers knew I had spent my time off selling newspapers and apples at the market, but I denied it. Instead, I told them that I had gone to the coast, bathed in rivers of crystal-clear water, and gone hunting with my father and some friends. I also mentioned that he had given me a horse as a reward for my high grades. I thought this fantasy that I had conceived in my mind was quite extraordinary. Clearly, I had acquired one of my mother's coping behaviors, which always guided us along our feeble path. My story sounded plausible, and people most likely believed it given the way, I thought, it had been perfectly phrased and so convincingly recounted. As you can probably already tell, I was quite a storyteller as a boy, and I told my stories with quite a dramatic flair.

I found the fifth year of basic education incredibly boring. We had a teacher who was overweight, short, and bald, and we could tell he drank a lot because he smelled like tequila all the time. The students didn't feel much enthusiasm toward his class, and neither did he. In fact, more than once we found our teacher nodding off at his desk after lunch. Whenever this happened, we'd sing a line from "Las Mañanitas," by Vicente Fernández: "Wake up, my dear, wake up, look its already dawn." But he couldn't care less; everything was a joke to him. He used to complain about how the other teachers didn't like him and how they all thought they were "hot shit," but he felt he was doing the right thing since he was carrying out his civic duty as a teacher.

There weren't many noteworthy events that year either, which added to my boredom. I continued to attend the poetry lectures. They were the only opportunity I had to develop my artistic talent, which I did with great intensity. Unfortunately, I was never selected to represent the boarding school during state competitions, not even as a backup.

Halfway through the school year, things took a terrible turn. One morning we left the school as usual, and while marching to Ixcotel, I suddenly saw a bus turn and heading directly into our path. I yelled a warning and jumped out of the way, knocking down a doughnut stand. Most of the students didn't see the bus coming, and approximately fifteen were injured; one of them suffered a devastating leg injury. Our old rifles were strewn everywhere around the victims, and it looked as though a war had been waged on that spot. There was blood everywhere, and the shocked faces of the students evoked a sense of desperation among the witnesses of the accident. It is surprising there were no fatalities. The doughnut vendor made me pay him two pesos, which was all I had, for the damage that I had done to his stand. Afterward,

we returned to the school with great sadness and gathered in the courtyard. The principal told us that we were not allowed to discuss the tragedy with anyone outside the boarding school. I never found out what became of the severely injured student, but I believe his parents took him home.

One day, as things were running their usual course, there was the blaring of the bugle and then the announcement for the students to line up in the courtyard. Not long after, the principal formed a group among the staff members. This group was charged with conducting a search of our belongings. They asked us to place our belongings outside in the courtyard, and then they proceeded to examine every single item. I didn't know what they were looking for, but rumor had it that a couple of wristwatches were missing, and that they had to be somewhere inside the school. The two missing watches were indeed found along with other completely unrelated items among the students' belongings. I heard that the school authorities found more than what they were looking for and accused many students of theft. After that, instead of being called by their name or number, those students were known as ratones. That was probably the punishment that the staff imposed on students who took things that didn't belong to them.

While on the topic of placing our belongings outside, we got used to doing that every other month for another reason. They had to fumigate our dormitories with DDT to get rid of all sorts of insects, including bedbugs, fleas, lice, and other pests that the students harbored. This was also typically done when students returned from their vacations in their home villages, as these pests traveled back to school on them or in their luggage.

Activities at the boarding school continued as usual. The staff members were often absent, and so their jobs would be assigned to the students. There was a certain interest in students doing the work that the employees didn't like doing, such as cleaning the grounds, helping in the kitchen, working in the bakery, and doing laundry. All these tasks were not officially assigned but instead the school would ask for student volunteers. I was always more than willing to help with the baking because I could eat as many bread rolls as I pleased. Years later, an article appeared in the newspaper shedding light on the recently discovered child exploitation that had taken place at the boarding school. Fraudulent dealings had been found everywhere, from the purchase of the soap we used to our uniforms, textbooks, and food. Even the employees' salaries. I'm not sure how this issue was resolved, but it was unbelievable since I thought the school's operations had been tightly controlled.

The school year finally ended, and I had received high grades. My parents were pleased to receive a letter from me describing my academic achievements. That year's report card was probably the best I had ever gotten in my entire academic life. No doubt this was probably due to our "boozy" teacher, who had either been too lax or simply decided against grading the exams that the students had turned in. Many tears were shed along with goodbyes as the school year came to an end, even though we would be back in two months. I bid farewell to a few of the friends I had been able to cultivate. We promised to write to each other and send post cards, neither of which was carried out. During these vacations, I was once again denied the privilege of returning to my hometown, since according to my parents, "it doesn't seem like the proper thing to do."

As I left the boarding school to take up my sleeping quarters in the tool shed at Aldama 22, I was surprised to find that the fabric merchants had moved out of their quarters and returned to their hometown. Again, I had no place to sleep, but this time I was familiar with the zócalo and was starting to know my way around the city a little better. Knowing that Aldama 22 was no longer available to me, I was once again back to square one, looking for a place to live during the school break.

I recalled that someone had mentioned a place referred to as La Casa Fuerte where students could rent rooms. The building was quite impressive. It had a large courtyard and had been used as the customs house during the Spanish-colonial period. The entire structure was built of green cantera stone, and its giant stairs with huge landings gave it a medieval feeling. I went there, gave the landlady my basic information, and was assigned a room to share with another student for two pesos a night. The rooms at La Casa Fuerte were huge and had very high ceilings. The toilets, located in the area where shipments and other taxable merchandise had been inspected in the past, seemed like they were two kilometers away from the main courtyard. Not having showers was something I easily overlooked, as there were affordable public restrooms with showers nearby. Señora Petrona could not have been a more fitting landlady. I can recall her stern voice when she wanted things done a certain way or when we were not following her rules.

My stay at La Casa Fuerte was short because soon after moving there, I had the blessing of meeting a family that lived at Libre 10 in the Merced neighborhood. They told me I could stay with them and that I was no bother

to the family since, in addition to the petate that I used to sleep on, all my possessions could fit in a single small cardboard box. I kept my job at the market selling apples and sold newspapers and magazines throughout our school vacation. I was able to finally save some money. I continued to live at Libre 10 on the weekends during my last year at the boarding school.

MY LAST YEAR AT THE BOARDING SCHOOL

My sixth year of basic studies marked the last year at the boarding school. I had a good teacher who was quite charismatic and had an extraordinary sense of humor. His name was profesor Manuel Bustamante Gris. He played the piano, and in fact, he played so well that he later went on to form his own band and became famous in Oaxaca. His band was known as Manuel Bustamante Gris and Company. During the first week of school, he tested everyone's voices to select a few singers. I sang, "little bit, little bit, little bit of mine," and hadn't finished the song before the whole class was cracking up, and my teacher was unable to speak because he was laughing so hard. Obviously, once again I was not picked to sing in the choir.

Somewhat later, though, I was selected to attend a special event at the Benito Juárez Autonomous University along with some other students. That day we excitedly changed into our military uniforms and started marching toward the university. As we entered the front doors a statue of Benito Juárez holding the Mexican Constitution in his hand was in the main courtyard. As I stood in front of him, Benito Juárez seemed to speak to me on a very personal level, underscoring that the fight for justice and peace had not ended and that discrimination lives on. Indigenous people are an easy target in Mexico. That night I realized that Benito Juárez was one of the heroes from our race of the bronze people. And that precise notion was part of a poetry piece that I would recite at a future ceremony.

During the program we sat in front of the statue of Benito Juárez. That night is almost indescribable. I will never forget the poise of the speaker, the respect he generated, and the content of his speech, in which he so eloquently commemorated this Indigenous leader of humble beginnings. At the end of the event, we marched back to the boarding school. Later I told my classmates that one day I would be studying there. They found that quite

amusing and one even went on to say, "Dream on, this school isn't for poor kids like us." I responded by pointing out that "Benito Juárez was Indigenous and poor." "But you are not Benito Juárez," murmured another one.

I didn't sleep well that night as the honorable Benito Juárez was in my dreams. He was a Zapotec from Guelatao to whom we had paid homage to that night. I asked myself, "Why didn't we have any Indigenous people like Benito Juárez in my hometown?" I remembered my grandmother used to tell me that there were "important men" in our community at one time but then came the "bad times," when the Spanish came and attacked our ancestors for their gold, killing people on the spot if they demonstrated any acts of bravery. Subsequently, from that moment on, Benito Juárez became the hero that I would look up to. Even though he was Zapotec, and I am Mixtec, I knew my grandmother would not find it difficult to accept him.

The school year was coming to an end, which marked my graduation from the sixth grade and the end of my boarding school education. Everyone looked forward to the end-of-the-school-year event, and for the first time in my life, I saw my name printed on an elegant program listing the poem

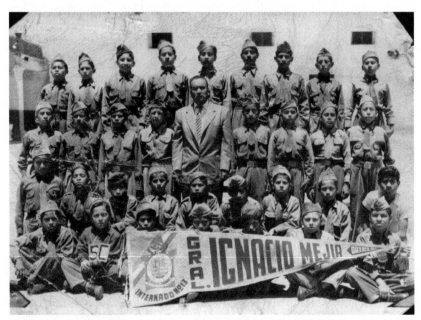

FIGURE 7. The graduating class of the Ignacio Mejía Boarding School, No. 13. Federico is third from the left in the top row, 1957. Photographer unknown. Jiménez Family Collection.

"Raza de Bronce" (The Bronze Race), by Amado Nervo, that I'd be reciting. The fourth-grade teacher was right when she said I was good at "epic and patriotic" poetry. I remembered her telling me how reciting the lines from various characters consisted of using a different intonation for each one. "I am Ilhuilcamina, I am Nezahualtcoyotl, I am Cuauhtemoc." I uttered these names, exalting some of the most outstanding leaders from the pre-Hispanic era. Being able to portray them was an honor because they were courageous leaders and died protecting their values and the freedom of their people. When my poem ended, I was overwhelmed by a wave of applause. I wasn't sure whether it had been out of common courtesy or because I had recited it with such passion, enthusiasm, and eloquence.

I was quite surprised by how quickly the ceremony had come to an end. My classmates and I hugged and cried and told each other that we'd write or keep in contact some way. The classic Carlos Gardel ballad "Adios Muchachos" resounded from the speakers, and we all sang along. Not long afterward, we found ourselves outside the school building in search of our futures. Our basic education had come to an end.

II

FINDING NEW WORK

AFTER GRADUATION FROM THE SIXTH grade in November 1957, I applied to attend classes at the Benito Juárez Autonomous University of Oaxaca. Originally founded on January 8, 1827, as the Oaxacan Institute for Arts and Sciences, the university initially offered a wide range of degrees. Under Governor Major General Vincente Gonzales Fernandez, the Institute of Arts and Sciences was granted autonomy in 1943. It was elevated to university status on January 18, 1955, by General Manuel Cabrera Carraquedo.

The term "high school" in Mexico corresponds to *preparartoria* or *bachiller-ato*. The Benito Juárez Autonomous University offered a high school program as a University Incorporated School for students aged fifteen to eighteen. I was accepted in preparartoria, which consisted of three years of education, divided into six semesters. It provided vocational training so that graduates could find employment as skilled workers, for example, as an assistant accountant, a bilingual secretary, or a technician. The first semesters focused on a common curriculum, and the latter ones on the degree specialization.

To attend classes at the university, I had to figure out how to make more money on the weekends to support myself and to pay for my classes. I knew that my studies and life at the university would not give me enough time to work as I had while in boarding school. I also had reached a new social status, a new level of intellect, and many times I had to ask myself whether I could

make it as a university student. I had a fervent desire to show my parents, and mainly everyone back home, that I would become someone important, a scholar. I stopped selling newspapers, magazines, and apples altogether but had difficulty finding the right kind of employment. Finally, a lady at the market offered me a job selling rebozos, and I couldn't complain; at least it paid more than my previous jobs. She said she would pay me well, but first, I had to prove my skills through two weeks of unpaid labor so I could be trained. The training consisted of offering customers our merchandise in a unique fashion.

The market had a section of rebozo stands where the sellers were very competitive. When someone passed by, I would throw a rebozo over their shoulder, be it a man or a woman, and then I would point out the quality of the rebozo's fabric and beautiful designs, as well as its fine stitch work. I would expound on the benefits of the rebozo, praising its functionality and everything you could do with it. I would end my sales pitch by folding the rebozo, making a zipping sound with my mouth. In one last attempt to lure the potential buyer, I would demonstrate that the rebozo was as rigid as a wall, long as the time of Lent, and as wide as the Calle Real. I would then add that the rebozo could withstand the curse of an ancient priest and was impenetrable even by a bull's horn. By this time, the customer would be completely mesmerized or totally confused, and we would proceed by negotiating a price. At the end of the purchase, the buyer would walk away wondering whether he or she had gotten a good bargain. The secret to closing a sale was really based on bartering. When initially stating a price, we would ask for twice the amount we were willing to accept. Some customers wouldn't buy anything, but they lingered just to be entertained by my sales persona as I recited the exaggerated benefits of the rebozo. At the end of the day, I would be paid whatever the owner thought was a fair wage for the number of rebozos I had sold that day.

Once again, I had to find new living arrangements. When the couple at Libre 10 realized that my stay would be permanent, they asked me to find another place to live. They said they already had a son, and that I was too old to be adopted. With the money I had saved up while living with them, I was able to rent a room at Murguía 38, which was around the corner from Libre 10. I bought a folding bed along with a small table to furnish my tiny room. I put the radio that my father had sent on the table. He had won it with a coupon he had found in a box of matches, but he couldn't use it back

home because there was no electricity. There was a sink in the courtyard just outside my room, along with an *anafre de cárbon* (small barbeque-style stove that was heated using coal) that I cooked on. That's all I needed. The rent for this room was fifty pesos a month. I enjoyed living in my small room on Murguía even though I never knew if I was going to have enough money to pay the next month's rent.

MY FIRST DAYS AT THE UNIVERSITY

I was now sixteen years old and ready to continue my education. I was enrolled in a special private accounting degree program at the Benito Juárez Autonomous University. On my first day at the university, I was feeling very important, and on my arrival, I went right up to the statue of Benito Juárez and said, "I am poor just like you were. I am Indigenous just like you. I, too, have been a victim of discrimination. I have the same eagerness and ambition you had to succeed, and I admire the path you followed. Please enlighten me with your wisdom."

My emotions were running high, and it felt as though the statue was about to reply when suddenly I found myself surrounded by a group of students. One of them pulled me by the hair while others held my arms back. The student who pulled my hair was now cutting it with dull scissors. "Now he's a *macoloche*," he said. That was the term given to the new students at the university. They led me to the zócalo, where they made me take off all my clothes except for my underwear. Then they made me run around the zócalo three times before going on to the next stage of the hazing ceremony. They ended by throwing me into the fountain. I had heard from others that it was best not to fight the hazing as the repercussions could be severe. In fact, two weeks later, I witnessed this when another macoloche, who had bloodied the nose of one of the students as he fought back, was forced to drink out of a spittle-filled cup that had been retrieved from a restaurant by the student with the bloody nose. Other macoloches got their heads shaved and black tar smeared all over their heads and faces. I asked myself why new students must go through those barbaric practices at such a distinguished and noble institution of higher learning? It turned out that this hazing was an initiation process that all new students were subjected to. Once you passed all the ridicule and embarrassment and you were accepted, which I was, what a difference it made.

One of my first classes at the university was an English class taught by profesora Mariela Morales, whom the students referred to as the "teacher." She must have been fond of me because she offered me a job cleaning the floors at her house, located at Matamoros 307, a house that interestingly I now own and is currently the home of the Belber-Jiménez Museum. Profesora Morales was expecting some guests from the United States and wanted the house to look nice. Afterward, this became a regular job for me, and every Saturday I would clean my teacher's floors. On one of those occasions, one

FIGURE 8. Federico marching in an Independence Day parade with other students while attending the Benito Juárez Autonomous University, 1958–1966. Photographer unknown. Jiménez Family Collection.

of her guests, an elderly American man, started talking to me. Our conversation seemed to go on forever with his incessant line of questioning. When I saw him again a month later at my teacher's house, he told me that he was interested in helping me pursue my education. He said he would sponsor me with a monthly scholarship of twenty American dollars, which back then amounted to two hundred and fifty pesos. The caveat was that I study the shortest degree program they offered, because he wanted to live long enough to see me graduate.

My sponsor's name was Jacob Gutknecht, and he was from Ocala, Florida. If I were to describe him, I would say that he was wise and a pleasure to engage in conversation with, although at times he seemed somewhat impatient. He would tell me about his travels and said that out of the many countries he had visited, there were only two that he would go back to. One was Mexico and the other was Argentina. He talked about some of the business deals he had closed with investors in Argentina.

Years later Jacob confessed to me that I had captivated him with my enthusiasm and confidence as I told him the story of my life. I also reminded him of his late son, Frederick, who had died during World War II. Frederick was constantly in Jacob's thoughts, and after his son died, Jacob made a series of trips to Latin America in search of spiritual peace. He wanted to turn his grief into social work. Jacob became like a grandfather to me. He would write long letters encouraging me to study hard and to avoid being sidetracked by other activities, more specifically drugs and alcohol. His letters also expressed much kindness and concern for my future, and his occasional reprimands made me feel like we were family.

When I found out that my accounting degree was going to take four years to complete, Jacob agreed to sponsor me with the previously mentioned scholarship of twenty dollars a month, as long as I completed the course of studies and graduated. My views about life had entirely changed by the pact we shared. Every month I paid my fifty pesos for rent. I was now able to eat regularly at the Merced Market eateries for about three to four pesos a day and still have enough money left over for textbooks and new clothes.

I was finally able to say goodbye to working at the market—goodbye rebozos accompanied by my poetic verses. Goodbye apples, newspapers, and magazines. I was no longer going to be ridiculed by my classmates for wearing shoes without socks. My lack of socks was not a fashion statement, but instead it was out of poverty. I was now a decent-looking young man. My

future had been forged. I was able to create a world of my own as a scholar, as I could now dedicate time to studying without so many distractions or worries. Now I studied at the library along with the other students.

It had been over three years since I had left Tututepec. With the money I was earning cleaning profesora Morales's floors and the monthly stipend I was receiving from Jacob Gutknecht, I was able to purchase a plane ticket to fly home for a week to visit my family during my first year at the university. Even though it seemed as if nothing had changed, it felt strange to be there. Many of the emotions I had felt when I left resurfaced. In particular, the emotional pain, the humiliation, and the loneliness. I was very discreet and either stayed at our house in town or went out to our land in the countryside. I didn't want to see anyone in town and certainly didn't want to be a source of their gossip and finger pointing. Interestingly, any thoughts of returning to Tututepec after I finished my course work at the university vanished. I realized that I could never go back there to live. My years away from Tututepec, learning to fend for myself, and receiving a formal education had changed me.

For the first time in my life I felt like a man, fully aware of the events that had shaped my childhood and early youth. I was also at the point in my life where I wanted to experience what it was like to be with a woman in a sexual way. At school a book with pornographic pictures, *Pan de Cada Día*, was circulated among the boys. So, one night after reading through this book, some of my school buddies and I decided to seek out a prostitute. About nine of us went to the red-light district in the city, and when we arrived at the area known as La Calle del Pecado (the Sinner's Street), we walked all around before deciding which prostitute we wanted.

We were all inexperienced, and one of us had to go first and then come back and tell the rest us about his experience. We couldn't agree on who would be first, so we tossed a coin, and the winner went first. He came back with the news that everything was satisfactory. He told us that there were two prices—one was three pesos for hot water and two pesos for cold water. He said, "She was very sexy, and I had a good time." He approved of everything they did, so we all got in line to use the same prostitute. Looking back at that experience, we had no knowledge about the consequences of not using protection or the possibility of catching some type of sexually transmitted disease.

I now felt more confident and had the courage to ask a classmate to go out on a date, hoping to become more than friends, and even to pursue marriage.

I dreamed of going for a stroll through the El Llano Park on Lent Fridays, where I would shower my girlfriend with the largest bouquet of roses I could find as a token of my love and passion. I was looking for someone who would accept me for who I was at that time, as I felt that I had changed my social status and no longer wanted to be seen as a poor Indigenous man. I saw these two defining attributes as social barriers that would prevent me from marrying into a mestizo family with a name from the Old World, the type that would impress the common folk, whether rich or poor. I yearned for a wife who would further my economic status and at the same time help me raise a family that could be socially accepted and live comfortably in the city of Oaxaca. I wanted my children to have an easy last name to remember like Otigoza, Candiani, Espinoza, Monteros, or Castillos.

I started keeping an eye out, but as luck would have it, every girl that I found interesting already had a boyfriend or was looking for "Mr. Rich and Handsome." One classmate went so far as to ask me if I had an estate with coffee plantations or large properties so she could determine whether I'd make a good partner. There was a young woman by the name of Hortensia who was the most accepting of me. Unfortunately, our interaction was short lived. I didn't think inviting her over would be such a big deal, but when she saw my little room, she never came back, and our friendship began to fade. All my other relationships were fleeting as well. I couldn't find the right opportunity for meeting the girl of my dreams, one who was rich and had a recognizable last name. I clearly was not having much luck in this area of my life, but I kept trying.

A TRIP TO THE CAPITAL OF MEXICO

Profesora Morales had become quite fond of me. Maybe she saw something in me that sparked her trust, as she was always very kind. One day when we were discussing Mexico's history with much enthusiasm, I told her that I had never been to the city that she spoke of, the one she referred to as the "The City of the Palaces." I told her that I was only familiar with Mexico City through the history textbooks I had read. She couldn't believe this and didn't say anything else, so I assumed that our conversation had been point-less since I had never been to Mexico City. But I would soon find that I had been wrong.

One day after class profesora Morales summoned me to her office. It turned out that she was also the university rector's secretary. As soon as I walked in, she asked, "Do you want to go to Mexico City and get to know the capital? If so, we will leave on Sunday night for a work trip with the rector, Dr. Federico Ortiz Armengol." Excitedly I accepted, and when Sunday came around, we all met at the train station. Shortly after boarding the train's second-class section, I found a seat where I slept for most of the night.

Once in Mexico City, we stayed at the home of profesora Morales's sister, whose nickname was Telera. I never got to know her real name, but I remember that she was a very nice lady. During the trip, I spent only one day working for Dr. Ortiz Armengol. It turned out that he had to take care of affairs pertaining to the university at various locations throughout Mexico, so the following day, profesora Morales said, "You are free to go now. We will return in five days. Mexico City is yours to roam."

For a couple of days, it felt as though Mexico City had indeed become mine. After waking up early and eating breakfast at Telera's house, I excitedly began my exploration of the capital of Mexico. I wanted to experience firsthand everything I had learned in my history textbooks pertaining to this magnificent city. I visited the tree of La Noche Triste (The Sad Night, or the Night of Sorrows) in Tacuba Plaza. I imagined Hernán Cortés engulfed in sorrow as he wept at this tree and regrouped after his defeat by the Aztecs at Tenochtitlan in 1520. I was astounded by this historic relic of a tree.

My next stop was the Castle of Chapultepec. As I stood in front of the statues of the Niños Héroes, I was reminded of these six Mexican teenage military cadets who died defending Mexico and the castle from invading United States forces at the Battle of Chapultepec on September 13, 1847. During the Mexican-American War the castle had been a military academy and legend has it that in an act of bravery, one of the boy soldiers, Juan Escutia, wrapped the Mexican national flag around his body and jumped from the top of the castle to keep it from falling into enemy hands. At least that is what our teachers told us at the boarding school. The Niños Héroes are celebrated annually during a national holiday held on September 13.

Tepeyac Hill came next. It is the famous landmark where Juan Diego saw the Virgin of Guadalupe multiple times, and on the last apparition she performed the miracle of imprinting her portrait on his cloak. I then reached the tallest building in the city, a skyscraper called the Torre Latinoamericana. There was an admission fee of three pesos, which I gladly paid to have such

an impressive view of the city. Then I went to the Museo Nacional de Antropología, which was something I had always dreamed of doing, and here I walked through the halls full of antiquities and historical cultural objects on display.

I also marveled at the city gardens, lush with roses, and the traffic islands replete with lilies and irises. I ended my tour at the city's main square, the zócalo, where I visited the National Palace and admired its colonial architecture, and the Metropolitan Cathedral with its baroque architecture. I also had the opportunity to see the section of the pre-Hispanic Aztec Templo Mayor that had been exposed by archaeologists. Over the decades much more of the magnificent city of Tenochtitlan, which was buried under Mexico City by the Spanish, has been uncovered. The city was very clean, and at the time, some people even called it the most crystal-clear city in the world.

After a couple of days in the capital city, it was now time to return home. Even though I was tired, I was extremely grateful for the opportunity to get to know some of the most important historic parts of the city. For weeks after my arrival back in Oaxaca, I kept reliving the wonderful experiences I'd had in our great capital and willingly shared them with all my classmates at the university.

THE INFLUENCE OF A GREAT LADY

During my first year at the university, I met a very special woman, Arcelia Yañíz, who made a difference in my artistic and social life and was instrumental in my professional development as well. I was around seventeen years old when I first spoke with her, and she told me that to succeed I had to first hone my social skills, starting with my Spanish because according to her it was dreadful. I would have to drop the small-town coastal accent and begin to arduously practice my diction. These were among the first words that Arcelia said to me the day I went to the Fine Arts Palace to enroll in the oratory and poetry classes offered through the university.

She attentively helped me through the interview process and gave me a voice test, which consisted of singing. When I sang "La Cucaracha," by Nora Galit, she kindly fixed her eyes on me, and when I finished, she asked me to recite something I had previously memorized. "This lady just wants to keep laughing at me," I thought. I could see it in her smile, but I couldn't have

cared less, so I recited "A Bohemian's Toast," a poem by Guillermo Aguirre y Fierro that I had learned at the Ignacio Mejía Boarding School. This was the first time I had recited it because one of my teachers there had barred me from ever delivering it. He pointed out, "If the speaker does not cry when performing it, he will fail at conveying its emotion." Bearing this in mind, I began to cry when I reached, "Comrades, I toast to my dear mother, to my mother, my holy mother." Arcelia looked at me with a hint of confusion, and she said, "Don't cry, goodness gracious, too much emotion! You're a mess, but you have potential. You have the emotion, but your diction is terrible. Your coastal accent will get the best of you, and your hand-eye coordination is terrible. Luckily your concentration does help, and like I said, your voice isn't bad." I felt I had failed, and I said, "Teacher, I want to improve. Please help me to succeed." She agreed and said, "I will help you, but you need to have a lot of discipline."

That marked the beginning of my training with Arcelia Yañíz, and I happily completed all the work she assigned. I never missed any of her lectures, and I paid attention during every performance we attended. Her lectures consisted of analyzing speeches that had been given or poems from our textbooks. I learned about voice, diction, emotion, hand gestures, authenticity versus falsity, enthusiasm, and concentration. She told me to listen to the leaders of the university, especially Adelfo Jarquin, Nicolas Castellanos, Raúl Bolanos Cacho, and some others who had been trailblazers as Oaxaca orators.

Standing before an audience and speaking is no simple task. Arcelia told us during a lecture, "The Greeks said that an audience is like a thousand-headed beast. Build a wall between you and your audience." After several months of practicing, I now felt prepared for my debut recital of a poem that Arcelia had recommended. The presentation was part of a program that took place at the Plaza de la Danza (Center for Dance). The Plaza de la Danza was situated in the central part of the city, which is rich in colonial architecture, where sounds echoed off the walls from the Basilica de la Soledad and the Convento de San José. The School of Education and adjacent buildings at that time complemented the Plaza de la Danza.

The program began at seven o'clock in the evening, and by half past six the seats were filled with hundreds of people. The place resembled an open Greek amphitheater. When I heard my name being called out, I walked on stage and began reciting "Corrido de Catarino Maravillas," a poem by Miguel N. Lira. When I reached the part where I said, "Domingo, is the bread ready?"

someone from the audience yelled, "The tortilla, you fool." At that moment I pictured the beast of a thousand heads that Arcelia had mentioned. It was my debut, and I was not about to let anyone overshadow it. Jokingly, I repeated the line "Domingo, is the tortilla ready?" In the end, I was surprised to see everyone in the audience clapping. Feeling great satisfaction, I took a bow and thanked my audience. The applause continued until the announcer introduced the next act. Arcelia was the first to congratulate me, and she embraced me tightly. It felt like a rite of passage. It was the first time I had spoken before a public audience, but it made an important yet unusual mark in my path. Maybe I will come to understand its significance someday.

Over time my mentorship with Arcelia grew stronger. Her house at Garcia Vigil 25 was part of my daily route from my rented room to the university. It was a safe place, and she had treats for all her guests. I mingled with the artists who also spent time there. Among Arcelia's guests were Juan Herrera, Rodolfo Morales, Edmundo Aquino, Virgilio Gomez, Enrique Audifredd, Alejandro Mendez, Rodolfo Alvarez, Socorro Merlin, and Martha Unda.

Garcia Vigil 25 was referred to as the "House of the Monsters," with Arcelia being the mother of all us "monsters." Our group became famous during an important time in the development of Oaxacan arts, culture, and society. Those of us who were the "monsters" had the opportunity to be enlightened by Arcelia's teachings, and we also benefited from the support and friendship she shared, which made a huge difference in our lives. She didn't hold a degree from a prestigious university; rather, she was a woman of pure and natural talent who was willing to share it to enrich her community. She played the role of a grandmother, mother, friend, girlfriend, wife, and adviser to many. She has since attained a high level of recognition in Oaxaca. To me, she was the woman who practically adopted me without expecting anything in return. Her only goal was that I flourish as an individual, and possibly she regarded me as a special challenge. She had a strong influence on the direction that both my life and my career would take over the next couple of decades.

Arcelia helped me find my inspiration through the performing arts, through poetry and traditional dancing. She used to give me roles to play at the Casa de la Asegurada, which operated under the auspices of the Social Security Department. I made my debut in a play that I wrote, *A Stone in a Shoe*, where I discovered that as far as acting was concerned, I had a long way to go and needed much more practice. That's when I decided to dedicate my

FIGURE 9. Federico reciting poetry during the commemoration of Benito Juarez's death in El Llano Park, ca 1961. Photographer unknown. Jiménez Family Collection.

talents to poetry. My strength was in patriotic poetry. I would proudly recite such poems at the El Llano Park honoring the heroes of the Americas. This was one of many public poetry recitals that I would give throughout the late 1950s and early 1960s.

On March 21, 1961, the day that Mexico commemorates Benito Juárez's birthday, I was invited to his birthplace, Guelatao, to recite a poem before Mexico's president Adolfo López Mateos. The poem I recited was titled "A Juárez Immortal," by Sara Malfavón. This was the first time I shook the hand of President López Mateos. On another occasion, I had the pleasure of accompanying the president as we walked from the university to the Monte Albán Hotel, where he was attending a dinner event in his honor. When we arrived at the hotel, I went to excuse myself, but President López Mateos asked me to stay so I could listen to his speech. I didn't have a reservation but luckily, I ran into a classmate who invited me to sit at his table, and I was able to stay and hear his speech.

Throughout this period, many of my successful endeavors were the product of Arcelia's mentorship. We were so close that people would confuse us for mother and son, and truthfully, in many ways I did feel as though I was

her adopted son. I always had a lot of respect for her children, even though they never accepted me. They also needed Arcelia's attention, but her many social commitments would sometimes interfere with her time with them. She was way ahead of her time, and she was both wise and well known. She taught me to work for my community's betterment without expecting anything in return. She opened my eyes to Oaxaca's multilayered society and its cultural diversity. She always insisted that the best recourse was to remain neutral in all battles; that way you could avoid problems since they always had both negative and positive sides to them.

I will never forget the day in 1996 when Arcelia publicly recognized me as her "spiritual son" in front of an audience of seventy-five hundred people at the Los Angeles Convention Center in California. She was being honored as the Woman of the Year by the Mexican American Opportunity Foundation. Indeed, to me she was my spiritual mother. Her influence has been extraordinary throughout many of my life's most important decisions. Whenever I wasn't sure about something, I consulted her, and she always showed me the right path to follow.

12

A SURPRISE VISIT

M Y MOTHER DECIDED TO COME to Oaxaca City in 1958 for a surprise visit. When I greeted her at the airport, I saw that she had flown in on the same small plane that I did when I left Tututepec. When we saw each other, we embraced, and our bond was as strong as ever. Even though my mother was tired from her trip, we talked most of the night about everything that had happened since my visit to Tututepec a couple of months before. I was more than eager to hear about everyone in my family and all the gossip. Then the conversation took a somber turn. She told me that even though my father was still working for Dr. Mendieta, his salary wasn't enough to cover the growing family's expenses. She said, "Without your help these last few years, our economic situation has gone from bad to worse, and I'm afraid we might die of starvation if we don't move somewhere in the next few years." This concerned me greatly, and of course I wanted to help in any way that I could.

To take our minds off our family situation for a little while, my mother and I went on a tour of the city the next day, starting with the Ixcotel and ending at the San Felipe waterfall. We saw many canals, cornfields, and orchids. Afterward, we went to the Fortin Hill, where Benito Juárez's statue stood facing the international highway. My mother chuckled when I told her that Oaxaqueños often said that Benito Juárez was standing there pointing his

finger at the highway leading to Mexico City, saying, "He who does not like my land might as well go to hell." Fortin Hill itself is a favorite place for artists and foreigners, who are inspired by the view of the city's beautiful landscape and colorful architecture. We also went to San Juanito to visit the wailing Christ. According to legend, the statue cries at noon, but even though we waited for hours, we never saw him shed a tear.

My mother stayed for a couple of weeks, and what impressed her most about this city was the Basilica de Nuestra Señora de la Soledad, maybe because of the Holy Virgin Soledad's popularity as the patron saint of Oaxaca. While I attended classes at the university and continued to work, my mother prayed to the Virgin for hours. Sometimes I would go with her and fruitlessly try to make out the words she was uttering. Maybe she was asking the Holy Virgin to fulfill the miracle that the Holy Infant of Atocha had not seen through. Maybe, since the Holy Virgin is a woman, my mother found it easier to express her wishes and emotions. After the prayers, when we laid our heads over the stone on which the Holy Virgin had appeared, we could hear the whispering sounds of the ocean. Now, I understood why they said that the Holy Virgin was the mariner's patron saint as well. My mother invested her time and energy worshiping the Holy Virgin for years afterward.

Many of our outings would conclude at the Juárez Market, where we would buy *tlayudas* (small tostadas) cooked in lard with beans and cheese and a dash of green sauce. Oh, how delicious those tlayudas were! There were other treats as well, such as beef stewed with yellow tomatoes, several types of mole, charbroiled tripe, and of course, the best were the stuffed peppers with ground beef. We used to eat it all without caring if it was good or bad for our health. To top our feast off, we had the famous water-based hot chocolate, an imperial drink of the Mixtec courts. We always drank it accompanied by egg-white bread. What mattered was that we satisfied our hunger, this "old hunger," as my father would call it.

After being dazed by the city, my mother prepared for her return to Tututepec. She noted that I had progressed and was no longer her child with white roses on his cheeks—the anemic boy with an infected scalp. The malaria and ringworm had vanished, and my mother was glad to see my health had improved. She was proud that I was studying at the university. We spent her last night thinking of ways to improve our economic situation.

It turned out my mother's visit had an ulterior motive behind it as well. She surprised me when she said, "Look, go talk to the governor. His last name

is Pérez, just like your grandmother Nabora. Head over to the Palace of the Governor and ask to speak to him. If they ask what the purpose of your visit is, tell them it's private." She then proceeded with her lengthy list of requests: "Once you are before the governor, ask him to help us. Let him know that your father needs work and your siblings need scholarships to attend the boarding school like you did. Tell him that your siblings really want to get an education. I know he will like hearing that. You got that?" I was shocked by my mother's request. I was Indigenous, seventeen years old, and had no social standing in the city. I was clueless as to how I could possibly meet her demands and expectations. Nevertheless, I assured her that I would pay a visit to the governor. My mother no doubt came up with this irrational request out of sheer desperation given the situation back home.

The next day as we made our way to the airport, I could sense an air of uneasiness between us. My mother was immersed in her thoughts and plans for her other children. At the same time, she felt as though she had just discovered a whole new world to conquer. I saw a weary woman with an extreme sense of urgency. When we arrived, the plane was ready for boarding. I began to cry as we said goodbye. She looked at me and said, "Do not cry my son; you will see me very soon. This is not a time for crying." As my mother started to board the plane, she managed to utter one last goodbye, and then she hollered over the passengers behind her, "Don't forget to visit the governor. Let him know that our family depends on his decision. Tell him we won't fail him, and that your brothers and sister want to study, oh, and send my regards! I'll see you soon!"

Several people heard what my mother said and made funny faces at each other. As my mother's plane took off, I started walking toward the bus stop while people kept looking at me, whispering to each other. I wasn't sure what they were saying, but I might have overheard something being said about the governor, which was of little concern to me. All I could think of was this monumental task my mother had entrusted me with. The thought of visiting Governor Alfonso Pérez Gasca alone was enough to strike terror in me.

A VISIT TO THE GOVERNOR OF OAXACA

Several weeks had passed since my mother's visit, and I still made no attempt to contact the governor. After many demanding letters from my mother, I finally decided that I had to go to the Palace of the Governor. The distance between my rented room at Murguía 38 and the Palace of the Governor on the zócalo seemed infinite to me. I had practiced what I was going to say to the governor and then nervously made my way to his office. Just as my mother had predicted, the governor's executive secretary asked me about the purpose of my visit. I responded by saying that my business with the governor was important and private.

I waited from four o'clock in the afternoon until nearly eleven o'clock that night. I sat on an old carved bench that was adorned with initials and words that I never was able to decipher. By then, even his executive secretary was starting to nod off. Finally, I was told that the governor would not be able to see me and that he was going home. Apparently, he was dealing with a health issue and needed to rest. I was disappointed, but I returned the following day hoping to speak with the governor but again was denied. Once again, I was told, "The governor is way too tired again today, and he is going home early to rest."

On the third day, I again returned at four o'clock to insist on speaking with the governor. At around ten o'clock that night, his executive secretary finally opened the door, saying, "Please, come in. The governor will see you now." I was speechless when I approached the governor, to the point where I literally had forgotten what I had prepared to say. I mentioned the important points about finding my father a job and that my siblings were enthusiastic about starting school in the city. I told him who my grandmother was, and he said that he didn't know her. But he asked me questions about my grandmother's birthplace, my siblings, and my studies. I told him that I had five brothers and a sister. The governor noticed my nervousness and said, "People from the coast are usually not so easily intimidated."

Toward the end of my meeting with the governor, I told him that my mother would pray to the Holy Infant of Atocha for his health. I also said that there were a lot of people with knowledge of traditional healing methods back home who could help him, many of whom were curanderos. He bowed his head to express gratitude. He then took a piece of paper and jotted something down on it and told me to take it to the chief of police. Then I was kindly escorted out of the governor's office.

Relieved to no longer be in the governor's office, I ran home after leaving the Palace of the Governor. When I arrived, I sat at the edge of my bed contemplating this encounter I had just had with Governor Pérez Gasca. I felt doubtful and didn't know whether my request had been effective. Regardless of the outcome, I was relieved to know that this matter had been taken care of. With great enthusiasm, I wrote a letter to my parents telling them about my meeting with the governor and how he had given me a piece of paper with something written on it to take to the chief of police. That was all the news I could give them on the matter. In response, my parents replied that they thought that I had addressed the issue in a less than desirable fashion. In their letter, they said that I hadn't explained myself appropriately and that I must make a second attempt to see the governor again in three months. I certainly wasn't looking forward to meeting the governor again and asking him for any more favors!

It turned out that not even a month had passed when great news arrived at Murguía 38. One day, a black limousine drove up and parked in front of the house. Such a high-brow visit got everyone's attention. The official driver of the governor went inside asking for me, and upon finding me, he said, "The following orders have been given by Governor Pérez Gasca. There will be a plane ready to fly your family out of Tututepec and into Oaxaca City this Wednesday morning. Send your family a telegram to let them know." I couldn't believe what I had just heard. What a pleasant surprise! I wasted no time sending the telegram, telling my parents that they would be flown to Oaxaca according to the governor's orders and that they had to be at the Tututepec landing strip on Wednesday morning to catch their flight.

The following day I arrived late to school, and as I sat at my desk, I shared the news with a classmate. I told him, "The governor has ordered my family to fly in from my hometown; he is a distant uncle of mine." The word spread from one classmate to the next, until the whole class was talking about it. When the teacher asked what all the commotion was about, someone said, "The governor has ordered Federico's family to be flown into Oaxaca on a special plane." The teacher then uttered, "I'm glad the governor will do something for Federico because as far as I can see he hasn't done much for Oaxaca." Most of my classmates laughed in disbelief. They said I was dreaming. They said the governor was not my uncle nor was he sending a special plane to fly my family to Oaxaca. I let them know that if they had any doubts about my family flying in on a special plane on Wednesday morning, they could

confirm it for themselves at the Oaxaca airport. I was very excited about being reunited with my family. I was also extremely apprehensive because all I had to offer them was the small room that I was renting. There wasn't enough room for the whole family.

THE JIMÉNEZ FAMILY ARRIVES IN THE CITY

The Wednesday morning of my family's arrival, I woke up very early and rearranged everything in my tiny room at Murguía 38, which didn't take very long since I had very little in the way of furniture and other possessions. I took the bus to the airport and much to my surprise when I arrived, I saw about ten of my classmates there waiting to see the "special plane" and witness my family's arrival. I couldn't believe it. One of them snidely remarked, "We wanted to see the special airplane that was sent to fly in such an important family by your uncle the governor."

Suddenly a plane appeared in the distance, slowly increasing in size as it approached the airport. As it landed, the plane formed dust clouds from the loose dirt on the ground. As we waited for the dust to settle, one of my classmates exclaimed, "That's a cargo plane." I responded by saying, "All planes are cargo planes; the only difference is that some carry animals, and others carry people." The door opened, and my mother was the first one to come out holding my youngest brother, Francisco, in her arms. Then came my father and Claudio, who was holding a box of coconut candy. Ramon held a bald-headed chicken in his arms, which my classmates found quite amusing, and they burst out laughing. Dolores was carrying a basket made from palm leaves that was filled with balls of purple string dyed with caracol. Carlos stood out from the rest as he was holding a cardboard box with little holes that held a green parakeet.

The plane staff carefully unloaded my grandmother's traditional mortar and pestle. Then came the mahogany chest my mother had been given as a wedding present. It had my grandparents' traditional Mixtec clothing packed safely inside. This included my grandfather Adrián's white cotton pants, natural brown cotton shirt, and a belt with caracol and cochineal designs, all of which had been woven with utmost precision and workmanship on a backstrap loom. My grandmother Nabora's backstrap loom and her two *posahuanques* and rebozo were also packed in the chest. One of my

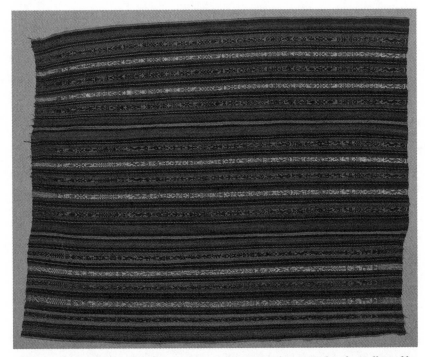

FIGURE 10. Photo of Federico's grandmother Nabora's posahuanque de gala. Collected by Octavia Schoendube. Donated by María Isabel Grañén and Alfredo Harp. #ENR0182. Photographed by Jorge López. Courtesy of Museo Textil de Oaxaca, Mexico.

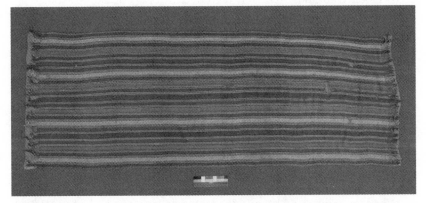

FIGURE 11. Photo of Federico's grandmother Nabora's rebozo de gala. Collected by Octavia Schoendube. Donated by María Isabel Grañén and Alfredo Harp. #REB0101. Photographed by Fidel Ugarte. Courtesy of Museo Textil de Oaxaca, Mexico.

grandmother's posahuanques, the one we called the *posahuanque del diario*, which she wore every day, is now considered a prized traditional handwoven piece from Tututepec. We referred to the other posahuanque as the *posahuanque de gala*, and the rebozo as the *rebozo de gala*, because they were used primarily as formal wear for festivals and ceremonies.

The story of these posahuanques and rebozo is quite extraordinary. My grandmother Nabora told me that during the late nineteenth century, a Spanish general arrived in Tututepec who was charged with overseeing the government's garment exchange program. This program was mandated to promote the assimilation of the Indigenous people. The general summoned every Indigenous person in Tututepec to the town square and demanded that they surrender all their traditional Mixtec garments in exchange for Western-style factory-made clothing. This was during the late Spanish-colonial period, when the government and the church wanted to exploit and convert Indigenous people. One way to accomplish this was by preventing them from wearing their traditional garments, which contained symbolic content and what the colonial authorities considered to be pagan imagery that identified individuals with specific Indigenous communities. All the Mixtec traditional garments were gathered up and burned in the middle of the town square. What a monstrous order! All the traditional garments were lost, but my grandmother decided to save two of her traditional posahuanques and one of her rebozos by sending them to a nearby community called Playa Vieja, where they would be kept safe with my grandfather Adrián's family.

As I looked around, I suddenly regretted my bragging and felt somewhat embarrassed having my classmates there to witness my family's arrival. They criticized the banana bunches, the coconut candy, and the bald-headed chicken my family had received as farewell gifts from friends and relatives. They didn't know that those gifts were symbolic of the social status my parents represented in my hometown. My family members were proud and honored to receive those gifts, and they enjoyed the attention. Between the embarrassment and the hustle and bustle of greeting my family, I no longer noticed my classmates. I was somewhat relieved because what mattered most to me was my family and to know that I was once again reunited with them. I would no longer be alone in the city.

When we arrived at Murguía 38, my landlady almost had a heart attack when she saw the long line of people formed by my family. Everyone, including my father, looked disoriented and confused. My mother, always an

optimist and the strongest member of our family, took immediate control of the situation. Raising her voice, she announced, "This is Oaxaca, where there is much to eat. We must all work so that we can afford to live here. Here we will not die of starvation. With God's will, we will not perish. If we must, we will clean the streets, we will wash dishes, and we will fight to survive. There is no return ticket, or the money to buy one." More than an ultimatum, her words felt like a prison sentence to me. There was no doubt that from that moment on, my mother was in charge of the family. She had plans for my father and all her children, starting with me. The independence I had gained over the past couple of years was quickly vanishing, and I knew that my mother was now in control of my life.

The day after my family's arrival, we stopped by the police station to visit the chief of police with the paper that the governor had given me. When we arrived at the police station, the chief of police greeted us with a smile. He proceeded to ask my father what type of job he would like to have. He also asked about my father's skills. My mother interrupted, saying, "My husband knows how to read and write. He has very nice handwriting; in fact, his brother is the municipal clerk back in our hometown. We are from the coast, and we're also very hardworking and honest people." The chief of police replied, "I am from the coast as well, and a man of honor, I think. I will appoint your husband to a position as part of the secret police. The entire process will take about three weeks. I'll let you know when we are ready." We left the police station, and once we were outside, my mother furiously declared, "Are we going to eat air for the next three weeks? I don't think so. Let's find your father another job!"

The twenty dollars I received monthly from my sponsor was not enough to support all of us. With my father's position in the secret police still pending, he started to get depressed. Just as things were starting to get desperate, my father found a job at the pottery factory. The factory was located on Aldama Street, across from the communal housing complex where I had lived during my boarding school years. I could tell that my father felt overwhelmed; he just couldn't seem to adapt to city life. He also could no longer be the municipal mayor in his hometown, nor a mayordomo or principal for the Mixtec people there. He suffered greatly and longed for Tututepec. He used to say that once the family was "well established" in Oaxaca City, he would return to Tututepec. This dream of his went on until the end of his life in September 1977. My father never got used to life in the city, nor did he ever return to his hometown.

My mother, on the other hand, was of a different mindset. When I got home after a long day at school, she would ask me all sorts of questions about my teachers, my classmates, and my friends. I was still working for profesora Morales. I washed dishes and cleaned the two communal courtyards when she had parties or houseguests. My mother told me to ask profesora Morales if she could help as well with chores around the house. So, to make a long story short, that is how my mother started working at weddings. I helped too. We washed dishes and served the guests, among other things. The weddings were catered, and profesora Morales would let us take the leftover food home for the rest of the family.

FINDING ANOTHER PLACE FOR THE FAMILY TO LIVE

After several months had gone by, our landlady at Murguía 38 asked us to vacate the premises as we were too many people for the small room I rented. She also said that some of the other tenants had complained, especially since we had allowed guests from our hometown to stay in the corridor of one of the dwellings that was not rented out. It was the one with no roof. Initially, we didn't pay much attention to this request because we thought the landlady was just warning us. We tolerated all her efforts to remove us until one day, she cut off the electricity, and we were left with no choice but to move.

We found another place in the neighborhood of Jalatlaco, directly across from some distant relatives. Curiously, we didn't realize that we were related until years later. We hired a man with a small wooden cart to move our belongings, which were minimal. We left Murguía 38 at midnight and walked in single file to our new place. The man who was pushing the cart had the audacity to ask if we had paid our rent, since only people who don't pay their rent moved out in the middle of the night. My mother angrily responded, "We are from the coast, where we are known for our honor, pride, honesty, and hard work. Damn old man, shut your mouth and just keep pushing the cart. If you keep asking questions, we won't get to Jalatlaco until dawn." The entrance to Jalatlaco had a bridge, and once across you would find yourself in an area where four leafy laurel trees stood tall. According to the people living in Jalatlaco, this spot was haunted; they said at night ghosts appeared around the laurel trees. Whenever I passed by that spot, I would keep my eyes peeled, curiously looking for a ghost, but I never saw any.

Our dwelling in Jalatlaco was part of a communal housing complex, and our rooms were much larger than what we had back on Murguía. It was dark when we arrived, and it wasn't until the next morning that we realized how dirty and depressing it was. The toilet was located at the back of the structure and basically consisted of a wood panel with an opening in the middle. There was an enclosure in the center of the street for the sewage to pass through, and the stench was unbearable. The landlord lived on the opposite end of our place, and the prostitutes lived around the area of the courtyard that was adjacent to the street. They worked at the bars and dance halls, where they charged two pesos for a dance and who knows how much more for other services. The clothes lines in this courtyard were filled with undergarments, including a rainbow of pantyhose and brassieres that were once white and now yearned for the sun to return them to their original color. In less than twenty-four hours, we had concluded that we had made a huge mistake.

The prostitutes found out that my mother had a sewing machine and soon started to place orders for dresses adorned with bright colors. As I recall, my mother charged five pesos per dress. These dresses were quite simple. My mother knew she was no fashion designer and that this was done out of necessity, rather than as craft work. I found it funny to see these prostitutes wearing their brightly colored taffeta dresses. They walked the streets looking like traditional Monos de Calenda (giant papier-mâché puppets) in a parade. The dresses my mother made were either red or green, the colors of the Mexican flag, and sometimes even a bright Mexican pink.

Jalatlaco was an important neighborhood during colonial times, primarily because it stood next to the Jalatlaco River. It was the second largest river in the region, the first one being the Atoyac River. The riverbank served as a place for the establishment of tanneries and harness shops, where they sold all types of animal hides. Many of these were still in operation when we lived there, and the urine that was used to tan the hides gave off a horrid stench. The sewage water that ran down the center of the streets into the river added to the stench of the tanneries, making the smell of the whole neighborhood unbearable. I would often arrive at my class with my feet covered in mud and whatever else I had happened to step in.

For the period we lived in Jalatlaco, everyone in the family tried to adjust as much as possible, with much effort focused on overcoming our unhappiness. It was here in Jalatlaco where we truly realized how poor we were.

We had hit rock bottom. Every day was more and more depressing, and to add insult to injury, my mother broke the news that she was carrying a child once again. She was expecting my brother Juan, and I did not take the news well. I confronted her and told her she should get an abortion. I told her it wasn't fair to the rest of us. She pointed out, "God has given me this child, and he will give me enough to provide for this child as he has for all of you. If you are tired of helping us, then leave, get on with your life. You don't have to help us." This was the tone my mother often used to manipulate everyone. She knew that I wouldn't leave, that we were a team and I played an essential part. I had a lot of responsibility as the eldest son and a specific role to carry out as a member of the family. For better or for worse, I was the leader among my siblings and partially responsible for their well-being and their survival in the city.

Life continued like this until one day I was unexpectedly offered a small commercial property to rent from the owner of a butcher shop. She was familiar with our situation and offered this to me one day as I was doing my usual shopping. The property was located on Bustamante Street in the Consolación neighborhood, and living there seemed like a wonderful idea to me. Upon learning that the property was facing the street, I realized that it was also a suitable location to start our own business selling fruit during the day and tacos in the evening. That night I spoke to my mother about it, and we started making plans, dreaming of everything we could do there.

Not long after, we joyfully left Jalatlaco, promising never to return to this neighborhood that smelled like dead animals and sewage. No longer would I have to pass over that God-forsaken river, its stench unlike any I had ever been exposed to. We were now free from this undesirable situation. Again, we rented a small pushcart, but this time we hired a different carrier. He didn't ask any questions about whether we had paid the rent or not; what mattered most to him was the six pesos he was to be paid once he delivered our large items and furniture. He chuckled on seeing us carrying all our other belongings the entire way. It looked like a procession, with the cart in the lead and all of us following as we sang a song we knew from the coast. The singing was my mother's idea. She probably came up with the idea just to cheer us up because we looked like we were on a pilgrimage.

We arrived at Bustamante 41 by midafternoon and unpacked our belongings. This was a relatively easy task since our limited belongings hadn't increased by much. The old Consolación neighborhood was located south

of the city on the way to the airport, and even though it was an old village, it didn't have much history. My mother was pleased to see the Church of the Virgin of the Consolation. What an appropriate name to describe the situation in which we found ourselves. We had faith it would improve through the Holy Virgin's ever-present solace. We were all crammed in a general living area and had no space to cook, so we placed our anafre de carbon outside. Things seemed to be improving. Now we lived in the city, close to the downtown area. The university was only seven blocks away. My classmates used to joke that I lived very far away, "where they pay you to live and give you a dog to take care of you," but I never paid attention to their remarks. Back then, the city was much smaller than it is today.

Bustamante 41 was part of an apartment complex, with many units surrounding a central courtyard. Some of the apartments had only dirt floors. There was a well in the center of the main courtyard, which overflowed when it rained heavily. Sometimes it would take days for the courtyard to dry out. The other tenants were very gracious. The neighborhood might have been poor, but it had a wonderful friendly atmosphere. We were located by the entrance to the apartment complex, but all the comings and goings didn't bother us.

We were now ready to implement the business plan that we had been discussing. We were ready to start selling tacos by setting up the anafre de carbón and a table for our diners. Our plan included a fruit stand by the living room entrance, where customers could purchase bananas, oranges, pineapples, jicamas, and other similar tropical fruits during the day and tacos by night. Three days into having our business up and running, however, we were almost fined by a health inspector, and most of our inventory was confiscated. The establishment was quite scanty and barely worth the inspector's time. He told us we needed a city permit, a property permit, a food safety certificate, and God knows what other permits.

At that point, we were faced with both the beginning and the end of our enterprise. We had no money for the inspector's "cut." He had asked for 150 pesos; instead we offered him a taco and a quesadilla, but it wasn't enough to satisfy the inspector's request. The inspector left our humble diner feeling frustrated because we couldn't pay him. My mother was enraged. "For our next move, we may as well set up a stand and sell marijuana cigarettes. Maybe the Health Department and City Hall won't bother us as much," she concluded. We never resumed plans for a new business.

Right around this time, I was absent from school for three days because I had come down with the flu. One of my classmates, whose Spanish lineage dated back to the old families of Oaxaca, found out that I was ill and came by to visit. He brought me a book as a gift and was surprised when he saw where I lived. As a result, he invited me over for a late lunch at his house a week later. Everything in his house was quite elegant; there were nannies for the children, and maids served us our lunch. After we finished our dessert, my classmate's parents mentioned that they had learned about my living situation and offered to provide me with daily meals at their house. They said their servants would be there to assist me and then added that they felt compelled to "help me." I felt queasy, humiliated, and even depressed, to the point where I almost threw up the delectable dessert I had just enjoyed. I pictured myself vomiting all over the table and the maids meekly cleaning it up. In an attempt not to offend my classmate, I told his parents that I would think about it, that they would receive an answer on Ash Wednesday, but I didn't say of what year. The topic never came up again with my classmate, so I assumed that the family got the hint.

One problem we had was that our landlady, a butcher by trade, was raising pigs in the unit right next to ours, and in the afternoons the heat would intensify the smell of the pig shit. That stench made life insufferable. We begged her to take her pigs elsewhere. Finally, after nearly a month of pleading, she agreed to move them on condition that we also rent that space since it was connected to our unit. We cleaned out the pigpen at once and another five hundred times afterward. We sanitized it with *creolin* and twenty other homemade cleaning products, the names of which escape me. Either the smell gradually faded as the days passed, or we became used to it. We felt more comfortable with all the extra space. Now we had a living room, a bedroom, and a kitchen. We didn't have much furniture, which prevented me from entertaining guests. All we had were two old couches that had been traveling with us from house to house.

All this extra living space that we had was short lived. My father quit his job at the pottery factory and took up a new job on a farm outside the city, in San Martin Mexicapam. Two weeks hadn't passed before I saw half the living room filled with wooden crates and chickens inside. I think this might have been my father's way of getting back at my mother. He loved his hometown, and with deep passion he spoke about missing his donkey, horse, and chickens. He talked constantly about his friends and how my mother had uprooted

him. He regretted the fact that he could no longer go out for drinks with his friends or have intimate encounters with different women. I truly disliked some of my father's ideas, especially the one involving chickens in our living room. When I approached him on the matter, he responded by saying, "At least now we have enough eggs to eat every day." I argued that the whole scene didn't look right. The chickens being caged being one problem, not to mention the noise and the smell, which was just awful. One day my mother finally decided to take the chickens to the market, where she sold them. That was the last time we ever had chickens in our apartment.

One rainy, depressing afternoon, my mother came up with a new strategy. She looked at me and said, "Go see the governor's wife. She is a very thoughtful woman and very kind to children. Maybe she will want to help us." I was surprised and speechless by these grandiose plans that my mother came up with, where once again I was the centerpiece! I couldn't believe this and said, "But mama, I am too shy to ask for favors from the governor's wife." She insisted by saying, "Son, one should be ashamed for stealing but not for asking for help. You have nothing to lose by going." My mother mentioned the governor's wife daily as though señora Pérez Gasca was really my aunt. The notion of paying her a visit slowly started to grow on me, but I was concerned because I had never met this fine lady, and the idea of asking her for help was unnerving to me. Finally, I decided to get over my intimidation and shyness and went to visit señora Pérez Gasca with my mother's request.

On the day that I decided to speak to the governor's wife, I took my books with me with the intention of showing her that I was a scholar. When I was invited into her office, she asked her secretary to step outside so we could speak in private. She had several questions for me, and we spoke about my earlier meeting with the governor. I told her about the special plane he had commissioned to fly my family from Tututepec to Oaxaca City. I even mentioned the note that the governor had given to me for the chief of police. I refrained from saying anything about my grandmother being Nabora Pérez because I felt it was unnecessary at the time. Throughout my presentation and during our subsequent discussion, I felt somewhat intimidated, and I acknowledged that maybe I was asking for too much.

At the end of our meeting, señora Pérez Gasca called her secretary into her office and asked her to arrange for a weekly delivery of provisions, including rice, sugar, coffee, flour, beans, and powdered milk, be sent to my family. She told her to speak to the principal at the Ignacio Mejía Boarding

School so that my brother Ramon could receive a scholarship. The secretary was also instructed to arrange for my younger siblings, Carlos, Claudio, and Francisco, to receive an education as well. Lastly, she told me to contact the chief of police again so that my father could be officially sworn into the secret police.

I left thanking her one last time, and I was so ecstatic that I mustered the courage to offer my help. "If there is anything you need, anything," I said, "please let me know." I made that offer out of common courtesy, but señora Pérez Gasca took it literally. She replied, "Yes, I need you to help with the preparation of the Christmas festivities. It will be hosted at the Palace of the Governor, where we will be collecting donations to help children and families that are going through hardship. You are more than welcome to join us whenever you are not too busy with school." I left señora Pérez Gasca's office in a state of utter ecstasy. I couldn't believe what had just happened.

When I arrived home, I told my family the story in its entirety. I must have spoken very fast because when I finished, my mother asked me to repeat the whole thing, calmly and in more detail. She was curious and wanted to know if señora Pérez Gasca was interesting and whether I had been able to keep my composure during our conversation. I assured my mother that she had been most attentive and gave orders that both granted and set in motion some of the plans we had in mind. Nevertheless, she made it clear that this was just the beginning and said, "Still, you must stay in close contact with this lady, and I will remind you every day if I must. If that's what señora Pérez Gasca said she would do, then we will make sure she keeps her word." I told my mother that there was no need to pester her because señora Pérez Gasca would do as she said.

A few days passed and my brother Ramon was the first to benefit from señora Pérez Gasca's acts of kindness; his scholarship for the boarding school had been issued. Claudio and Carlos were now enrolled at the primary school, Basilio Rojas Academy, and Francisco started attending the daycare center that señora Pérez Gasca had founded. My father was finally granted a full-time position working for the secret police. And just as our responsibilities increased, so did our basic needs. We needed more money for clothes, books, and other unexpected expenses that would arise. We were still under the same living conditions, but we felt as though we now had been adopted by a group of powerful individuals, and therefore everyone in the family had to convey a more presentable image. Putting a proper

outfit together was no problem for me since my friends from school would loan me clothes on occasion, especially for parties or official meetings that I had to attend.

MY FATHER'S WORK WITH THE SECRET POLICE

Everyone in the family kept working hard toward a successful life in the city. My mother constantly made plans for all her children. Some of them seemed far fetched, but she had lofty expectations for all of us. Her ambitions were monumental, and she firmly reminded everyone in the family that our individual contributions were necessary to reach our overall goals. We all believed her and continued our path forward; if something didn't work, we would opt for an alternative. My mother took care of the family and made tamales to sell, while Dolores sold newspapers and magazines at the newsstand. I was taking classes at the university and working for profesora Morales, and the rest of my siblings were going to school full time.

FIGURE 12. Dolores and Federico selling tamales in the city, ca. 1960. Photographer unknown. Jiménez Family Collection.

My father's employment with the secret police was unlike any he had ever held before. He had vaccinated cows and been a farmworker, and he had no idea what it meant to be in the secret police. He worked twenty-four-hour shifts and then would rest for twenty-four hours. When he would come home early in the morning, he would tell me about his work over breakfast. According to my father, the office of the secret police was also known as the headquarters. It was located on the corner of Flores Magon and Aldama. Every situation that these special officers had to encounter was different from the previous one. Most of the arrests were based on cases dealing with drugs, theft, prostitution, and even homicide.

One of the most fascinating police stories that I remember my father sharing with me was the case involving a high-class call girl who provided her services to politicians and high-ranking officials. According to my father this call girl was a gorgeous and fashionable young woman from Tehuantepec. She lived alone, and one morning on returning home from work, she discovered that all her belongings were gone. Apparently, the thieves had left her house empty. She angrily marched to the police station to file a complaint directly with the chief of police. She told him about the burglary and added that if she were a man, she would beat up the so-called perps herself. She thought they were spineless and should not have done that to a woman. The chief of police asked her to stay at a hotel for a while, and when she returned home a couple of days later, everything was exactly as she had left it; even her handbags were hung in the exact same place.

The call girl's burglary was one of many in the city. Officers from the secret police knew who was behind the burglaries by analyzing the crime scene; they also knew who operated the burglary rings in that area. These tightly organized groups of thugs perpetrated their criminal acts in places where people gathered, such as bus terminals, churches, wedding events, festivals, parades, circus shows, and protest rallies. But they were not alone; there were many criminal networks in the whole region, such as the ring that used to rob people traveling along roads and paths between towns. They were quite the pros.

One time I witnessed a couple of men at the Tlacolula market feigning an accidental fall, where one tackled a tourist as he fell to the ground. When trying to help the tourist up, one of the thieves pulled the wallet out of the man's pocket. With the staged chaos, the tourist had no idea that he had just been mugged and robbed, so he smiled and thanked the men for helping him

up. None of the bystanders said a word for fear of retaliation at the hands of the thugs.

Some elements in law enforcement were cruel and corrupt, and many of the interrogation methods that were used dated back to colonial times. Some men and women received shock treatments or were submerged in water tanks. The most common method consisted of putting a flour sack over a suspect's head and beating him until blood ran through the sack. If things got a little too rough, and the suspect died, they would take the prisoner over to the San Juanito Bridge and run him over with a patrol car. The next day, those same officers would file a report claiming that the victim had been hit by an unidentified vehicle. The victims' families were prevented from following up with an immediate investigation, and after they buried their loved ones, the investigation went nowhere.

When I later worked at the courthouse, I would sometimes visit the police station to deliver court appeals for the protection of some of the prisoners, which safeguarded an individual's constitutional rights while being held in custody. Sometimes I would find officers interrogating a suspect and would yell through the holding cell, telling them that the person they were beating up had an appeal for protection. But the officers didn't know what that was, much less care about it, and would continue with what they were doing.

To me the most interesting cases were the ones that dealt with political arrests or crimes perpetrated by city officials. Dirty money seemed to flow heavily in the Oaxaca Police Department. One day as I was walking through the zócalo with a high-ranking officer, we were approached on every corner by people who would say, "Señor Juanito, here is what I owe you, thank you so much." After seeing the same thing five or six times, I mustered the courage to ask this officer whether he was in the habit of lending money, to which he responded, "No, these people are thieves, and they have a monthly quota they have to pay if they wish to be left alone."

WORKING FOR THE GOVERNOR'S WIFE

Two weeks after my father was hired by the Police Department, I went to see señora Pérez Gasca to see if I could help her with the upcoming children's fundraiser, and she agreed to hire me temporarily. After this program was successful, she officially hired me to work part time for her. Working for the

governor's wife was very important to me, and over the next couple of years, we became very close. Not only did she help my family from the beginning, she remained a source of continuous support to us.

On a personal level, señora Pérez Gasca was always supportive of my goals and encouraged me to complete my education. The bond with someone in power and the idea of having the offices of the governor's wife at my disposal gave me hope and the strength to succeed in all that I was doing, even though I often asked myself if it was just a hopeful illusion. I started to network with important people and resorted to assertive name dropping, likening myself to part of the Oaxaca elite. Sometimes señora Pérez Gasca would send a chauffeur to pick me up after my evening class at the university. If the chauffeur wasn't driving the black Mercedes, he would be in a chrome-colored car, which my classmates called "the rocket" because of its color and design. It looked ready for takeoff with its tiny wings. When this happened, I would proudly walk past my fellow students toward the car. Now when I look back, I think this act was pure vanity on my part.

For the most part I came to enjoy working for señora Pérez Gasca. I always tried to fulfill her expectations, although there were some undesirable moments. I can still remember one of them with much regret, when I was not able to meet her high demands. One evening, as everyone in the Palace of the Governor was preparing for the Christmas celebration, señora Pérez Gasca wanted to decorate the marble pillars with painted dried jacaranda fruit shaped like poinsettia flowers, which are known as the *flor de Nochebuena* (Christmas Eve flower). Many of the staff members tried to hang the first branch that would serve as the model, but nobody was able to hang it correctly. Señora Pérez Gasca wanted the petals to point upward, but gravity made the task difficult. She called on me, saying, "Federico is the only one who will understand me. What I need right now is intelligence, and he is both detail oriented and artistic." As instructed, I went up the ladder carrying a large branch and tried to place it just as señora Pérez Gasca wanted but the branch kept falling. I tried to hang it again and again, until suddenly she burst out saying, "Get down from there! You're the most useless person I've ever come across." She lashed out at me right in front of everyone, which made me feel very small, and I left the Palace of the Governor feeling like a dog with his tail between his legs.

Señora Pérez Gasca was quite controlling. She knew how much influence she had on the decisions made at the Palace of the Governor. As a result, her

moniker was Maria Calzones, the Spanish word for men's underpants or briefs, which alluded to her high position of power. On the one hand, she could make such demands because the governor adored her and would let her do as she pleased. On the other, she was a determined woman. One of my jobs was to sell tickets to the Las Posadas program to the business owners in Oaxaca to raise funds for the children. When I returned to señora Pérez Gasca's office, she asked me how many tickets I had sold and for the names of those who did not purchase any tickets to the event. It was rumored that, to please his wife, the governor demanded higher taxes from those business owners who didn't purchase tickets.

Señora Pérez Gasca was also up front and frank with the women who came to her office asking for assistance. She would tell them that the next time they visited her office, they should at least wear their dresses inside out to hide the dough that was smeared all over them. When pregnant women visited her office, she would say, "All right now, I will help you only this one time because you've had one child per year." She once told a single mother of five, "Listen dear, keep your panties on because the next time I see you, if you have a lump under that rebozo I will certainly show you to the door." Señora Pérez Gasca's office was in the Instituto Nacional de Proteccíon de la Infancia building on Murguía Street. This was next to the children's dining area, where social workers oversaw the distribution of breakfasts to schools located in the working-class neighborhoods. This facility also head-quartered the tea and bridge evening events for ladies of the Oaxaca elite.

Señora Pérez Gasca was a close friend of Mexico's First Lady, Eva Sámano de López Mateos, who would send special guests her way. One time she invited President John F. Kennedy and his lovely wife, Jacqueline, to meet the governor's wife when they had planned to visit Oaxaca. Unfortunately, the Kennedys had to cancel at the last minute, which disappointed many. Mexico's First Lady visited the City of Oaxaca often on official business. I recall one afternoon when señora López Mateos was riding with señora Pérez Gasca, Lili the secretary, and me in the black Mercedes, which was a semilimousine. Señora Pérez Gasca suddenly ordered the chauffeur to pull over in front of the main entrance of the Juárez Market. She wanted to buy some *hojaldras* (traditional Oaxaca puff pastry with cochineal powdered sugar on top), one of the governor's favorites. I opened the door for señora Pérez Gasca, who was so focused on buying the hojaldras that she forgot about señora López Mateos. As señora Pérez Gasca and I looked back toward

the car, Lili and señora López Mateos were already walking toward the pastry stand. I am sure this was one of the rare occasions when señora López Mateos shopped for her own pastries!

Thanks to the efforts of Mexico's First Lady, señora Pérez Gasca had her fifteen minutes of fame when all the first ladies of each state met in Oaxaca for their National Convention for the Instituto Nacional de Protección de la Infancia. It was a week that concluded with many festivities. The closing ceremony was accompanied by a delicious dinner held at the Palace of the Governor. Afterward, the first ladies of each state paraded through the Teatro Macedonia de Alcalá (Oaxaca's opera house) dressed in their states' typical attire. Señora Pérez Gasca wore a beautiful traditional dress made by the Trique, one of Oaxaca's Indigenous groups, and señora López Mateos wore an outfit typical of the state of Guerrero. Everything that night was enchanting. The following day the first ladies returned to their home states after a delightful weekend. I attended this event and was thrilled to see the traditional Indigenous garments worn by such elegant and important women.

Señora Pérez Gasca's loneliness was something I was especially sensitive to. She was unlike the other ladies in politics, who surrounded themselves with an entourage of staff, colleagues, or family members whenever they went to official events. Her daughters, Lillian and Tahlia, had no interest in politics, and her son, Alfonso Pérez Gasca Jr., well, much less. Whenever an important task was delegated to her son, he was set up for failure, putting his parents' reputation at risk. Alfonso Pérez Gasca Jr. was responsible for the corn scandal of the early 1960s. He had warehoused Oaxaca's supply of corn, forcing its price to rise, just as the state was going through a terrible period of food scarcity. When President López Mateos learned about this, he traveled to Oaxaca, where he and the general secretary of the government of Oaxaca, Ing. Norberto Aguirre Palancares, ordered the locks be broken on the warehouses where the corn was stockpiled, thus enabling the corn to get to the markets and sold at a lower price. As a result, señora Pérez Gasca's son was given the nickname of El Gorgojo de Maiz (the corn weevil).

13

A BAPTISMAL CEREMONY FOR JUAN

D ESPITE ALL THE HELP WE received from señora Pérez Gasca, our family was still struggling. With the addition of another child, we were going to become a family of ten living under one roof. On many nights, my mother expressed her concerns about how we were going to survive once she had the baby. She was concerned about how long she would have to stop working. She said she was no longer going to be getting an income from sewing shirts at twenty centavos apiece. The twenty dollars I got from my sponsor and the pesos from my odd jobs for señora Pérez Gasca and profesora Morales were not enough, and Dolores's newsstand was not profitable. My father's income with the secret police was not enough to sustain such a large family. Also, it didn't take long for my father to find drinking buddies in the city, so a lot of his salary was wasted on alcohol and partying. Something needed to happen to remedy the situation.

We all concluded that we would have to turn to one of my teachers at the university, señora Consuelo Domínguez Carrascosa, for help. We asked her and her husband, Lic. Luis Domínguez Carrascosa, a federal judge, to be my brother Juan's baptismal godparents. They promptly accepted, but they knew little about what they were getting themselves into. My family and I came from a town with deep-rooted traditions, and the act of being some-body's godparent is one of the strongest ties between families and friends.

It goes beyond merely attending or sponsoring the baptismal ceremony. The godparents practically become members of the family. At least that is what my parents expected based on what they had experienced back home. It was considered the norm.

The baptismal ceremony took place at the Cathedral of Oaxaca. A friend from our coastal hometown offered to host the celebration at her house. My mother baked bread and made tamales, aided by some of the ladies she knew from the coast. They followed the local recipe to the letter. These special tamales from the coast are filled with mushrooms, shrimp, or mussels and clams in their shells, and then wrapped in banana leaves. We invited my classmates from the university and some of our friends from the coast. Everyone sang and danced to traditional songs coming from an old record player. A sherry-type liquor was served to complement the festive mood, thanks to some friends who brought it from the coast.

MY MOTHER FINDING ME A JOB

Approximately two months after Juan's baptism, my family invited the Domínguez Carrascosas over for dinner. My mother served tamales, sweet egg bread, and hot chocolate. When the subject of work came up, my mother asked the judge if he would give me a job at the district courthouse. She told him, "Federico is one the few young men in the country, and maybe even in the world, who has a natural talent to work in such a distinguished place." She added that I knew nothing about the law but could quickly learn whatever I was taught. The judge nearly choked upon hearing this and responded quite politely, "Yes, Imelda, as soon as there is an opening for a position, I will assign it to Federico." My mother interrupted, saying, "We are at your service. Just let us know whatever you need." Minutes later, my mother went back to the subject, saying, "Really, whatever you need."

Tired of my mother's persistence, the judge finally came up with an offer. He said, "My dear, the only job I have available at the moment is cleaning the staff offices and bathrooms." Before the judge could even finish his sentence, she blurted out, "Very well, Federico could start with that position and move on to a higher one as soon as it becomes available. He could even hold two jobs, or maybe his brother Ramon could help. I could also help if you need me to. We're here to serve you." My father was very quiet throughout this

conversation. It appeared as if he didn't approve of what my mother was say-ing, but then he didn't speak up to reject it either. He just sat there listening to my mother's persistent requests. Every now and then he nodded his head to express agreement. The judge was probably thinking that the price he had to pay for this tamale feast was a little excessive. All the while, I supported whatever my mother said. It felt as if we were both actors in an endless play.

On the Monday morning following our dinner, I was cleaning staff offices and bathrooms at the Federal Palace, which also housed the Federal District Attorney's Office. It was a magnificent building, with a façade that gave the building a unique architectural appearance. It was both neoclassic and colo-nial, with features reminiscent of the ancient temples of Monte Albán. I was honored to be working at such a reputable establishment. Approximately two months after being hired in a custodial position, I was appointed as a judicial court officer. I didn't know what all this entailed, but I was happy and proud to have such an outstanding title. Ramon was hired in my old position cleaning offices and staff toilets.

To my dismay, I learned very quickly that this new work environment was rather unwelcoming. Some of my colleagues were indifferent, while others were plain rude. The personnel manager complained about my lack of experi-ence compared to some of the other staff, who had been there longer and who deserved to have my position. He said that it wasn't fair and pointed out that employees with ten years of seniority had been overlooked for promotions. He insisted, "They wanted the union to get involved in this injustice that had taken place at the so-called Palace of Justice." I feigned ignorance of office politics and unions, and when I spoke to the judge about the issue, he told me not to worry, and that I was a valued and trusted employee. He also told me that everything would be fine and that there were no irregularities that would pose a threat to my employment.

My friendship with Judge Domínguez Carrascosa grew, along with the job security I enjoyed at the Federal District Attorney's Office. Or rather, that both Ramon and I enjoyed. Certain employees often complained that the cleaning hadn't been done right, and anytime I made a clerical mistake, the entire staff would hear about it. I never paid much attention to all the rumors; I knew that some people liked to criticize others out of jealousy.

My mother was happy that I had an important job and that Ramon had taken over the cleaning position. Having this full-time job from Monday through Friday from eight o'clock in the morning until two o'clock in the

afternoon left me little time to devote to my studies. By this time, I had completed my accounting degree and was continuing my education by taking evening classes at the university. I was also working for the governor's wife. She was always planning elaborate breakfast events, and then there were the annual Christmas festivities.

The money earned from working at the Federal District Attorney's Office helped to support my family. Every now and then I was able to buy myself some new clothes, but for as long as I can remember, the idea of amassing a collection of jewelry and traditional Indigenous textiles had fascinated me. On the weekends, I would go out to the surrounding towns in search of "folk art," as my friends called it. I loved documenting everything I found and quickly realized that this was truly a passion of mine. I came back from every collecting trip with memories of a unique experience!

On one of my earlier collecting trips in 1961, I visited the Huaves along the coast with my friend, sociologist Emma Cosío Villegas. We hired a driver from the town of Tehuantepec and a guide from San Mateo Del Mar, a native village near the sea, where we were planning to conduct our research. On the way, we had to cross a river. We all had to get out of the Jeep and remove our shoes and pants and cross the river on foot. When our guide removed his pants, I was surprised to see that he was wearing a loincloth, like the ones worn during pre-Hispanic times. When I examined it more closely as we crossed the river, I realized that it had caracol dyed designs. From the moment I saw that loincloth, I begged and pleaded with him to sell it to me. He told me that he couldn't sell it since his grandmother had woven it for him several years before. Notwithstanding, for the entire week we spent in San Mateo del Mar, I insisted that he sell me his loincloth. One day he brought me a huipil that his grandmother had woven forty years earlier. I gladly purchased it, and when I paid him, I asked, "How much more for the loincloth?" He laughed whenever I mentioned it.

On the last day as we loaded the Jeep, our guide came to me with something wrapped in an old piece of newspaper. As he handed it to me, he said that it was his loincloth. I could tell he felt a little embarrassed, but I was delighted and thanked him and paid him. He was surprised that someone would pay so much for his loincloth, which had served as his underwear for most of his life. After arriving back home, I personally washed it twenty times or more and tried to iron out the wrinkles, but I could never get it to lay flat.

At the time I knew it was a unique piece, and today this loincloth is one of the most important pieces in our collection.

Nancy Audifredd became one of my closest friends, and over the years she encouraged my interest in collecting native Oaxacan textiles. My mother expressed her concerns about my new hobby of collecting traditional arts. Who knows? She might have been right. It seemed that every time my collection reached five or six pieces, some emergency would come up at home, leaving me with no alternative but to sell pieces from my collection! Señora Maria Luisa Audifredd, Nancy's mother, would happily take the items off my hands.

The catalyst of a series of changes in my life came the day that I found that I had no choice but to sell one of my grandmother Nabora's treasured handwoven posahuanques. That day, as I came home from school carrying my books under my arm, I noticed that my mother was quite distressed. We had no money for the bare necessities and couldn't pay the rent, which was sixty-five pesos a month. The landlady was putting a lot of pressure on us to pay the rent, so out of frustration, I left my books on a chair and dashed to the chest that contained my grandmother's posahuanques and rebozo. I grabbed one that had caracol and cochineal dyed designs that we referred to as the posahuanque del diario. I marched out the door, embracing the textile as I made my way from Bustamante 41 to the corner of Independencia and Porfirio Díaz, the location of señora Audifredd's gallery.

As I walked to the gallery, I had to come up with an asking price for the posahuanque. It started at 200 pesos, but with every approaching block, the price of the posahuanque increased because of my anxiety and disappointment, and especially the resentment I felt at having to sell this priceless family heirloom. When I crossed La Alameda, the price had risen to 275 pesos, but when I arrived at señora Audifredd's gallery, a voice inside me said, "Three hundred pesos, and if she chooses not to accept that offer, then I'll starve to death." Señora Audifredd was entertaining a client when I interrupted to show her my grandmother's posahuanque. I gave her the three-hundred-peso price, and she immediately took the money out of her dress pocket. She seemed excited as she showed the posahuanque to her client, saying, "Look here, this art piece should be on display in a museum." With the money received for the posahuanque del diario, we could pay the rent and afford basic supplies to make ends meet.

Several years later when my economic situation had improved and my collection had increased, I offered señora Audifredd five cochineal-dyed textiles from the Valley of Oaxaca, including one unique posahuanque from Macuiltxochitl, in trade for my grandmother's posahuanque del diario. It was either that or five thousand pesos. Sadly, she didn't accept either offer, and in the end, she eventually sold her complete collection, including my grandmother's posahuanque del diario, to the Museum of Anthropology in Mexico City for 150,000 pesos. I was extremely hurt and disappointed.

Years later, the Santo Domingo Regional Museum (now El Museo de las Culturas de Oaxaca) was founded, and during one of my visits to Oaxaca, I reconnected with my grandmother's posahuanque del diario when it was on exhibit there. Every time my wife, Ellen, and I visited Oaxaca, we went on a pilgrimage to see my grandmother's posahuanque del diario in its display case, until one day we discovered that it had been removed from the exhibition. I was quite distressed to learn that my grandmother's posahuanque del diario had once again vanished from my life. I was shocked by how quickly it all had happened

MY ONGOING WORK FOR THE JUDGE

The judge's trust in me grew with each passing day, and he felt comfortable enough to talk to me about his private affairs and the cases that required his decisions. He would also talk to me about things that were troubling to him. I thought he was an extraordinary individual. He was a smart, sincere, and honorable man, but I also realized that he was very lonely and didn't have many close friends. Maybe he saw me as more than an employee and possibly more like a son. Throughout his career he made numerous attempts to find a balance between federal and state powers, and to this date I still doubt whether he ever reached his goals. Nevertheless, I vividly recall his enthusiasm when talking about this topic.

At one point I played a part in one of the judge's cases; however, I have often wondered how effective my involvement proved to be, especially given my lack of experience and knowledge on the matter at the time. This case involved an oil refinery located along the border between Oaxaca and Veracruz. The refinery owners had paid taxes to both states, until one day it stopped its usual payment to the state of Oaxaca. Governor Pérez Gasca

was upset by this and decided to bring a lawsuit against the owners and demanded that the refinery be shut down until it paid its taxes. The owners sought legal protection through the state of Veracruz, thus preventing the governor from shutting it down. This marked the beginning of what I remember being referred to as the oil refinery trial. As the communication between the district attorney's office that was working on the court case and the governor's office gradually decreased, the judge asked me to serve as an intermediary in the matter. My task consisted of speaking with Governor Pérez Gasca and convincing him to withdraw the lawsuit against the refinery, since the date for the final ruling was approaching, and everything pointed in favor of the state of Veracruz.

I was quite nervous about the whole thing, but when the day came to see the governor, I put on my best suit and made my way towards the Palace of the Governor. On my arrival, I spoke with his executive secretary. Shortly after, I was escorted to the governor's office, and I respectfully greeted the governor, who calmly replied, "Please, have a seat. What news do you bring me today?" With my limited knowledge of legal jargon, I explained that the oil refinery was on Veracruz soil, so it did not have tax obligations to the state of Oaxaca. Therefore, because the refinery was located outside our state's jurisdiction, Judge Domínguez Carrascosa had no choice but to rule in favor of the state of Veracruz. I spoke for nearly fifteen minutes, which seemed like an hour. When I paused for a response, I realized that it would have been better to have had a dialogue with the governor instead of presenting my monologue. He answered coldly, "Tell your boss that I wish to cordially invite him to my State of the Union address. A front row seat will be reserved for him so that he may hear me better. Let him know his presence would be greatly appreciated." He called his executive secretary and asked him to give me the invitation.

As I left the office, I felt a great burden. I wasn't sure that my visit had achieved its goal. I wasn't sure I was accurately reading the governor's intentions as I informed the judge that the governor had invited him to his upcoming State of the Union address. I handed him the invitation, thus having completed my mission. In the end, though, I couldn't let go of my uneasy feelings about my overall performance in presenting the information to the governor and his response.

When the day for the State of the Union address arrived, the judge was one of the first guests to arrive. The president of the Chamber of Representatives

announced the governor's entrance and introduced him to the public as he prepared to deliver his address. Governor Pérez Gasca spoke about all the programs he had overseen, about the millions spent on highways and on public health, as well as his efforts to sustain the progress made in education. He spoke about peaceful relations and a thriving economy and finally came to the end of his speech, where he commented on the despicable public officials who hindered Oaxaca's fair share of state taxes. He used the oil refinery as an example and declared, "What an injustice. Such individuals are blatantly disregarding the needs of Oaxaca while stealing from the common-law system." He was clearly directing his remarks toward Judge Domínguez Carrascosa.

The applause grew louder with every remark. It felt as though the governor's verbal attack of Judge Domínguez Carrascosa would never stop. Anyone else would have stood up and walked out, but the judge was a well-mannered person with class. He simply sat there listening until the governor finished his remarks. As soon as the State of the Union address had concluded, the judge hurriedly made his way to the Federal Palace, where he summoned me. When I entered his office, the first thing he said was that the governor had only invited him to insult him in front of everyone. He said, "I gave him a choice, but he has opted for war!" The judge was clearly plotting his next move and told me to prepare for a trip to Mexico City the following Monday. I left the office feeling terrible, frustrated, at fault, and, to say the least, inept for having failed. I thought I had complicated things by not elaborating more on the details of the oil refinery being in Veracruz, and that the judge had said that Oaxaca could not legally tax it. Maybe my words were not quite clear or succinct enough.

On Monday, we boarded a train for Mexico City. This was my second trip to the capital. I couldn't believe I was traveling with a federal judge. We stayed at the Hotel Gillow, located on Calle Isabel La Católica in the historic district. The Hotel Gillow was once the property of an archbishop who lived in Oaxaca, and thus it had been named after him. After eating breakfast, we made our way to the Supreme Court offices. I quickly became aware of the judge's importance and popularity when, after making our way up the stairs of the Federal Public Ministry, we were greeted by several attorneys. We visited many offices there, and I didn't know any of the judges or attorneys we saw. The only person I recognized by name was Minister María Cristina Salmorán de Tamayo, the first woman in Mexico's history to be appointed to

the Supreme Court. She was surprised to learn that I knew her son Rolando Tamayo Salmorán. A fellow student at the university had introduced us during holy week one year, and we visited the Basilica de Nuestra Señora de la Soledad, where we found a place by the atrium to sit and listen to a piece by Mexican composer Juventino Rosas.

The judge and I walked for about fifteen minutes until we finally arrived at the offices of the president of the Supreme Court of Justice of the Nation (Supreme Court of Mexico), Lic. Alfonso Guzmán Neyra. We waited in a foyer briefly, and then Judge Domínguez Carrascosa was escorted into the Supreme Court president's office. I waited outside for the judge, and after the meeting, we walked through another part of the building. Countless officials warmly greeted him and wanted to talk to him, which kept us busy until two o'clock in the afternoon. It felt as though he was on a campaign and was setting the foundation to become a Supreme Court justice. I could tell the judge was well liked and admired.

I had never seen him so ecstatic. "Let's have lunch at La Blanca," he offered. So, we headed to the restaurant, which was located across the street from the Hotel Gillow. As we sat at our table, the judge suggested that I try the frog legs. The thought of them made me lose my appetite. Then for dessert he told me the pie a la mode was excellent. "Pie" in Spanish is translated as "foot" in English. So, I thought he was saying foot a la mode, which I couldn't even imagine being in such a fine restaurant! I was beginning to wonder what kind of restaurant he had taken me to, and I certainly didn't feel like eating anything on the menu. Once I realized how poorly I was translating the different dishes, I was finally able to order something that sounded more appetizing. By nightfall we were on a train back to Oaxaca, ready to resume our work the following day as if nothing had happened.

During the two months that followed our trip to Mexico City, I noticed that the judge seemed rather apprehensive, until one day he received news from the Supreme Court that they were getting ready to render a decision on the Oaxaca-Veracruz oil refinery case. He left immediately for Mexico City, this time taking his wife. Two days later newspapers all over Mexico published the latest developments and accused Governor Pérez Gasca of being a dunce for not handling the case appropriately. It was felt that the case never should have reached the Supreme Court, and that it should have been decided at the state level. I couldn't believe what I was reading as I uncomfortably fixed my eyes on the newspaper headlines. The governor and his wife

FIGURE 13. Office staff welcoming Judge Domínguez Carrascosa when he arrived home from Mexico City. Federico is standing second from the right. Photo published in *El Imparcial*, ca. mid-1960s. Photographer unknown. Jiménez Family Collection.

had done so much for me and my family, as had the judge. I couldn't help but feel that I was trying to serve both God and the Devil at the same time.

Everyone at the Federal District Attorney's Office celebrated the final decision. and we all met at the train station to welcome the judge upon his return from Mexico City. He joyously stepped off the train. His smile revealed a heroic triumph. As we embraced, he whispered in my ear, "This is my cue to move on to the Supreme Court." Sadly, this dream never materialized, but if he had been appointed, he would have been one of the most fair and impartial judges on the Supreme Court.

My colleagues and I organized a dinner party for the judge at a local restaurant called Doña Elpidia. We feasted on mole, zucchini flower quesadillas, and succulent roasted pork loin with pineapple and onion. One of my co-workers brought the roasted pork loin to the restaurant in honor of the judge, and it was prepared wonderfully. This made the banquet very special for the judge. Sadly, this celebration marked the last time I would be part of an event as a staff member for the Federal District Attorney's Office. By then, I had made more connections and had close ties with individuals who became key players in my career development and in my social life.

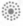

14

NEW OPPORTUNITIES AND MARRIAGE

W HILE I WAS WORKING FOR the judge and señora Pérez Gasca, Arcelia Yañíz continued to play an important role in my life. One day she introduced me to Ing. Norberto Aguirre Palancares, a Mixtec born along the coast in Santiago Pinotepa Nacional. At the time Aguirre Palancares was the general secretary of government of the state of Oaxaca from 1956 to 1961, under Governor Pérez Gasca. He was a well-known politician who focused on agrarian issues throughout Mexico. I met him when he was running for national office as senator from the First District along the coast. Arcelia praised me in such a loving tone that Aguirre Palancares finally asked, "Is he a son of yours whom I haven't met?" As I recall, her response was something like, "No, but this young man has a bright future."

Ing. Aguirre Palancares grew fond of me in the years to come. I was asked to accompany him when he was campaigning for the senate seat. I gave introductory speeches at some of his campaign stops. Twice he told me, "Bring me a university degree, and I'll make you a local representative. You've got a knack for politics." After the second offer, I mentioned this to Arcelia, and she replied, "You could never be a politician. You are too sensitive; you are an artist. Your warm and friendly nature and compassion would get in the way. Politicians are cold, toady, and usually corrupt. It's a whole different deal; you don't want to be part of that. You have an even temperament, eloquence,

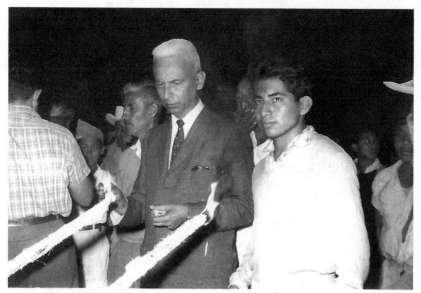

FIGURE 14. Ing. Norberto Aguirre Palancares lighting candles at one of his campaign stops. Federico is standing next to him, ca. 1961. Photographer unknown. Jiménez Family Collection.

and you have principles . . . no, no." Many years passed before I realized what Arcelia meant. In fact, she guided me and introduced me to the world of politics in a way that I would not have to be directly involved, neither in Mexico nor in the United States. Unfortunately, Aguirre Palancares was never elected as a senator, but he was appointed as secretariat of agrarian reform from 1964 to 1970 under President Gustavo Díaz Ardaz.

A CHANCE MEETING

When I was around twenty-three, Arcelia suggested that I consider writing for one of the local newspapers, the *Oaxaca Grafico*. Thanks to her encouragement, I started writing articles mainly about Oaxaca's traditional arts and cultures. I wrote an article about doña Rosa, whose full name was Rosa Real Mateo de Nieto. She was a famous Mexican ceramic artist from San Bartolo Coyotepec. Doña Rosa was noted for perfecting a technique that made the local pottery type, *barro negro*, which was black and shiny. The traditional barro negro pottery was matte and grayish, but in the 1950s, when doña

Rosa found she could change the color and bring a shine to the pieces by polishing the dry surface with a quartz stone and firing the ceramics at a lower temperature, the pottery would emerge black and shiny. This created new markets for the ceramics with collectors and tourists. The technique is now being carried on by her daughter and grandchildren.

In 1965, I decided to write an article about the herbalists who sold medicinal herbs and remedies at the Tlacolula market in the Valley of Oaxaca. Interviewing Tlacolula herbalists became my Sunday routine. I would take the budget bus in the morning, which charged two pesos, conduct my interviews, and by evening be back in the city. On one of my final research trips to Tlacolula, I took my usual bus and happened to sit next to a young American man. During the half-hour trip, we talked about Oaxaca, and I told him about my research in Tlacolula. When the bus reached our destination, we said goodbye to each other and went our separate ways.

Two hours later, I was pleasantly surprised to see him again while I was interviewing an herbalist in the market. He was with another young man from the United States, whose name was Martin Diskin, an anthropologist also conducting research at the Tlacolula market.[22] The topic of his research mainly centered on the town's traditional market and its economic structures. He expressed an interest in my work, and after a pleasant conversation, he invited me to his house for lunch the following Sunday, when I came back to do more interviews.

I arrived as planned a week later. The Diskins lived in Tlacolula, and Martin's wife, Wilma, had been cooking, and I could smell something delicious as I approached their house. Later that afternoon we ate and talked mainly about anthropology and the Tlacolula market. As I was leaving, he invited me to an upcoming party at a home in the Colonia Reforma neighborhood in the city. I happily accepted the invitation.

On the day of the party, I was quite excited when I arrived at the house and found that it served as the headquarters of the UCLA Oaxaca Market Study Project, a major study directed by Ralph L. Beals between 1965 and 1969.[23] It

22. See Scott Cook and Martin Diskin, eds., *Markets in Oaxaca*, (Austin: University of Texas Press, 1976); and Martin Diskin "The Structure of a Peasant Market System in Oaxaca," In Cook and Diskin, *Markets in Oaxaca*, 49–65.

23. Ralph L. Beals, *The Peasant Marketing System of Oaxaca, Mexico*, Berkeley: University of California Press, 1975.

was where the data and other information that the anthropologists collected was kept. Many of the anthropologists working on the project also lived there while conducting their fieldwork. When I walked in, I couldn't help but notice the presence of the pillars of Mexican and American anthropology in the room. Among them were Ignacio Bernal, director of the Museum of Anthropology in Mexico City; Ralph Beals and his wife; Fernando Câmara Barbachano; Rubín de la Borbolla; and others who were part of the highest circles of Latin American anthropology at the time. I am almost certain that I was about twenty-four years old, yet my youth didn't prove to be a barrier, and they all welcomed me and made me feel quite comfortable.

The most surprising moment of the night was when I saw the most beautiful young woman I had ever seen walking down the steps that led to the living room. I could tell by the way she was dressed that she was different, not like other American women. Her name was Ellen, and she wore a traditional Oaxacan huipil made of handwoven fabric and an elegant amber necklace. When we were introduced, we looked at each other for what seemed like an eternity. Her green eyes mesmerized me. Her company was endearing, and I enjoyed every minute of being with her. We discussed all sorts of topics, including Oaxacan culture. That evening is most memorable because I met many important people who would have a role in my future one way or another.

When it was time to leave, I decided to walk home rather than ride with anyone. I walked from the Colonia Reforma neighborhood to the Consolación neighborhood, which seemed to take no time at all. It was a rainy night. Huge drops fell from the leafy trees that lined the sidewalks. I needed to digest everything that had just happened at the party, but more than anything I was going through every word, gaze, and thought from my encounter with Ellen. Suddenly the thought of being close to her invaded my senses; that's when I realized my feelings for her were too strong to ignore. All I could think about was how could I possibly see her again and find out if she felt the same as I did. As luck would have it, the stars were aligned, and I would be seeing her sooner than I thought.

Shortly after the party, Martin Diskin showed up at my house and invited me out to lunch. We talked about the possibility of a job where I would be part of a group tasked with writing reports and conducting research at traditional markets in the Valley of Oaxaca. I immediately answered that I couldn't accept the job. In the first place, I was now earning a little over two

thousand pesos a month working as a court officer for Judge Domínguez Carrascosa, and I was taking night classes at the university. Martin counter proposed, saying, "If we double that salary, would you accept my offer?" I told him I would give him an answer in one week. And so, I spoke with Judge Domínguez Carrascosa about the offer that Martin Diskin had made. He was pleased with my prospects and granted me a six-month leave so that I could test the waters.

Before I started working for Martin Diskin in the Tlacolula market, Ronald Waterbury, who was doing similar research, approached me and offered me a job on his project, which was being carried out in the city.[24] I decided to accept Waterbury's offer instead. Ronald Waterbury's research, like Martin Diskin's project, was one part of the larger UCLA Oaxaca Peasant Research Project. Funded by the National Science Foundation, the research lasted three years and involved numerous researchers and field assistants, who focused on different aspects of the project. Professor Ralph Beals from UCLA was the general director, and Ronald Waterbury served as field director for the first two years. Some of the other field staff included Richard Berg, Theodore Downing, Paul Steinberg, Charlotte Stolmaker, and Clyde Woods.[25]

I began working on the research project headed by Ronald Waterbury on April 6, 1965, and Martin Diskin continued his work in Tlacolula. I was pleasantly surprised to learn on the first day that I would be working with Ellen Waterbury when we were assigned to stay in the office typing up reports. At times my sister, Dolores, also assisted in copying documents and typing up field notes left by the anthropologists. I soon learned that Ellen and Ronald were not married. Like so many young people who came of age during the counterculture movement of the 1960s and 1970s, they were living together more as friends than as a traditional married couple. Ellen had changed her last name from Belber to Waterbury more for convenience than anything else.

Everything seemed like a dream come true. Ellen and I spent all day talking about each other's lives and interviewing merchants in the markets. I saw

24. See Ronald Waterbury, *The Traditional Market in a Provincial Urban Setting: Oaxaca, Mexico*, (Ann Arbor, MI: University Microfilms, 1968); and Ronald Waterbury, "Urbanization and a Traditional Market System," in *The Social Anthropology of Latin America*, ed. Walter Goldschmidt. (Los Angeles: Latin American Center, UCLA, 1970), 126–56.

25. Beals, *Peasant Marketing System*, viii.

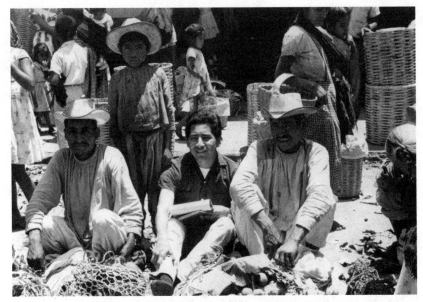

FIGURE 15. Federico interviewing vendors in the Juárez Market on Aldama Street in Oaxaca City, ca. 1965. Photo by Ronald Waterbury. Jiménez Family Collection.

Ellen as an elegant young woman with extraordinary experience, and someone who could fulfill every aspect of my being, whether physical, mental, or emotional. I found her intellect outstanding. As we got to know each other, my love for her grew stronger, and despite our eleven-year age difference, I couldn't help but sense that she felt the same way for me. I often found myself daydreaming about her since the night I had met her at the UCLA party. When we finally shared our deep love for each other, I coined that sweet encounter as "The night at the steps."

One afternoon, I invited Ellen to accompany me to Monte Albán to see the sunset. I was well acquainted with the Monte Albán archaeological site just outside Oaxaca City because I used to spend a lot of time there hiking on and around the pyramids on Sundays. Ellen delightedly accepted my invitation, and we drove to Monte Albán in her turquoise Chevrolet. Once there, we walked around the ruins and climbed a pyramid, which at one end descended into tunnels and hidden labyrinths, their existence unknown to many. We climbed another pyramid that faced Arrazola, which to me is the most beautiful one, mainly because of its view of the Etla Valley.

While we were at the top of this pyramid, one of the security guards loudly announced that it was closing time and that we had to leave the premises. I climbed down the pyramid and extended my hand to him with six pesos, the sum of my cash at the time. In return I asked that he allow us to stay and watch the sunset, which was going to give way to a beautiful full moon. I knew I was asking a lot in return for such a modest sum. Nevertheless, he accepted my pesos with a glance that said "good luck."

I calmly made my way back up the steps of the pyramid with a sense of triumph and embraced Ellen. This was our first embrace, and since she didn't push me away, I was encouraged. We sat watching the sunset and imagined how the inhabitants of these temples must have felt during moments like these. No doubt they prayed and chanted as the sun was setting while playing the *teponastle* (drum), the *chirimia* (flute), or the conch shell, while copal incense burned in the background. As we sat enjoying the full moon, we talked softly about our feelings for each other.

Later that night we took each other by the hand and proceeded to make our way down the stone block steps in the moonlight, feeling as if the gods of the past had approved of our being together that night. We enjoyed the silence, the peacefulness it brought, and the tranquility that permeated our bodies. We arrived at the car and made our way back to the city, its lights shining bright as though they too were celebrating our love, a love that the Mixtec-Zapotec gods had decreed for eternity at Monte Albán.

As we continued to work on the research project, Ronald and Ellen would come and visit me often, and my mother would fix them something to eat that usually included eggs and salsa. They got to know my family. Ellen and I tried to see each other as much as possible. As our love for each other grew stronger, I wanted Ellen to know more about my childhood, so I took her to Tututepec. Even though I had put my past behind me, being there brought back many unpleasant memories. Several of the folks in town wasted no time in reminding me of my sins and banishment when I was fourteen years old. I was shocked that they still held on to these attitudes about me being a failure and a troublemaker. But despite this I felt liberated in many ways, because I was no longer a kid, and I had overcome so much that I just ignored their comments and thought, "To hell with them!" They were surprised when I told them that I was a journalist and that I was working as a researcher on the UCLA project. This was the last time that I visited the place of my birth.

MARRIAGE

On one of our research trips in late 1965, Ellen and I decided to get married. While we were conducting market research in Tehuantepec, we found the mayor's office and asked if he could marry us. We were told that we needed two witnesses, so we went outside and asked two drunk campesinos (farm laborers) if they would come inside and witness our marriage, and they agreed. At the end of the wedding ceremony, they had to sign the marriage certificate, but they couldn't read or write, so they put their thumbprint instead.

When we returned to Oaxaca, we were careful to be very discreet and professional in our relationship. We didn't tell anyone in the office that we were married, and Ellen and I continued to live apart as we had before we had gotten married. I did tell my family, however, and they didn't take it very well. My father was extremely upset with me because I had married an American woman who was older than me. As you can imagine, my mother was upset that we didn't get married in a church. Both my mother and father thought I should marry a mestiza from Oaxaca. I am sure some of it had to do with the fact that I was still supporting my family economically, and they saw my marriage to Ellen as a threat to their survival.

Then the day came at the end of the summer of 1966 when Ronald and Ellen returned to the United States. After working with Ellen and having

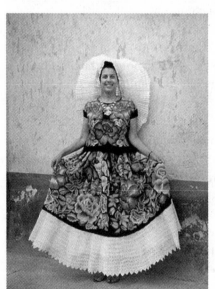

been around so many anthropologists, I decided that I wanted to study anthropology in the United States. Ronald helped me fill out the paperwork and arranged for letters of recommendation from several anthropology colleagues to be sent to the immigration authorities in support of my work visa. Seven months later I was informed

FIGURE 16. Ellen wearing a Tehuantepec fiesta outfit after she and Federico were married, 1965. Photo by Ronald Waterbury. Jiménez Family Collection.

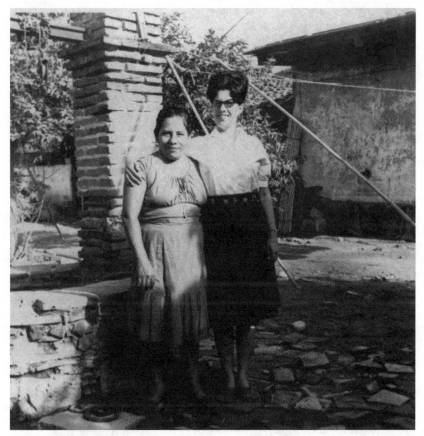

FIGURE 17. Ellen and Federico's mother in Oaxaca, 1965. Photo by Ronald Waterbury. Jiménez Family Collection

that Ronald had arranged for me to work for Ralph C. Altman at the Museum Laboratory at the University of California, Los Angeles. This was an opportunity I could not pass up, and I would be able to see the love of my life, Ellen, again.

I completed my university courses in November 1966. I then started into my first year of law school at the Benito Juárez Autonomous University in Oaxaca the following January. I had completed several of the required courses when I was working on my accounting degree and taking night classes at the university, so I was able to move into advanced classes when I enrolled. Not long after I started law school, my work visa was approved, and I left for the United States in August 1967. This was two months before

FIGURE 18. Federico receiving his graduation ring from Arcelia Yañez and his diploma from Lic. Agustin Marquez Uribe in the rector's office at the university, 1967. Photographer unknown. Jiménez Family Collection.

my scheduled graduation ceremony for my accounting degree. Since I was going to miss my graduation ceremony, Arcelia was able to arrange for me to receive my diploma in advance. It was given to me in the rector's office, and I also received my graduation ring from Arcelia. I said goodbye to my colleagues and friends, who wished me the best of luck. Leaving my family was not so easy.

One day after lunch, I called everyone in the family to come together so I could tell them that I had an opportunity to go to the United States to work and to study. I told them that I was waiting for my papers to be approved

for a work visa, and that I would have to leave immediately on receiving them. Everyone was surprised and concerned with this news. My mother was very upset at first, but as always, she was happy for me and wanted to be encouraging. Nevertheless, she was worried about how the family was going to survive, especially since up to that point, I had contributed the most financially. As always when faced with adversity, she immediately started making plans for everyone in the family. She decided that Dolores would take my job with the judge and study law at the same time; Ramon would study medicine at the university in Mexico City, where he had already received a scholarship; Claudio and Carlos would continue their studies at the second-ary school; and Francisco would continue his studies at the boarding school. My father would continue to work for the secret police. Four months later I received a telegram that I had to go to the American embassy in Mexico City to get my passport and work visa and leave directly from there for the United States. Shortly after receiving this telegram, we gathered to have a family photo taken.

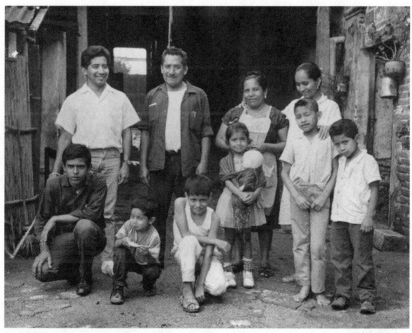

FIGURE 19. Photo of the Jiménez family in 1967 before Federico left for the United States. Photo by Ronald Waterbury. Jiménez Family Collection.

On the day that I left Oaxaca, my whole family gathered for breakfast, and then they all went to the airport to see me off to my new life in the United States. When we arrived at the airport everyone was crying, including my father. My father hugged me tightly and whispered in my ear that he loved me very much. This was only the second time in my life that he had expressed any kind of love toward me. The first time was when I left Tututepec. Everyone was yelling, "Don't forget us! Write to us and let us know how you are doing! We will miss you! God bless you! Come back soon!"

PART III

FINDING MY WAY

15

LEAVING OAXACA

AS I LEFT OAXACA ON the morning of August 16, 1967, I couldn't believe I was leaving my home and my family for a second time. Not only that, I was going to a foreign country. Even though I wasn't quite sure what to expect, I was excited about this next chapter in my life and this new adventure that was unfolding before me. I was older, more experienced, and more mature, and my outlook on life was totally different. This time I was going to see my wife, Ellen, the woman I was madly in love with, and I had the promise of a paid research position at the University of California, Los Angeles, when I arrived.

When I boarded the plane for my flight to Mexico City, where I was to connect to my flight to the United States, I was extremely conscious of how this second trip was so very different from the one that I had taken twelve years earlier. It was a short flight, and as I walked through the terminal in Mexico City's International Airport, the music that was playing in the background suddenly stopped. Seconds later an announcement could be heard throughout the airport, saying, "Federico Jiménez, please come to gate twenty for your departure to Los Angeles." Minutes later I found myself sitting on the largest plane I had ever seen along with 175 other passengers. It felt like a flying house it was so big. It was hard to believe that this huge house would be flying thirty thousand feet above the ground. As I looked

out the window, I said goodbye to the majestic Aztec city that I had become familiar with over the past couple of years. I left my nation's capital, with its unique cultural wealth, which cannot be compared to any other city on earth. As we gained in altitude, I could see Mexico's green fertile valleys, its high deserts, its grand rivers, and its cities and towns, both large and small. The scenery from this height left me completely awestruck.

Despite my overwhelming excitement about starting my new life in the United States, I couldn't help but feel sad about leaving my friends and colleagues behind. Before leaving I made promises to see some of my buddies within six months, but this promise took a very long time to fulfill. I did see one of these friends, Genaro Sardaneta, at a dinner party in 2014. On our departure, he teasingly said, "Now don't you wait another fifty years before we see each other again."

As had happened before in my life, I was once again leaving my home, and I felt uncertain as to what my future might hold. Failure wasn't part of my life roadmap; it was out of the question. I had faced many challenges up to this point, and I had always found a way to overcome them. As a young Indigenous boy in Tututepec, I had to face many hardships and difficulties. I was constantly discriminated against in school and in my hometown. It seemed that I didn't fit in anywhere, except when I was on my land in the countryside.

Coming of age in Oaxaca City, where I was faced with different challenges, was not easy either. In the city, I was constantly faced with discrimination and did whatever I could to keep from starving and to put a roof over my head. Yet, I survived and made my way no matter what obstacle was thrown in front of me. My youthful achievements were part of everyday life in the culture I was raised in, and I adapted to the changing world around me. But now, I viewed the journey ahead of me as more of an adventure. Quite honestly, I really had no idea what was ahead of me at that point, but not being one to hold back, I was anxious to move on and see what this next stage in my life had in store for me.

I was aware of the cultural and physical divide that existed between these two countries, which was both overwhelming and exciting. I was going to be living in a country where people spoke another language, and where there were other customs that I was not even aware of yet. I would have to adopt the new language and customs if I was going to be successful. In Oaxaca, I had left behind fragmented dreams of being an accountant, a lawyer, or a

politician. Who knows, maybe I would have tried all three just to see which one would stick.

The next time I looked down, I saw the beautiful Southern California landscape, which ranged from the desert to the Pacific Ocean. I could see small towns, orange and avocado groves, and highways full of cars and trucks. As we started our descent into Los Angeles, I could see the individual houses, some of them with beautiful gardens that reminded me of the nativity scenes that people set up in their houses, yards, churches, and even whole villages to celebrate Christmas in Mexico. Before I knew it, the flight attendant was announcing our arrival at the Los Angeles International Airport, and the sprawling city came into view.

It was a hot afternoon, and the air was thick in this highly industrialized city. I could see smokestacks polluting the air with fumes. City Hall, the tallest building in Los Angeles at the time, stood out in the distance. At that point in my life, I couldn't even imagine that I would someday be involved in the election of the first Latino mayor of Los Angeles in more than 150 years, a man whom I would get to know very well personally. It was as though fate had called on me to experience the transformation that was taking place in this country at that time. New social movements were emerging that countered the conservative social norms. Some of the issues I noticed immediately were centered around racial discrimination and the civil rights movement, as well as equal rights and pay for women.

ARRIVING IN MY NEW HOME IN CALIFORNIA

After the plane landed, I collected my luggage at the international baggage claim, which was more than a cardboard box this time. I presented my documents to the United States customs officer, and he said, "Welcome to the United States." I left the airport and took a taxi to Ellen's house in Venice, one of the numerous neighborhoods in the city of Los Angeles.

On my way to Venice, I tried to practice my English with the taxi driver. The poor man couldn't understand a thing I said, and boy, he made it clear by saying very slowly, "Yo no hablar Español." Minutes later, I wanted to know the time, so I asked in my broken English, "What hour it is?" The driver stared blankly at me. I pointed to my watch, and he answered inquisitively, "Do you mean the time?" I nodded, and he replied, "It's four o'clock." This

made me realize that my English wasn't going to be good enough to communicate with people in Los Angeles. Finally, after driving through several neighborhoods, we arrived at the address that I had given him.

Ellen was waiting anxiously for my arrival. When we embraced, our deep love for each other was immediately rekindled, and we were reminded of the wonderful times we had spent together in Oaxaca. It was an extremely emotional reunion for both of us. By this time Ronald Waterbury had taken a job as assistant professor at California State College, Los Angeles, and was living with his future wife, Carole Turkenik. Ellen and I were finally able to start our life together as a "real" married couple. It was late afternoon, and we spent the rest of the day and evening talking about our work and times together in Oaxaca. We also discussed the plans that were in place for me to begin my work at the university.

Our house faced the ocean, and it was very different from the homes in Mexico. It was a white wooden house that had been built at the turn of the twentieth century. It had three bedrooms, a living room with a dining area, and a porch with a view of the ocean. As I got settled in, Ellen and I would often eat our breakfast on the porch as we watched the hippies on the beach directly across from our house. It was a nice clean beach. It had a lot of white benches, which were often used as sunbathing stations by elderly men and women.

The day I took my first walk along the boardwalk, I ran into an older woman carrying a clipboard and a pen. I figured her job consisted of interviewing people. She stopped me, called me Honey, and then continued talking to me, calling me Honey over and over again. I took a step back for the sake of distance and looked up the translation of "honey" in the Spanish/English dictionary that I carried with me. Once I understood what it meant, I took yet another step back as I thought she was trying to seduce me. I later figured out that all she wanted was my signature on a petition for a social cause of some sort.

MY FIRST LIFE LESSON IN THE UNITED STATES

Obtaining permanent resident status (a green card) in the United States was, fortunately, less difficult than it is now. Ronald Waterbury completed the paperwork to sponsor me. To fulfill the requirement of a job offer, he and

Ralph Beals confirmed that I was an expert in Mexican folk art and culture and arranged for the UCLA Museum and Laboratories of Ethnic Arts and Technology (now the Fowler Museum) to provide me with a paid position as a research assistant. When I arrived to start my research position, however, I learned that, because of deep cuts in the university's budget, the position I had been offered had been eliminated. So, I suddenly found myself in the United States with a green card but no source of income. I was also deeply disappointed to learn that my student aid would no longer be granted either, so I was not able to take any classes. This was the result of California governor Ronald Reagan's implementation of several spending cuts throughout the state, especially in the University of California system.

After getting over the shock of this change in plans, I had to figure out what my next steps would be. Two things were working against me: my poor command of the English language and the elimination of what was to be my financial support and a project that I was looking forward to working on at UCLA. Being Imelda's son, I was reminded that there was always a way to change my situation or circumstances. This had been my guiding principle up to this point and would continue to guide me throughout the years.

I decided I should work on my language skills, so I enrolled in an English class at Venice High School. I quickly realized that the English I had learned previously in Oaxaca was of little use in the United States. Venice High School was a community school, where the registration cost only twenty-five cents and the practice materials were free. The English class included international students from many countries, and I quickly made acquaintances with fellow Latinos from Chile, Argentina, Cuba, and Mexico. We spoke longingly about our home countries, and we complained about how difficult it was to adjust to the United States, especially dealing with the blatant discrimination against foreigners, particularly Latinos. We would often talk about how much ignorance there was in this country. How it was void of any culture and filled with an attitude of imperialism. But we all agreed that no one had kidnapped us. We weren't forced to be here, nor were we invited. We weren't restricted from leaving the country either, and we could leave whenever we pleased.

Sometimes we gathered on the weekends at someone's home to share meals that reminded us of our own culture. We longed for our traditional foods since the local restaurants didn't please our palates. Whenever my classmates invited me over for a meal, they would make *pollo ranchero*, or

ranch-style chicken, eggs with cactus, or ground beef tacos. The situation seemed quite hilarious to us because back in Mexico, men in the household didn't cook. Nevertheless, in times like these, satisfying our hunger with familiar foods came before all manner of tradition.

People of Mixtec heritage, like other Latinos, are found almost everywhere on the North American continent today where they have been able to obtain an education and find employment. And, like so many of my distant Mixtec brethren, I no longer live in my homeland, but my heart, my sentiments, and my thoughts return home often. We have a song that says it all, "Canción Mixteca," a Mexican folk song written by Oaxacan composer José López Alavez in 1915. In this song López Alavez describes his feelings of homesickness for his home region of Oaxaca after moving to Mexico City. The song has become the anthem for both the region of Oaxaca and Mexican citizens living abroad who miss their homeland.

While taking my English classes at the high school, some of the anthropology faculty who worked on the UCLA Oaxaca project let me sit in their classes and listen to their lectures. It was helpful for me to listen in English and to have conversations with some of the students. Slowly my English started to improve.

Ellen was a social worker for Los Angeles County and was studying social anthropology as a graduate student at UCLA. Ronald was teaching anthropology. I learned a lot from both during these early months after my arrival. On the weekends, Ellen and her friends would keep me busy with their political activities on the University of California, Berkeley, campus. This mainly consisted of organizing rallies in San Francisco to protest the United States' involvement in the war in Vietnam. Other rallies and marches took place in Los Angeles.

During this time, I started to look for employment and noticed a want ad on the bulletin board of a supermarket in Marina Del Rey, a neighborhood next to Venice. I applied for a job as a bag boy and was hired on the spot. This was my very first job in the United States, and I earned $1.25 an hour. I didn't care much about my low wages since everything I did seemed to provide me with new experiences. My boss was fond of the fact that I arrived on time and was always on task. At the market, I learned a lot of common and important idioms and expressions in English. This was a place where one could hear everything from the most vulgar of phrases to the most refined vocabulary and everything in between. I was exposed to an array of playful expressions

that could be mixed and matched, by incorporating phrases from different origins, including Yiddish, Italian, Arabic, Russian, and of course, Spanish.

I learned that if I showed up on time and worked hard that I could move up the job ladder. One day, we were short a cashier, and I was asked to check out a customer's groceries. As a result, I was promoted to cashier soon after. Unlike today's computerized cash registers, the prices on the groceries back then had to be manually punched into the cash register. If an item didn't have a price, a request was made to the specific department over the loudspeaker. Every time this issue came up, I would take the microphone and describe the item, using English to the best of my abilities, "Groceries, may I have the price on two pounds of brown sugar, please." The shoppers at the supermarket would stop and listen to my accent, laughing and probably thinking "how cute," while a fellow on the other microphone would respond by imitating my accent in an exaggerated tone, practically making a spectacle out of it. I tried to ignore the comments of my co-workers by going with the flow and thinking that at least we had an atmosphere with some camaraderie.

In mid-November the manager told me I was going to work more hours since Thanksgiving was coming up. As usual the week leading up to that Thursday, people needed to buy a lot of groceries, and the store was extremely busy. I had never seen so many shopping carts in my life, and the lines were very long. I wasn't used to checking out so many groceries, and it was overwhelming. Being overwrought with anxiety and suffering from total exhaustion, I decided to quit my job. By then my English was improving, and I was feeling more confident.

INTERESTING TIMES

At the time, Venice was among the poorest communities in Los Angeles, and there were hippies everywhere. No one ever locked their doors because the local philosophy centered on the notion that everything belonged to everyone. I got the impression that some people wanted to turn Venice into a communal neighborhood. When there was a party, you could attend it with or without an invitation. You could eat and sit next to someone that you had never seen before and probably would never see again. Food usually consisted of chili con carne, an affordable choice. It tasted good to me because it had similar ingredients to many of the dishes you find in Mexico.

Smoking marijuana was the norm at these parties, and at night the entire neighborhood smelled like weed. Another popular drug was LSD, a strong substance yet widely used. Venice had the reputation for being a very liberal neighborhood full of dirty hippies and underprivileged folk. Drugs were never scarce, nor were the lazy people who spent their time meditating and listening to sitar music by Ravi Shankar. I saw Venice as setting the stage for the social and cultural movements centered on human rights issues that would later spread throughout the country and would eventually be adopted by most of its citizens.

Ellen was active in the women's liberation movement, and sometimes we would argue to the point where sometimes we would agree to disagree. These were very exciting times. The whole country seemed to be engulfed in the news of people demonstrating in the streets and songs of protest. The performers that stood out the most for me during this time were Joan Baez,

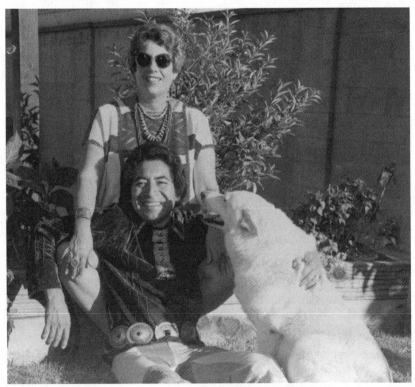

FIGURE 20. Federico and Ellen in their yard in Venice, ca. 1969. Photo by Bob Dixon. Jiménez Family Collection.

Buffy Sainte-Marie, Pete Seeger, Bob Dylan, and the Beatles. One could hear an amalgamation of songs of protest like "Deportee" and "This Land is Your Land" by Woody Guthrie. These songs, along with many others, would stir up emotions and create unity among those fighting for civil rights, equality, and social justice. The ongoing protests against the war in Vietnam were catalysts that strengthened these movements.

The civil rights movement was at the forefront as African Americans were being treated like second-class citizens and were segregated from the rest of society, much as they had been in colonial times. Other activists focused on Chicano power, gay rights, women's liberation, labor, and the American Indian Movement (AIM). These social struggles were significant, extraordinary, and contagious. I felt that it was my duty to be a part of something. I hadn't found my place yet or an ideology that I wanted to fight for, when finally, and purely by chance, I became involved in a cause that I could relate to. The office of Dennis Banks and Russell Means, two leaders of AIM, happened to be located directly behind our house in Venice. This was the Los Angeles headquarters for the movement, which was focused on bringing together the Native peoples living in the city to work on the sovereign rights of all Indigenous people. I immediately identified with their cause and felt embraced by its members, so I decided to join the movement. They gave me a poster with an image of a Native American wearing a headband and holding a flag in his arms that symbolized Red Power. It had the phrase "AMERICA, LOVE IT OR GIVE IT BACK" written on it.

When I went to the marches, I felt proud to be involved in something that was familiar to me, something that reminded me of when I was in the third grade. My teacher, señora Edelmira, told us that the United States had robbed Mexico of more than half of its vast territory to the north. She was referring to the 1848 Treaty of Guadalupe Hidalgo, which transferred the ownership of present-day California, Texas, New Mexico, and most of Arizona, Nevada, Utah, parts of Wyoming, and half of Colorado from Mexico to the United States. Mexico and the United States also recognized the Río Grande as America's southern boundary. The Native Americans I worked with had similar experiences when their lands were usurped by the United States government historically.

It was difficult to gather Native Americans together in Los Angeles, as they were spread throughout the large city. Our cause amassed much interest, yet there was never enough funding. Plus, even though there was a high

level of distrust of the U.S. government among the Native American population, they were still reticent to get too involved with AIM. The largest sponsors were the actor Marlon Brando and the singer Buffy Sainte-Marie, who performed some of her concerts as benefit events for the movement. One of her best and most admired hits about Mexicans that I especially related to was "Welcome, Welcome Emigrante." Sentiments against Euro-Americans were deep seated at the time.

One afternoon when there was supposed to be a meeting, I went around behind our house to the AIM headquarters and knocked on the office door, but there was no answer. When I opened the door, I found that no one was there. I saw a pot on the stove with something cooking in it, so I figured they would be back soon, and I left. An hour later I returned, but the house was still empty, so I turned off the stove and went back home. The next day I found out that Dennis Banks's bodyguard was an FBI agent who was keeping tabs on the entire American Indian Movement. He was tall, handsome, well built, and had long hair. He had a very subtle personality, almost humble. I spoke with him several times, and he seemed very amicable. He would tell me all about firearms and how to handle them. No one ever came back to the house, and I lost contact with the movement's leaders. So, I turned my attention to other social issues that I felt strongly about.

It was about this time that I met Flora Chavez, a west side activist who was the director of the Los Angeles branch of the Community Service Organization, an important California Latino civil rights organization. The building was located on California Avenue just around the corner from where Ellen and I lived in Venice. Flora cared deeply for the community and helped immigrants apply for citizenship, sponsored a food co-op, and ran a credit union where she provided small loans to those in need. She marched alongside Cesar Chavez in the late 1960s and early 1970s, when the farm workers' union took a historic stand for grape pickers in Delano, California. Flora brought food to the striking workers on the weekends. When I learned about Flora and what she was doing, I volunteered to help.

I met Cesar Chavez at one of Flora's meetings, and he gave me a poster that had his photo in the center with the words ¡VIVA LA CAUSA! and a quotation from him, saying, "We are not afraid. If this is what it takes to build a union, a free and democratic union, and a good union for good people, we're willing to do it. As long as there's one ounce of strength in our bodies, that ounce of strength will be used to fight for this good cause. And in the end,

we will win." I used this poster on a placard that I took down to the local Safeway store on the weekends, where I would march in the picket line to show my solidarity with the Latino community and the United Farm Workers. Chavez also gave me a poster with a drawing of a United Farm Worker and the slogan "I Am Somebody, Together We Are Strong" printed on it, as well as a record titled *Sí, Se Puede!* that featured several different recording artists. Whenever I could, I helped Flora distribute food. I also served as a translator for the lawyers providing legal aid to Mexicans trying to obtain their citizenship, even though my English was still fairly rough.

MAKING A LIVING

After continuously hustling and bustling, standstills and protests, I decided in early 1968 that it was time to find another job. One morning I saw an ad in the newspaper that Trevi Plating Company on Bundy Street in West Los Angeles was hiring. So, I got all dressed up and went down to the plant to apply for a job. When I arrived at the main office, I told the secretary that I wanted to apply for a job. She looked at me from head to toe, and when she saw how I was dressed, she said, "You don't need to fill out an application. You are the inspector that Mr. Dinny is waiting for." She practically pushed me through the door into a huge office, where Mr. Dinny was sitting. The secretary then said, "This is inspector Jiménez." Before I could even open my mouth, I was joyfully greeted by Mr. Dinny, who exclaimed, "It's about time you showed up."

Mr. Dinny then proceeded to show me through another door and gave me a tour of the enormous plant, introducing me to people along the way. Finally, at the end of the tour he took me to the department where I would be working. After he introduced me to the manager of the Quality Control Department, he left us alone, saying, "You are in good hands." By this time, I was shaking, and as I sat across from the manager, I explained that I wasn't the inspector that they had been waiting for. I told him that everything had happened so fast that I didn't get a chance to tell Mr. Dinny that there had been a mistake, and I apologized. He immediately replied, "If you are not the inspector we were waiting for, then I'll train you. If you pass the test, you will replace me as manager because I must go to Chicago. My family has been waiting for me there for two months."

To make a long story short, I showed up somewhat anxious the following Monday and got my badge and uniform, which consisted of a pair of white pants, a white shirt, black shoes, and a white lab coat. That was the start of my career at the plant. Training was difficult since my English wasn't very good, but I managed to study the most important aspects of the job and the steps required to inspect the metal parts that were my department's responsibility. The McDonald Douglas Company was one of our clients. They would regularly send us parts to be inspected before they were used in building their airplanes. The inspection consisted of checking for chinks, porosity, or any other defects. The parts were examined under black light, and then they were coated with a chemical and run through a furnace. This process would bring out any imperfections on the part. I managed to pass the test and was issued a diploma that I hung in my office.

After I completed my training, the manager introduced me to the staff and told them that I was the new manager of the Quality Control Department. There were twenty-two employees in total, all of them young Euro-American men with long blonde hair. It was as though they had all been hand picked. The first week as their boss felt like a honeymoon, but I had no idea what was in store for me. The following week I called a staff meeting to go over the production schedule and to discuss specific tasks and deadlines. As I was going over the task schedule, all the guys just shook their heads and were probably thinking, "Where'd this fella come from?" They were not used to such meetings, I guess. Regardless, I didn't feel intimidated at all, and the days marched on uneventfully until one morning I saw Thomas, one of my guys, working at the speed of a tortoise. I said, "Thomas, God gave you two hands, and I want you to use them," to which he responded, "God gave you a big mouth, and I'm going to kick its teeth in." This was the first of many incidents that I had to deal with during my short career as a manager of the Quality Control Department.

The social climate at the factory became increasingly stressful, and supervising twenty-two employees wasn't easy. Anytime I gave instructions, the guys would make fun of my English, and when they thought I wasn't looking, they would mock my every word. I tried to ignore them, but that didn't make the horrible eight-hour shift any more bearable. Our department was next to a furnace that was extremely hot and constantly spewed fumes, and there was a tank with chemicals on the opposite end of the floor that emitted strong vapors. I hate to think of what was going into my lungs when I worked there.

This was one of the worst experiences of my entire life; nevertheless, our production line went uninterrupted, and there hadn't been any delays in our inspections. My boss seemed quite pleased with me and the way I ran the department. Shortly after I passed the three-month probation period, I attempted to turn in my resignation. My boss wouldn't accept my resignation, but I continued to submit it every month thereafter because my work environment was making my life miserable. This type of work was not what I had been seeking when I came to this country; I was searching for something more rewarding and meaningful. The general manager would always convince me to keep working, and every time we met, he would increase my hourly pay by twenty-five cents. The whole situation had turned into a game that was growing tiresome.

To soothe my sorrows and get through my eight-hour day, I dedicated my lunchtime to writing poetry and creating artwork with discarded materials from the plant. I etched designs on metal plates, then covered them with enamel paints and put them through a kiln. The design ideas were inspired by cave paintings, animals, and magical beings. My art pieces became popular at Venice High School, where I was still taking English-language classes in the evenings. My classmates paid me five dollars for each piece, and they bought all I had.

Then one day, I'd had enough and told the general manager to keep his twenty-five-cent pay raise and resigned. My decision had been equivalent to a one-way ticket, as there was no going back, so I proceeded to take a two-week vacation, and I enjoyed it immensely. I didn't have to wake up at four o'clock in the morning to catch my bus to work. Instead, I became a tourist for a couple of weeks, watching the hippies with their ceremonies and dancing essentially in my backyard. I even entertained the idea of living like them and becoming part of their movement to change America.

16

A TURNING POINT

ONE DAY IN 1969 ELLEN and I drove by an open-air flea market on Robertson Boulevard that caught my eye, so we pulled over and parked. I got out of the car as fast as I could and headed toward the entrance. The festive atmosphere and the antiques on display inside piqued my interest. The thought of selling this type of merchandise seemed quite doable to me, so I asked for information regarding the vendor spaces that might be available. The fellow in charge seemed quite interested in renting me a booth for two dollars. Hurriedly, I paid the two dollars, and the following Saturday, I was ready to start a new stage of my life as a vendor at the flea market. I arrived that morning in my little Volkswagen Beetle, a small and quaint vehicle that had cost us three hundred dollars. It had a compartment in front that I filled with the knick-knacks that I had been collecting. We also packed a small card table that one of my classmates in the evening English class had lent to me. Today, that classmate, José Luis Rodriguez, is my accountant.

My inventory included some jewelry that Ellen had. All the jewelry was made of silver, and the majority had been purchased in Oaxaca. I also included some Mexican textiles. After I finished setting up my booth, a gentleman came by and bought most of the merchandise that I had on display, which came to 140 dollars. This was a large sum for me on my first day of business. All the other vendors had a look of shock at my first day's sales. Clearly my

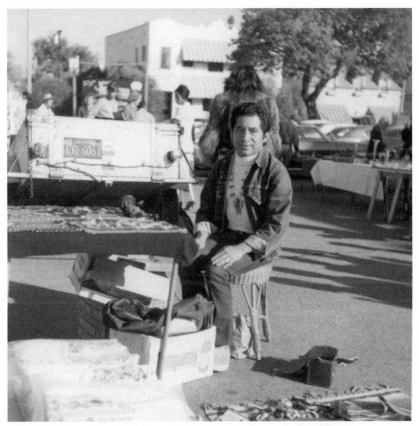

FIGURE 21. Federico on his first day at the flea market, the start of his first business in the United States, 1969. Photographer unknown. Jiménez Family Collection.

early training selling rebozos in the market in Oaxaca had paid off. I hadn't lost my touch as a salesman! Later that day a Japanese man walked by my booth and took my photograph; he gave it to me the following year. It was a testament to my first day doing business in Los Angeles. Little did I know that this day marked an extraordinary step toward my future. That first 140 dollars symbolized the turn my life was about to take.

The following week the man who had purchased my entire inventory on my first day came back. He told me that he made a living producing commercials, and he suggested that at the end of the day I visit his studio, which was across the street. From my booth, I could see the entrance to his studio, so after I closed for the day, I went over to see him. We made an appointment for me to audition for a commercial.

When I arrived on the day and time he had specified, I noticed two large stages with cameras and filming equipment. I had never seen such an elaborate assembly of cables, televisions, and cameras before. I sat down in a high director's chair, and the producer told me how to pose and look at the lens of the camera. Finally, he told me that he wanted to shoot a commercial with me. I had no idea what making a commercial entailed and told him that I would talk it over with Ellen, promising to give him an answer the following Saturday. After I closed my booth that Saturday, Ellen and I went to meet with him. He told us that he would pay me six hundred dollars for the commercial, which Ellen approved of. We then scheduled the time for the filming.

When Ellen and I arrived at the studio to do the commercial, the costume designer dressed me in a long sleeve shirt and pair of white shorts, which were too big. The producer said, "the bigger the better," and he complemented the outfit with a red scarf, huarache sandals, and a sombrero with a huge cone that fell to one side of my face. I was supposed to come out of a kitchen holding giant bags of tortilla chips in each hand and yelling, "Frito bandido!" The first time I did it, he was impressed with my acting and said, "Good, very good, let's do it again." At that point, Ellen interrupted him and said, "Sir, there's no way my husband is going to do this. It is so stereotypical, and perpetuating the stereotype makes me sick. I'm sorry but I can't allow my husband to do this. It's an insult to his culture!"

That was the end of my short-lived career in commercials. Granted, this was due in part to the times we lived in, as human rights groups were fighting against discrimination and the perpetuation of stereotypes. The producer surely had the good intention of helping me. He looked disappointed and told Ellen that it was a shame she felt that way, and that we could always contact him if we changed our minds. Every weekend he would come by my booth and chat with me about all manner of topics, except commercials.

Selling at the flea market was one of the most important ventures in my life. It became a full-time job and something quite fitting for me, as I had long hair and wore bracelets, necklaces, rings, belts with silver and turquoise, and sometimes a cowboy hat. Sporting the fashion of the time along with my poise and friendliness helped me stand out among the merchants. From the beginning, I focused on cultivating potential long-term clients. I didn't have an extensive amount of merchandise, but my income continued to grow. I wasn't making 140 dollars anymore, which was very symbolic to me. With the income I was making, I could afford to go to other flea markets during

FIGURE 22. Federico at the flea market in Hollywood, ca. 1973. Photographer unknown. Jiménez Family Collection.

the week and buy merchandise to sell over the weekend in my booth for a profit.

It was during this early period as a flea market vendor that I started taking jewelry-making classes at University High School in West Los Angeles. I learned the different techniques of silversmithing and the cutting, shaping, polishing, and setting of gemstones. I made necklaces, belts, bracelets, and earrings. I also developed many of my own unique designs. I found something that I had a passion for, and I also had a creative sense that I didn't know existed. In the evenings, I made jewelry that I sold at the flea market. Later, when I designed and made jewelry in the back of my gallery in Santa Monica, I sold it there, as well as at jewelry shows and art markets around the country and in Mexico.

The manager of this flea market lost the lease on this location, and so some of the other vendors and I moved to a different flea market at the corner of Santa Monica Boulevard and Havenhurst in Hollywood. This was a positive change for me. The number of clients greatly increased, along with their higher level of taste and interest in quality merchandise. It was an intimate yet important flea market in Los Angeles back then. I had never seen movie and TV stars walking around a flea market before, but then, this was Hollywood. Tinsel Town, as many refer to Hollywood, gave me the opportunity to meet many of the rich and famous.

My first famous client at this flea market was a well-known TV personality. Cher arrived with two friends, and she picked out an old Navajo belt, a necklace, rings, and bracelets, all of them by Southwest Native American artists. When one of her friends wrote out the check to pay for them, I told her that I didn't take checks. They were surprised and explained who she was, but at the time, I had no idea who they were talking about. I saw only a

woman at my booth dressed like a hippie with long black hair and sequins on her cheeks. Minutes later, everyone at the flea market noticed the situation, and several of the other vendors came to my booth, suggesting that I accept the check, but by then it was too late. She had already sent one of her friends to cash the check at a restaurant across the street called Theodore's. She came back and paid me in cash. That was the first time my booth had gotten so much attention.

The following Saturday a very pretty lady came by my booth and asked me to show her some of the items I had in a display case. After looking at several items, she whispered in my ear, "Can I sit next to you behind your table?" I agreed and immediately noticed that everyone who walked by the booth looked at us in wonder. I later learned to my surprise that she was Catherine Deneuve. It turns out she wanted to sit beside me so she could discreetly bargain for the items she was interested in. I was fortunate to have numerous clients from Hollywood who came by my booth regularly. Important designers also dropped by, along with vendors who had shops on La Cienega Boulevard, home to the largest concentration of prestigious antique shops in Los Angeles. I was fortunate to have such a wonderful clientele. This flea market was tiny yet very successful.

A NEW OPPORTUNITY COMES MY WAY

A middle-aged Jewish lady, Gen Ruben, used to visit my booth at the flea market. She loved to chat with me, and one day she invited me to her shop on Main Street in Santa Monica. In 1972, she offered half of the shop space to me at no cost with the condition that I have the shop open at least five days a week. In return, I would also tend her half of the shop, which included antiques and other merchandise. And so, that is how I got my first official retail space.

Her side of the shop was filled with antique furniture and Victorian vintage jewelry. There were oriental items, American ceramics, and lots of artifacts from Jewish culture. My half of the shop was decorated with Mexican jewelry and textiles, as well as items that I had purchased at flea markets. There were numerous signs around the shop that I didn't agree with. At times, I was even embarrassed when clients came in and began reading them: "No children; no smoking; if you break it you buy it; no checks; no discounts; no returns; do not open displays; do not touch; hold children's hands; no food;

no drinks; no shoes, no shirt, no service." This gave me the idea that I should have my own business cards printed. So, I ordered them with the name of my business and my self-proclaimed title as Director of Gen's Bric-a-Brac printed on the back.

Gen was like a mentor to me and taught me all the ins and outs of the antique business. She explained everything in great detail, particularly how she paid special attention to her clients. She told me her life story and how long she had been in the world of antiques. Our talks would usually take place when she stopped by on Saturdays to check on her business. Gen was somewhat strange and eccentric, but she had good intentions and was a wise businesswoman. I learned a lot from her. During this time, I was still selling at the Hollywood flea market on Sundays, and with what I learned from Gen Ruben, I was able to sell higher-end merchandise and increase my regular clientele.

ON MY OWN AT LAST

After three years in Gen Ruben's shop, I decided to open my own business on Washington Boulevard, now known as Abbott Kinney Boulevard, in the city of Venice. This was around 1975. It wasn't the best place, as it was quite small, but the rent was only two hundred dollars a month. We sold vintage clothing, antiques, and jewelry. For my own safety, everyone who entered the store had to ring a doorbell on the outside. Even though my shop was in a dangerous part of Los Angeles, many of my long-standing Hollywood clients would come and buy from me there. I also had a growing clientele from the surrounding neighborhoods. During this time, I also continued to sell at the Hollywood flea market on the weekends.

One day a lady and her daughter rang the bell and entered my store. After looking around, they filled a display table with Native American textiles and jewelry, as well as Mexican items. Some were the highest quality items in my shop. When it came time to pay, I found it quite odd that they hadn't asked for a discount. Nevertheless, I went ahead and rang up the items. When they gave me their check, I wrote down both of their driver's license numbers, along with their home and business addresses and phone numbers. In addition, when their merchandise was loaded into their car, I took down their license plate number. They said there wouldn't be any issues with the check,

but I was still a little nervous about such a large sum. Later that evening, Ellen stopped by after work and saw the name of the person who wrote the check. She said she hoped I had treated them especially well. "Why, do you know them?" I asked. She told me they were the wife and daughter of a well-known banker and financier in Southern California.

I suppose my shop was rather unique as it was filled with popular artwork made by Native Americans, which was in vogue back then. My clients were always pleased with the merchandise I carried since they always found something to buy. Shortly after opening my shop on Washington Boulevard, I heard that the flea market in Hollywood would close permanently. Its owner had sold the property to a developer, who wanted to build an apartment complex. It didn't affect me much since I was doing well where I was. Around that time, my father passed away, in 1977, from a gunshot wound he sustained when the holstered gun he was wearing accidentally discharged and hit an artery during one of his drunken escapades with his friends. Shortly after, my brothers Juan and Francisco decided to come up from Oaxaca to work with me in California. When they arrived, they lived at our house in Venice. My brothers and I would go around and barter for goods at different flea markets to add to our inventory. Business was very good, and we were selling both wholesale and full retail out of my little shop, which continued to be popular and successful.

A couple of years later I joined Don Bennett's Whitehawk Antique Indian and Ethnographic Art Show in Santa Fe, New Mexico. The first show in 1980 had about one hundred dealers and was held at the Hilton Hotel just off the Santa Fe plaza. There were about thirty of us founders who had tables set up in the lobby, while others did sales in their hotel rooms. As it grew, some dealers sold merchandise out of their cars in the hotel parking lot. The Whitehawk Show got so big that it eventually moved to the Santa Fe Convention Center, where it continues to be held to this day on the weekend before the annual Santa Fe Indian Market. As one of the original founders, I continue to show there every year.

A GROWING BUSINESS

One morning in 1982 when Juan, Francisco, and I arrived at my shop on Washington Boulevard, a man with Asian features was waiting for us. It

turned out that he was a Korean businessman. On entering, he looked at the merchandise on display and struck up a conversation with me. We spoke about Venice and about the business. Despite my enthusiasm, I felt somewhat disappointed that he didn't buy anything when he left.

The following week the Korean businessman came back to my shop with an offer: "I know you are a good and honest businessman, and I have an open space available on Montana Avenue in Santa Monica, the most important street after Rodeo Drive." It turns out he wanted to sell his property, but to do that he had to prove that his space was worth the price. The rent was three dollars per square foot, but he offered it to me for three months free of charge and would pay the expenses to relocate my inventory. He said that if after three months I didn't feel I could pay the rental fee, he would cover the cost for me to relocate back to my current location.

Such a good offer along with the opportunity to have my own antique store and art gallery on Montana Avenue, which was in a prestigious area of Los Angeles, sounded perfect. Nevertheless, I held back on my final answer until I had a chance to discuss his proposal with Ellen and my brothers Juan and Francisco. We talked it over that week, and everyone agreed that I should accept his offer. I called him to let him know that I accepted.

The following week we loaded a truck with our entire inventory and moved it to our new store and gallery space on Montana Avenue. When we arrived, the neighboring business owners came out of their stores to see what was going on. We unloaded an assortment of items, including old Mexican furniture that was a bit decayed and riddled with insect holes. The gallery was move-in ready, and we didn't have to do anything. It was freshly painted, the flooring was ideal for furniture, and there was a storefront window facing Montana Avenue. The only thing we had to do was wash the floors and clean the windows.

On the second day at our Montana location, we displayed Native American jewelry from the southwestern United States in the window. On the third day a woman was passing by while walking her dog and knocked on the door, inquiring about the price of a silver concha belt with turquoise settings that was in the window. I told her the belt was $2,800 and that our grand opening was planned for the upcoming weekend. She insisted on looking at the belt, so I took it out of the window display and showed it to her. She held it, tried it on, and looked at herself in the mirror. Then she proceeded to open her little change purse, took out a credit card, and gave it to me. I told her that

I wasn't set up for credit card transactions yet, but she insisted on buying the belt that day because she had a party that night and really wanted to wear it, so she wrote a check instead. This was my first sale, and I celebrated it with my brothers after she left. We yelled and jumped for joy, but the most exciting thing was yet to come.

As we were getting ready to leave at the end of the next day, another woman, who had also been looking at the jewelry display in the window, asked about the turquoise and silver necklaces. I let her in, and she tried on almost all the necklaces from the display, which had taken me the greater part of the day to set up. Suddenly, the lady looked at me and said, "I'd like to buy all of the necklaces and bracelets." When she gave me her credit card, I realized she was the singer-songwriter Joni Mitchell. This was my first sale to Joni, and our relationship as business acquaintances and friends has continued over the years.

That night, after the second sale I decided that our store and gallery on Montana Avenue would be our location for a long time. I called my store and gallery Federico's on Montana, and I think this was the golden age of my business. Often it seemed there were more clients than merchandise, as popular art and Indian jewelry and folk art were in style then. Upon the release of a publication titled *Casa Mexicana: The Architecture, Design and Style of Mexico*, by Tim Street-Porter, in 1989, Mexican popular art and folk art grew even more popular among collectors and interior decorators in Southern California and the Southwest.

Shortly after we got settled on Montana Avenue, another opportunity came along that involved the purchase of an antique show in Veteran's Auditorium in Culver City. This antique show was in decline, and the vendors weren't entirely on board with the way that it was being managed. There was a need for new energy, engagement, and marketing. The owners were an elderly couple whose interest had shifted toward selling the business. We made a deal, and I gave the antique show in Culver City a new name and look. One of my new responsibilities included the supervision of seventy-five vendors, who would meet on the third Sunday of the month. It was here that I opened my own booth, called the Jiménez Antique Shop and Sale in the Culver City Antique Show, which I considered to be the best one-day indoor antique show in Southern California. I closed Federico's on Montana on Sundays, and once a month Juan and Francisco helped me with the Culver City antique show.

Figure 23. Ellen wearing a beaded blouse and some of her Mexican jewelry, and Federico wearing a Navajo velvet shirt and silver concha belt at the Southwest Museum, ca. mid-1980s. Photographer Alan Berliner Studios. Jiménez Family Collection.

Some vendors participated merely to socialize while others did it for a living. I would specifically ask them to bring quality merchandise and included vendors whose merchandise was acceptable even though it was not considered antique, such as pop art or Indigenous craftwork. We had an ample array of goods, which kept the public happy. Being the owner had its perks. I had priority to purchase the best pieces before they were displayed to the public. As a result, all my new acquisitions were added to the Montana Avenue location.

It was quite satisfying to see that American Indian silver jewelry did so well. On the other hand, Mexican silver was in the pits; it couldn't compete with American Indian silver. Nevertheless, I promoted Mexican jewelry by showing it with traditional Mexican textiles, especially silver filigree and beads made of silver, glass, and jade. The fashion trendsetter Frida Kahlo was the first to combine pre-Hispanic Indigenous jewelry with traditional huipiles and full skirts. Breaking away from the European and American influences in clothing and jewelry, Frida created a fashion statement that continues to the present. Frida also influenced our own personal collecting, and Ellen wore huipiles and Mexican jewelry to work and to various public events in Los Angeles.

By this time, I had many clients in the United States and in Mexico who wanted to learn more about Mexican jewelry and clothing, and I helped them start their own collections. I also started organizing exhibitions of high-end Mexican silver merchandise in my store and at the Culver City Antique Show. When I undertook this new endeavor, I had already amassed a large collection of jewelry by famous silversmiths from Taxco, in the Mexican state of Guerrero. Among them were William Spratling, Hector Aguilar, Antonio Piñeda, Freddy Davis, Siggi, Margot de Taxco, Matilde Poulat, and others.

Every month I would place a sign near the entrance to my booth at the Culver City Antique Show that read, "not for sale—only on exhibit" so that people could familiarize themselves with high-quality Mexican silver. I'd explain the history, the process, and the importance of Mexican silver, as well as the techniques, design, and pre-Hispanic influences. Additionally, I would mention some personalities that valued and proudly wore Mexican silver, such as Frida Kahlo, the great actresses Maria Felix and Dolores Del Rio, the Rockefellers, and other celebrities from far and wide. I also had the opportunity to promote Mexican silver at two conferences for the Bead Society held in California. One was held in Los Angeles and the other one in

Berkeley, where I discussed beaded jewelry from pre-Hispanic to contemporary times.

In addition, I started inviting guest artists to come to Federico's on Montana to discuss Mexican silver while promoting their work. After a while I started presenting exhibitions of artists from Latin America and the American Southwest, as well as local artists, in my gallery space. Latin American artists, painters, and sculptors, as well as silversmiths from Taxco, displayed their works in my store and gallery. There were also exhibits of American Indian artists.

One very successful exhibit in the mid-1980s was the one I had for Helen Cordero, a Cochiti Pueblo potter from New Mexico who was renowned for her Storyteller clay figurines. Her clay figurines consisted of an adult Pueblo male storyteller with numerous children climbing on him to listen to his stories. During the opening of the exhibit, Helen told stories about her family and the Cochiti Pueblo people. Her exhibition was a huge success. Within two hours of opening the showroom, all her pieces had sold. Helen's husband, Fred, played his traditional drum and sang and entertained the attendees that night. Helen and Fred stayed at our house, and they were hypnotized by the Pacific Ocean when they saw it for the first time. Another New Mexican Native American artist we exhibited was Michael Bird Romero, a renowned silversmith from Ohkay Owinge (formerly San Juan Pueblo). He was also a big hit with my customers on Montana Avenue.

Among the grand masters of Mexican silver was my friend and artist Antonio Piñeda. He was well received by Americans for his modernist style. He had an exhibition in my gallery around 1985. In all the time that I had known Antonio, I had never seen him so happy. His reputation as a sought-after jewelry artist was affirmed that night. This exhibition was highlighted by the presence of Ricardo Montalbán, who cut the ribbon for the opening of Antonio's exhibition.

Federico's on Montana's popularity grew as the number of events increased. In addition, we constantly brought in new items in the style of popular art that Native Americans created, especially the Navajo, Zuni, Hopi, and other tribes from the Southwest. The pieces that came from the high plains of the United States included moccasins and clothing covered with cut glass and metal beads. Mexican colonial furniture and religious art were part of the remarkable inventory that caught the eye of our clients, who responded with great enthusiasm and interest. Some would purchase works to decorate their homes, to give as gifts, or to add to their collections.

FIGURE 24. Federico in his store Federico's on Montana, ca. 1990. Photographer unknown.
Jiménez Family Collection.

A CHANCE TO FIND FORGIVENESS FOR MY SINS

During my years on Montana Avenue, Ellen and I traveled to numerous countries around the world. One of my most memorable trips was the one we took to the Middle East, where we visited Israel during its Fortieth Anniversary of Statehood celebration on May 14, 1988. We stayed at the King Solomon Hotel in Jerusalem to observe the celebration. While there, I was reminded of the time I unknowingly committed a sin as a child when I spit out the host on the church floor, and then that fateful Christmas Eve when the Baby Jesus was burned. Both events resulted in my excommunication from my mother's church for five generations, twice. I recalled my mother saying that I needed to walk along the Via Dolorosa and stop at each station and ask for forgiveness, cry, and repent for what I had done. The Via Dolorosa, a processional route within the old city of Jerusalem, is believed to be the path that Jesus walked on before he was crucified. I couldn't believe I actually had a chance to finally be absolved of all the sins I had made against the church, Baby Jesus, and God. So, I took this opportunity to walk the Via Dolorosa and afterward felt relief that I was finally forgiven for my sins.

Even though it was important for me to go to Israel and to walk the Via Dolorosa, my mother also told me that I needed to ask for the pope's blessing. So, years later when Ellen and I went to Rome, Italy, we visited the Vatican and the Sistine Chapel. My mother's warning was still fresh in my mind as we stood in Vatican Square, and the pope came out on his balcony and blessed all the people who were there. As I stood there, I was finally able to receive the pope's blessing and God's forgiveness. The relief I felt at having another opportunity to finally be forgiven after all these years was overwhelming. I almost felt as though my mother was looking down on me and smiling. I was finally liberated from the burden of being a "sinner" and that "wretched boy" of my childhood in Tututepec.

EXPANDING FEDERICO'S ON MONTANA

When the business next door closed in 1991, we had an opportunity to expand our store and gallery another one thousand square feet. I gladly signed the new lease, which doubled the size of the space at Federico's on Montana. The sheer size of the store and gallery increased our level of prestige as well,

as it was the only store on Montana Avenue that was this large, and maybe even in all West Los Angeles. I knew that this posed a greater responsibility and risk, but it also gave us a chance to show art in all its greatness as more influential clients came in and bought from us.

My dear friend Ali MacGraw, who was one of my regular clients at Federico's on Montana, is to this day like a sister to me. In Santa Fe, Ali volunteers much of her time to assist me at the Whitehawk Indian and Ethnographic Art Show and at Ortega's on the Plaza during the annual Indian Market. More recently, she has helped me at the annual International Folk Art Market held in Santa Fe in July.

Many of my regular clients like to wear both the jewelry I made and pieces by other silversmiths. Some of my clients would spend time with my mother and eat some of the tacos she had prepared when she was visiting. When my mother came to visit for a couple of months at a time, she would come to work with me at Federico's on Montana, where she enjoyed talking with my clients and customers. She stayed in the little apartment next to our house that we had built especially for her. When my mother got bored, she would go back to Oaxaca to be with other family members. She passed away shortly after her visit in 1991, and our clients often mentioned how much they enjoyed meeting her.

I am very thankful for having such a regular clientele who shopped at Federico's on Montana. One time when Governor Ann Richards of Texas was visiting Los Angeles, her security detail came into the store before she did and scared the daylights out of us. My brother Juan thought they were with the FBI because they were all in suits, and we panicked because we didn't know what we had done wrong. Moments later Ann Richards came in and said she collected Matilda Poulat's jewelry and had heard that we carried her jewelry in our store. She bought a couple of Poulat's pieces that she liked.

I kept Federico's on Montana for seventeen years. At the same time, I was traveling and setting up booths at several other antique and jewelry shows throughout the country and going back and forth to Mexico on collecting trips. These were very successful years for me. When Juan and Francisco decided to go back to Oaxaca in 1999, I decided it was too much for me to run both Federico's on Montana and the Jiménez Antique Show and Sale in Culver City. So, I decided to close Federico's on Montana and focus on the Culver City business and other shows.

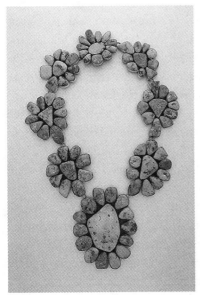

FIGURE 25. Turquoise and silver necklace
designed and made by Federico, ca. 1990s.
Photo courtesy of Federico Jiménez.

FIGURE 27. Advertisement featuring Ali
MacGraw wearing jewelry made by Fed-
erico during the 2010s. Jiménez Family
Collection.

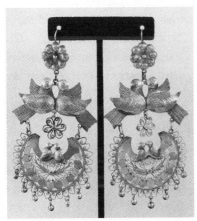

FIGURE 26. Silver earrings designed by
Federico, ca 1990s. Photo courtesy of
Federico Jiménez.

Before closing Federico's on Montana, I was already selling my jewelry at other venues. I have had a lot of success selling my jewelry and antiques at the annual California Gift Show at the Los Angeles Convention Center, now the LAMKT, which is held in July. Depending on the time of year, I have sold my jewelry at the New York International Gift Fair at the Jacob K. Javits Convention Center as well. At times this show conflicted with the Whitehawk Antique Indian and Ethnographic Art Show and the annual Indian Market in Santa Fe. In addition to the Whitehawk shows, I started showing and selling my jewelry at Ortega's on the Plaza in Santa Fe during the annual Indian Market in 1995. I was given a section of the store to sell my jewelry during this market, which proved to be a successful venture for more than twenty years. Over the years I have also participated in the Tucson Gem and Mineral Show, where I continue to sell my jewelry and purchase gems and stones to incorporate into my new jewelry pieces. I no longer make all my jewelry pieces and instead hire silversmiths in Mexico to make my silver earrings. I continue to design unique one-of-a-kind larger pieces, especially necklaces, that I have fabricated in gold and silver by specialists as well.

In 2003 Charmay Allred told me about a new international folk art market that she was involved in getting started in Santa Fe. The first one was held in July 2004. Unfortunately, the date conflicted with the timing of the California Gift Show, which I had been participating in for years. Finally, she was able to convince the organizers to move the date by one week, and in 2006 I attended my first International Folk Art Market (IFAM). I joined more than 150 artists from all over the world. Except for 2015, I have participated in this market for more than a decade. I especially enjoyed meeting artists from around the world as well as visiting with artists and friends from my homeland.

During my years participating in the IFAM, Ellen and I have provided funding to the Museum of International Folk Art to sponsor an artist from different areas of the world. These artists come from all continents and all corners of the world, and I have learned much about the different cultures of the artists we have sponsored. Through the sponsorship of the Belber-Jiménez Museum that Ellen and I founded, we also bring a jewelry artist from Oaxaca to IFAM who is continuing the tradition of Mexican filigree silverwork. This is a special program in which the Belber-Jiménez Museum is supporting the preservation, revival, and continuation of this art form.

17

LEARNING ABOUT MUSEUMS
AND PHILANTHROPY

M Y CALENDAR WAS ALWAYS QUITE full, but when one of my clients, Charmay Allred, invited me to be her guest at the opening of a special exhibition of Mimbres pottery at the Southwest Museum of the American Indian, in the Mount Washington area of Los Angeles in the early 1980s, I gladly accepted. The Southwest Museum was created by Charles Fletcher Lummis and the Southwest Society in 1907. It was the oldest museum in Los Angeles, and it had a collection of a quarter million works of art, cultural items, and archeological artifacts representing the Native American and Hispano peoples of the American Southwest and California.

I already knew a little about the Southwest Museum, and on my arrival at the exhibit opening, Charmay introduced me to her friends. Charmay was energetic and affectionate, hugging and kissing everyone who came in. I quickly realized that she was a very important lady in this social circle. Afterward, when I arrived home, Ellen asked me about the opening, and I told her that it went very well, that Charmay was one of a kind, and that she was friendly, energetic, and extremely interested in museums. That night Charmay told me that the Southwest Museum was "her baby," and after some time I realized why. She had invested both money and time in ensuring the success of this museum. Soon after that, she invited me to be a part of the steering

FIGURE 28. Federico and Charmay Allred at an exhibit opening at the Southwest Museum, ca. 1985. Photographer unknown. Jiménez Family Collection.

committee and the collector's club. She told me that we would be raising a lot of money for the Southwest Museum through special events.

MY FIRST VENTURE INTO PHILANTHROPY

The first event I had the opportunity to organize was a special presentation of our personal collection of Indigenous Mexican costumes to raise funds for

the museum. This gala event was called Noche Mexicana (Mexican Night). For the first time in its history, the Southwest Museum charged 150 dollars for a ticket to the event. The Mexican food was delicious, and the marimba band was fantastic. The biggest event of the night was the parade of Mexican garments from our collection that were worn by members of the Southwest Museum. There were seventy textiles included in the fashion show, which made it a vibrant and colorful event. It was such a success that this type of fundraising event became an annual celebration.

After a couple of years working on fundraising events with Charmay, she recognized my growing interest in the Southwest Museum, so she invited me to join the board of directors. When I went on the board of the Southwest Museum, I was a well-known collector of Mexican jewelry and textiles. At one of the meetings held by the public events committee of the board, it came to my attention that the Southwest Museum would be celebrating its eightieth anniversary with an exhibition showcasing the Nelson A. Rockefeller Collection of Mexican Folk Art. The museum director asked me to complement the exhibition with a display of our Mexican jewelry on the opposite side of the gallery, which of course I was delighted to do. The exhibition, *The Federico and Ellen Jiménez Collection of Mexican Jewelry*, opened in September 1987 at the same time as the Rockefeller Collection.

Both exhibits were part of the anniversary gala celebration, which also honored the former ambassador to Mexico from 1981 to 1986, John Gavin. Ellen and I attended along with my mother, Imelda, and my brothers, Juan and Ramon. Ambassador Gavin attended along with his wife, Constance Towers, and several other dignitaries from Los Angeles and Pasadena. Throughout the evening Constance came up to our table several times to talk with my mother. My mother, of course, was very impressed and pleased with her son's obvious success and recognition.

The Southwest Museum was always in need of operating funds, so in November 1987, I organized a fundraiser at the Pasadena Convention Center called the Pan American Indian Art Show. It included 250 artisans specializing in popular Indigenous and Native American art. We raised quite a bit, which enabled us to offset the operating deficit in the budget. Shortly after we held this Pan American Indian Art Show, the museum director, Patrick Houlihan, resigned and left his post at the Southwest Museum, on November 30, 1987.

In 1989, I gave the Southwest Museum a large cash donation, and I continued to organize the Pan American Indian Art Shows. At our fifth

FIGURE 29. Photo of Federico and Ali MacGraw at the Pan American Indian Art Show in 1992. Photographer unknown. Jiménez Family Collection.

Pan American Indian Art Show, in 1992, Gloria Molina, supervisor of the First District of Los Angeles, along with actress Ali MacGraw and singer-songwriter Joni Mitchell, hosted the opening. Through this fundraiser we were able to net $22,000, which was a considerable amount for the Southwest Museum at the time.

One of the fundraising events that I organized as a board member was a trip to Oaxaca with forty-two museum members paying five hundred dollars each. The trip was successful, and everyone had the opportunity to witness the Guelaguetza festival, where seven state regions meet in the capital to showcase their traditional costumes, regional dances, crafts, and produce. Everyone had a wonderful time attending the festival and especially learning about the costumes and crafts of the coastal region that were representative of my childhood home. They also received a certificate from the mayor of the City of Oaxaca, making them honorary citizens.

THE MILLICENT ROGERS MUSEUM IN TAOS, NEW MEXICO

When I joined the Southwest Museum board, Patrick Houlihan was the museum director. He served as director from 1981 to 1987. When he left the Southwest Museum to become director of the Millicent Rogers Museum in Taos, New Mexico, he suggested that I join its board of trustees. I had visited the Millicent Rogers Museum in 1970 when Ellen and I became interested in exploring northern New Mexico, which included visits to Taos and its museums. Taos is a remote, beautiful, and spiritual place where one is overcome with the urge to meditate and pray to the gods of Taos Mountain, which is considered a sacred place by the Native peoples of Taos Pueblo. The pueblo is a special place that has remained timeless and exceptional, even with all the influences of the surrounding modern world.

Words fail to describe the way I felt the first time I set foot in the Millicent Rogers Museum. My mind filled with ideas of creating a museum like this "Jewel of the Southwest" myself someday. Millicent Rogers's legacy was preserved by the museum's founder, Paul Peralta-Ramos, one of her sons. He established the museum as a tribute to his mother in 1956, not long after she passed away in January 1953. Millicent Rogers led an extraordinary life, and I admire her greatly for that. Serving on the board of the Millicent Rogers Museum has been one of the most remarkable experiences of my life.

Around 1990, the Millicent Rogers Museum hosted an exhibition of my collection of Mexican jewelry. This exhibition included William Spratling, Antonio Piñeda, Fred Davis, Margot, and Hector Aguilar. It was like the one we held earlier in my gallery on Montana Avenue in the mid-1980s. It was very popular and well attended by people from both Taos and Santa Fe.

About this time, I was getting frustrated with the board at the Southwest Museum. I felt that there needed to be more diversity on the board, and I argued that given the importance of the Native American collections, it was especially important that there be Native Americans on the board. Some of the board members felt that they already had Native American represen-tation by having Iron Eyes Cody on the board and that should be enough. I pointed out that he wasn't a Native American and instead was an Italian Hollywood actor. At the time, Jerome Selmer was the director, and in 1990 I finally decided I had to leave and just focus on the Millicent Rogers Museum, so I resigned from the Southwest Museum's board.

Now I was able to concentrate on the Millicent Rogers Museum and to do what I could to help it succeed financially. Millicent Rogers was not only known for her individual style and her relationships with famous fashion designers, but she was also a talented artist, and she left behind sketches of several of her own jewelry designs. When these were found in the museum archives, I was asked to showcase reproductions of some of her personal jewelry designs at Federico's on Montana in California. I arranged for my brother Juan to reproduce twenty-nine of Millicent's original jewelry designs to be sold in the museum's gift shop as part of a fundraiser for community programs. We opened an exhibition of Millicent's jewelry reproductions at Federico's on Montana on May 17, 1991, and more than five hundred of Hol-lywood's rich and famous attended this special event.[26] It was shortly after this show that I doubled my store and gallery space.

The Millicent Rogers Museum's board meetings took place four times a year in Taos, and I never missed a single one. During my six years on the board (1987–1993), I had the opportunity to visit many of the Pueblo and Hispano villages in northern New Mexico and witness the diverse cultures and customs. Ellen and I particularly enjoyed the ceremonial dances at Taos Pueblo and the Hispano religious ceremonies and pageantry. During our

26. See Tisdale, *Fine Indian Jewelry*, 176–184, for examples of Millicent Rogers's designs reproduced by Juan Jiménez.

travels throughout northern New Mexico and other areas of the Southwest, we added pueblo pottery, Native American silver and turquoise jewelry, textiles, and baskets to our collection, along with Spanish colonial *retablos* and *santos*, furniture, textiles, and jewelry.

JOINING THE BOARD OF THE AUTRY MUSEUM OF WESTERN HERITAGE

Joanne D. Hale and her daughter Susana were part of my clientele at Federico's on Montana. Around 1991 the two of them, along with Jackie Autry, invited me to tour their museum, known as the Autry Museum of Western Heritage, in Griffith Park. Joanne D. Hale was the president and CEO, and Jackie Autry, along with her husband, actor and singer Gene, founded the museum, which opened in 1987. At the end of the tour they invited me to have lunch at their office, where we discussed the cultural aspects of Los Angeles, along with the history of western ranching and Native American arts and

FIGURE 30. Federico, Gene Autry, and Ellen at one of Mr. Autry's birthday celebrations, ca. mid-1990s. Photographer unknown. Courtesy of the Autry Qualified Interest Trust, The Autry Foundation, Los Angeles, California.

culture. They also invited me to join the board of trustees. I accepted the invitation to join the board under the condition that I have an opportunity to promote Latino culture. Subsequently, during my first board meeting, the museum director and the museum curator provided me with a list of programs that would positively affect Latinos in Los Angeles.

Ellen and I have had extraordinary experiences and great times with Jackie and Gene Autry. When Gene was still alive, we were invited to their home every year to celebrate his birthday. Gene and I would sing songs in Spanish like "Cuando se Quiere de Veras," "Allá en el Rancho Grande," "Cielito Lindo," and "La Cucaracha." I was pleased to be welcomed and treated so well by the members of this board as well.

Not long after joining the Autry Museum's board, I decided it was probably time to become a United States citizen. I had no plans to move back to Oaxaca, and I had a successful business and paid taxes, so I went ahead and submitted the paperwork to make it official. I had my resident green card from my sponsorship with Ronald Waterbury and the UCLA project when I had first come to the United States, and it served me well. Now that I had lived in California for over a quarter of a century, it made sense that I become a citizen. I was naturalized as a U.S. citizen on June 23, 1994, at

FIGURE 31. Federico and Ellen after they were remarried in Las Vegas, Nevada, in 1996. Photographer was Lois Varga, who served as a witness. Jiménez Family Collection.

the age of fifty-three. Even though we were legally married in Tehuantepec back in 1965, Ellen and I decided to get a marriage license in the United States. We also wanted to renew our wedding vows. So, Ellen and I went to Las Vegas, Nevada, and we were officially remarried there on March 2, 1996. We felt more secure in having our marriage officially recognized in the United States.

PLANNING FOR A NEW LATINO MUSEUM IN LOS ANGELES

When my term of service on the board of the Millicent Rogers Museum came to an end in 1993, I focused full time on my store and gallery on Montana Avenue. I hosted Chicano art exhibitions, and at one of the openings, I was introduced to David de la Torre, who had been hired as a consultant to explore the possibility of opening a Latino Museum of History, Art, and Culture in Los Angeles. David and I discussed the art and cultural activities that I was developing at Federico's on Montana, and we discovered that we had much in common. Most notably, we were searching for a place to celebrate Mexico's rich cultural heritage. We talked about the need to create a museum that belonged to the Latinos based in Los Angeles.

David de la Torre was moved by the sense of urgency behind my ideas, interest, and passion for a museum for Latinos, and he suggested that I meet a very important woman within the Latino community, Antonia Hernandez. Interestingly, I had already made her acquaintance a couple of years earlier, when I was invited to a luncheon at a home in Bel Air. I was seated next to Antonia Hernandez, and we discussed the possibility of a Latino museum at that time.

In 1994, David de la Torre set up a meeting with Antonia Hernandez, who at the time was the president and general counsel of the Mexican American Legal Defense and Educational Fund (MALDEF). This is a national nonprofit organization that protects and promotes the civil rights of the millions of Latinos living in the United States. Headquartered in Los Angeles, with regional offices in Washington, DC, Chicago, Atlanta, and San Antonio, MALDEF focuses on the critical areas of immigrant's rights, education, employment, political access, and public equity. MALDEF especially works to ensure that Latinos enjoy equal opportunities to participate fully in our country's democratic process so that they can make a positive contribution

toward its well-being. It is an organization that I believe in, and I support the work they do on behalf of the Latino community.

During our meeting with Antonia Hernandez, I was invited to join the board of directors of the Latino Museum of History, Art, and Culture that was being planned for Los Angeles. Antonia Hernandez, Roxanna De Soto, Gloria Molina, and California state senator Charles Calderon (1990–94) were among the board members. I accepted and immediately formed a committee to host exhibitions and shows of popular Latin American arts and crafts to raise funds for the new museum. Since I was already familiar with the Pasadena Convention Center, it was easy to gather Latin American artists to participate in this fundraiser.

The board worked diligently to find an appropriate building for our museum. One of our board members represented the Bank of America and was able to provide a list of properties that were in the bank's possession. This provided us with the perfect opportunity to ask the bank to donate a building to our cause. Roxanna De Soto and I met with the regional president of the Bank of America to make our request for a building donation. At the time of this meeting, everyone was on edge because weeks earlier members of the African American community in Los Angeles had burned down part of the city during the riots over the beating of Rodney King in 1991 and the acquittal of the four police officers in 1992. The lingering tension in the city was very much on our minds when we went to the bank for our meeting. During our meeting with the bank's regional president, Roxanna and I went so far as to threaten that we would be willing to burn the entire city down if that is what it would take to get a building for our museum. Maybe it wasn't the most tactful way to conduct business, but we had hoped that our passion might have some influence on their decision to provide a building for our museum. Additionally, Senator Charles Calderon pledged $1 million from the State of California for educational programs contingent on our finding a suitable building. We were willing to do or say whatever it took to convince the bank that we were very serious. Needless to say, we didn't leave with a building in hand for our museum!

Unfortunately, conflicting opinions and ideas among the board members eventually became so toxic that we couldn't agree on anything. Sometimes we didn't have a quorum to approve minutes and discuss the agenda. Little by little the organization deteriorated until Antonia Hernandez, Gloria Molina, and I reached the point where we submitted our letters of resignation. I felt

like a failure, as my efforts to see this museum come to fruition had been derailed. After this disappointment, I distanced myself from the Latino community for a while.

Despite all of this, my rapport with Antonia Hernandez has remained strong throughout the years. Today, Ellen and I still get together socially with Antonia and her husband, the Honorable Judge Michael Stern. I always admired Antonia as a mentor and have felt that we were family. She would invite me to her office to discuss issues regarding MALDEF. During one of these meetings Antonia invited me to become a member of the board of directors of MALDEF. It was an honor for me to be part of this prestigious organization, which served the Latino community so broadly. Antonia told me from the very beginning that the job I would be performing on the board was vital since it focused on education.

In 1999, I did an exhibition of Antonio Piñeda's silver jewelry at the Bonaventure Hotel in downtown Los Angeles as part of MALDEF's annual gala. On that occasion, Antonio personally presented a silver stirrup to the keynote speaker, Mexican presidential candidate Vicente Fox. When Antonio presented his gift to Fox, he told him that the other stirrup would be given to him when he visited Taxco as President Fox of Mexico.

Another time I had a discussion with Antonia Hernandez regarding the support of twenty-five Latino law students who were short the two thousand dollars they needed for their graduation fees. They were not able to get government aid as they didn't meet certain requirements. In response, Ellen and I contributed some funds to support the students, and Antonia contributed the rest so they could graduate. At the MALDEF gala held at the Bonaventure Hotel in 2000, Ellen and I were pleasantly surprised by the presence of the students who had received our support. They lined up at our table to thank us. I was touched and teary eyed as I told them I had no children of my own, but it felt like they were mine at least for one night. In addition to this, one of my contributions to MALDEF was to invite artists from Los Angeles and Mexico to submit artwork for the cover of our gala invitation. One of the winning artists was from Oaxaca, which was particularly pleasing to me. Another exciting aspect of this gala was that Vice President Al Gore was the guest speaker that evening.

Another gala that MALDEF hosted took place at Avenue of the Stars in Century City. Roxanna De Soto and I organized a live auction to raise educational funds for students. Roxanna can be very persuasive, and that night she

FIGURE 32. Federico and Ellen at one of the MALDEF galas, ca. late 1990s/early 2000s. Photograph by Silvia Mautner. Jiménez Family Collection.

was in a lively mood. Between the two of us, we raised substantial funds for MALDEF. I especially enjoyed my time on the MALDEF board and meeting all the wonderful movers and shakers in the Latino community that I continue to work with and support today.

A REUNION WITH MY GRANDMOTHER NABORA

In 1997 while I was on the boards of MALDEF and the Autry Museum, Michael Heumann, chair of the Southwest Museum board, asked me to come back on its board. By this time, they had a Native American director, Duane King, a Cherokee, so I felt better about there being some Native American representation at the museum. The Southwest Museum was still struggling financially, and several discussions were taking place with other institutions and communities in Southern California and the city of Los Angeles about taking over the responsibility of the museum and its collections.

When I went back on the board, the Southwest Museum had also suffered major structural damage from the 1994 Northridge earthquake, and there were discussions taking place about moving the valuable collections to a safer and more adequate facility. By this time the Southwest Museum board and John Gray, president and CEO of the Autry Museum, were actively working on the plan started by Joanne D. Hale to merge the Southwest Museum with the Autry Museum of Western Heritage.

While these negotiations were going on, the Southwest Museum was still open to the public and hosting traveling exhibitions. In October 1999, it hosted an exhibition featuring Mexican textiles. This traveling exhibit was based on a research project carried out by the Regional Museum of Oaxaca (now the Museo de las Culturas de Oaxaca) and the Getty Conservation Institute. A team of conservators and ethnographers traveled throughout Oaxaca interviewing weavers and learning about their weaving techniques, dyes, materials, and designs. The contemporary weavers were in turn invited to the Regional Museum of Oaxaca to examine the historic textiles in the collection. Like the publication, the exhibition explored the ways in which historic traditional textile designs and techniques influenced the production of modern textiles. The results were published in the 1997 book, *The Unbroken Thread: Conserving the Textile Traditions of Oaxaca*, edited by Kathryn Klein.

When the curators started planning the exhibition at the Southwest Museum, some of the team came to our home to examine our collection. They borrowed some of the historical Mexican jewelry that Ellen and I had collected over the years to complement the textiles that were part of the traveling exhibit. Ellen and I were not able to attend the exhibit's opening ceremony because we had previously made plans to visit Peru. On the first Sunday after our return, we went to visit the museum to see how our jewelry had been displayed. In the second display room I enjoyed seeing the regional huipiles from Oaxaca. Some of them seemed familiar to me. Although these pieces were now owned by the Museo de las Culturas de Oaxaca, I was almost certain that some had originally been part of the Audifredd collection that I had seen when I was still in Oaxaca in the 1960s.

As I walked farther into the exhibit, I was reminded of the time that I came home from school and my mother told me that we didn't have any money for food and couldn't pay the rent. Out of desperation those many years ago, I sold my grandmother Nabora's precious posahuanque del diario to señora Audifredd. It turns out that the majority of the Audifredd Oaxacan textile collection was transferred from the National Museum of Anthropology in Mexico City to the Regional Museum of Oaxaca at some point after it opened in December 1972. The Museo de las Culturas de Oaxaca operates under the Instituto Nacional de Antropología e Historia (INAH).

I also recalled my friendship with Ignacio Bernal, director of the National Museum of Anthropology in Mexico City. He was sympathetic to my emotional attachment to my grandmother's posahuanque del diario when it was acquired by the museum. This connection prompted me many years later to offer a valuable collection of important textiles that Ellen and I had put together to the National Museum of Anthropology in exchange for my grandmother's posahuanque del diario. At the time, Bernal responded, "I will see what I can do," but I never saw my grandmother's posahuanque del diario again.

So, as you can imagine it was truly an emotional experience for me to see these impressive textiles again. Suddenly, Ellen stopped me and said, "Your grandmother's skirt is right behind you!" Upon seeing my grandmother Nabora's posahuanque del diario again, I was overcome with the deepest of emotions. Before I realized it, I had taken the textile, including its exhibition mount and all, and embraced it tightly against my chest, and I started crying intensely. Here I was, a fifty-eight-year-old man hugging one of the displays

in a museum exhibition and crying uncontrollably. The museum's visitors couldn't help but notice the scene I was making and were no doubt puzzled by my reaction to the display. Then the museum director, Duane King, became aware of the situation and came over to talk to me. He noticed that I was crying and asked me what the problem was. Ellen told him that the posahuanque I was holding had belonged to my grandmother. Sympathetically he said, "Do not worry, I know a great weaver who will make you a posahuanque just like this one, same colors, same measurements." I replied, "It's not just the textile, sir, it's the history it contains. My grandmother Nabora is here in spirit; she is now with her grandson."

My grandmother's posahuanque del diario was on display for two months, giving me the opportunity to go to the museum and admire it on several occasions. I would take a chair and sit in front of this display to partake in a conversation with my grandmother's spirit and the spirits of the gods, the Tatas, as we did together in Tututepec. Then one afternoon on a visit to talk to my grandmother's spirit, all I found were empty display rooms. My grandmother Nabora had paid me a visit, and now she was gone again. I left the museum and drove down that mighty hill that is a part of the Southwest Museum's landscape. As I descended toward the street I cried out, "Grandmother Nabora! Grandmother Nabora! Grandmother Nabora!" The City of Angels couldn't hear me over the roar of the Metro, which symbolized our modern civilization.

My grandmother's posahuanque del diario was returned to Oaxaca, where it is safely kept in the collection storage at El Museo de las Culturas de Oaxaca. Her ceremonial posahuanque de gala and rebozo de gala are both in the collection of the Museo Textil de Oaxaca. My grandmother's posahuanques and rebozo are much more accessible, and I occasionally go into the collections to see them now.

18

A MERGER AND MY ONGOING ROLE ON THE AUTRY BOARD

I WAS STILL SERVING ON THE board of the Southwest Museum when the negotiations to merge it with the Autry Museum of Western Heritage were finalized in an Agreement and Plan to Merger on March 4, 2003. The transition of the Southwest Museum to the Autry became final on June 30, 2013. The two became known as the Autry National Center of the American West. At the time of the merger, John Gray was the president and CEO of the Autry, and three members of the Southwest Museum board were invited to join the Autry's board of trustees: Michael Heumann, Tom Lee, and I. At the time I was serving on the Autry Museum's board, so the transition was an easy one for me. To this day the three of us continue to serve on the Autry's board.

A GREAT CEO AND LIFELONG FRIEND

An important friend in the Autry circle was John Gray, who became president and CEO in 1999 after Joanne D. Hale announced her retirement in August 1998. He served in this capacity until he retired in late 2010. To this day, Ellen and I remain very close friends with him. He always made us feel welcome. I admire him greatly for all the work he did to transform a museum filled with cowboys and Indians to a cultural center of extraordinary status,

FIGURE 33. Federico, Ellen, and John Gray at an Autry Museum gala, ca. mid-2000s. Photographer unknown. Jiménez Family Collection.

with activities that represent the arts, music, and literature of all western America. John Gray left quite a legacy at the Autry. He was responsible for completing the merger of the Southwest Museum and the Autry by acquiring its extraordinary collection in 2003. This gave the Autry credibility among the other museums in Los Angeles and in my opinion made him the best president and CEO in the Autry's history.

One of the advantages of being in the Autry circle involved another board member who became a close friend. Liam McGee, his wife, Lori, and I liked to discuss our upbringing when we got together. I was from Oaxaca, and he

was born in County Donegal, Ireland, and grew up in Southern California. Even though he was of Irish descent, he spoke perfect Spanish. I first met Liam through John Gray. One day when John was at my house in Venice, I showed him my box of Mexican silver jewelry. He was concerned about my having such a valuable collection in my house, so he called his friend Liam McGee, an executive at the Bank of America, which was also my bank in Los Angeles, and asked him to give me the three largest safe deposit boxes they had for the safekeeping of my jewelry collection. John thought it would be in my best interest to keep all of the collection in the bank given its value. Thanks to John and Liam, I was able to secure three safe deposit boxes at the Bank of America free of charge indefinitely.

Liam also helped me in other ways. I recall a time when I forgot to withdraw money from the bank before going to Mexico to make some purchases for my antique business. It happened to be on Columbus Day, and the bank was closed, but I urgently needed enough money for the trip. I was terribly embarrassed to call him, but I decided I had no alternative. So, I called and told him that I needed twelve thousand dollars for my trip. He told me to call him back in thirty minutes. Liam called the manager of my bank, who was out of town. He then located the manager of another branch in Los Feliz, a neighborhood in Los Angeles. It turned out that he was available and would be able to open the bank for me. A few hours later I showed up at the bank and found the bank manager waiting for me with cash in hand. He looked at me from head to toe and said, "You must be a very important person because in the forty years that I have worked here I've never opened the bank on a holiday for a client." I was relieved that he could accommodate my request, and I thanked him and headed straight to the Los Angeles International Airport to catch my flight to Mexico.

AUTRY BOARD RETREATS

Molly Campbell was John Gray's secretary. She assisted John in carrying out his affairs pertaining to the Autry and planned and oversaw the board meetings and retreats. The board retreats took place annually. Some were serious and formal, while others were almost comical. The Autry board retreats often took place and still do at the residences of one of the board members. One especially memorable board retreat was in San Antonio, Texas. It was held

at the home of a board member who was the head of a large media company. When we arrived, it felt like it took fifteen minutes to drive up to their residence from their gate at the road. On finally arriving at their home, I told them that when they come to dinner at my house, the entryway consisted of only two steps. They replied that they wouldn't mind paying a visit if there was enough space for their helicopter to land in my backyard!

Another memorable board retreat took place in Santa Fe, New Mexico, and to seal the deal after the meetings, we were led by Molly to "a train without a destination." It was a complete surprise, and nobody knew where it was going. The train had a full bar, and almost everyone had one drink too many. Suddenly, the train stopped in the middle of the high desert, and we got off in whatever manner we could. First of all, we were well oiled, and second, the sand was so soft that our feet kept going out from under us. The ladies had it worse, as they were in high heels, and their heels kept sinking in the soft sand. Nevertheless, we made our way to a tent in the middle of the desert, where an ensemble was playing music from Gene Autry's playlist. The consensus of everyone in attendance was that the dinner wasn't as important as the cocktails, and everyone drank and danced.

Another board member and I took the microphone and sang well-known Mexican songs, such as "Cielito Lindo," "Bésame Mucho," "Solamente Una Vez," "Ay Jalisco No Te Rajes," "La Cucaracha," and "Quizás, Quizás, Quizás." The night was unforgettable, and at the next board meeting, the chairman of the board made it public that the singer of the next Autry gala would be Willie Nelson. He added that if Willie Nelson were to cancel, he had the perfect replacement. He opened his briefcase and took out a photograph and passed it around the room. Every member of the board had their turn looking and laughing as the picture was passed around until I saw that it was me in the photo, singing in the desert of New Mexico! Throughout the years many of the Autry's board members have become close friends. I will always be thankful to Joanne D. Hale and Jackie Autry for giving me the opportunity to be part of such a unique institution.

AUTRY GALAS

Ellen and I always supported the Autry's galas through donations of auction items as well as attending the annual fundraiser. One of the Autry's board

members let us use his corporate jet to raise funds for live auctions at the gala. One time one of the bidders was not to his liking, so he outbid him and won the auctioned corporate jet for himself. He then came to my table asking me if I would give him a private tour of Oaxaca. He added that we would fly to Oaxaca in his corporate jet. I had never flown in a corporate jet before, so I jumped at the opportunity. Shortly afterward Ellen and I were flying out of Burbank on the jet. In less than three hours, we landed at the airport in Oaxaca.

We stayed at the Camino Real Hotel, which is a beautiful five-star hotel housed in a sixteenth-century convent building. We had a wonderful time visiting the city and the surrounding areas. I took them to Ocotlán de Morelos, where the famous painter from Oaxaca Rodolfo Morales lived, and they bought two of his paintings. We also had a spectacular lunch at the Morales residence. We visited the archaeological sites of Mitla and Monte Albán, and some of the traditional markets in the Valley of Oaxaca. It turned out that our friends loved Oaxacan food as well. Finally, the day came when we had to return to Los Angeles with our memories of an extraordinary trip.

At another Autry gala I provided a saddle for the live auction. John Gray made a grand entrance on horseback, brushing past the guests who had paid ten thousand dollars per table. Only moments before he had been toasting with champagne with the guests. No one expected to see a horse make its way between dinner tables full of dignitaries, including the Los Angeles mayor and other important people. Some people were astonished and speechless, while others applauded either John or the horse, I am not sure which. I was delighted when the saddle sold for a substantial amount at the live auction part of the gala.

Throughout my years on the Autry board, I have participated in important museum events and of course in our annual galas, where I have served as cochair of the gala auction and was chair of the 2017 gala. I have contributed several pieces of jewelry that I designed to raise educational funds. My jewelry designs are highly sought after by gala attendees, which in turn satisfies me greatly. To this day the silent auction that supports the educational programs at the Autry continues to be part of the gala event, and Ellen and I enjoy being both auction donors and gala attendees. In 2016, after a reorganization of the Autry's board committees, I was asked to join the Interpretation and Research Committee and the Collections Committee, which are both dear to my heart.

19

MAKING LOS ANGELES A BETTER PLACE FOR LATINOS

ONE OF THE GREATEST DREAMS I've had since I arrived in the United States was to see a museum that celebrated Latino culture, my culture. Finally, after so many struggles, the failure of previous efforts, and so much waiting, this dream has become a reality.

LA PLAZA DE CULTURA Y ARTES

La Plaza de Cultura y Artes opened in April 2011 and is the cultural center that Mexicans, Mexican Americans, and other Latinos have needed in Los Angeles for over a century. Thanks to Gloria Molina, the first Latina elected to the California state legislature; the Los Angeles City Council; the Los Angeles County Board of Supervisors; and the California State Assembly, we have a place that makes all Latinos proud. Located on a significant historic site, La Plaza celebrates and recognizes the important contributions of Latinos both past and present through its exhibits and educational programs. In addition to the significant funding provided by Supervisor Gloria Molina through the County of Los Angeles Board of Supervisors, many important Mexican Angelinos also provided funding for operations and programs. Its exhibits and educational programs tell the stories of the prominent Mexicans

FIGURE 34. Federico pinning the medal on Mayor Villagairosa's sash at La Plaza de Cultura y Artes, 2013. Photographer unknown. Jiménez Family Collection.

and Mexican Americans who played an important role in the establishment and development of Los Angeles as a major West Coast city.

I was one of the cochairs of La Plaza's Inaugural Gala on April 9, 2011, where we honored Gloria Molina, who made an enormous difference in the Latino community with her support of La Plaza. We finally have a place to show the world our cultural wealth, talent, and qualities through interpretive exhibits, theater, poetry, food, arts, and crafts. The time had come for a place where we recognize the forty-four Mexicans who founded Los Angeles. It is a large multicultural city in which we now share our cultural heritage as Latinos with the rest of the world.

The programs that the board developed, such as the organic garden, have benefited children by providing them with healthy foods that promote the regional tastes of Mexico and will surely continue to benefit them as time goes on. La Plaza promotes some of the most traditional and recognized dishes, like mole, tortillas, tamales, and exotic beverages like *champurrado* (traditional Mexican chocolate drink with ground maize flour), *horchata* (sweet rice milk with vanilla and cinnamon), *agua de Jamaica* (hibiscus iced tea), and mezcal, among others. The project that Supervisor Molina had envisioned was extensive and exceptional, and hopefully destiny allows me to continue to enjoy not only the finished product, but also the diversity within Latino culture.

In 2013, I was involved in the planning of another gala at La Plaza, this time to honor the forty-first mayor of Los Angeles, Antonio Villagairosa. He was the first Latino mayor of Los Angeles in over 150 years and served from 2005 to 2013. As he was completing his second term as mayor, Gloria Molina and I planned a major celebration to recognize Mayor Villagairosa for his many accomplishments and contributions to the Latino community in Los Angeles. This was a special occasion for La Plaza. I was commissioned to create a medal to honor Mayor Villagairosa and was surprised when I was asked to go on stage to present the medal to him. The medal was to be attached to a sash made of the colors representing Los Angeles. I was humbled by the experience, and when I pinned the medal on his sash, he whispered in my ear, "I feel like a king now."

La Plaza is a place where I feel welcome. It fills me with a sense of belonging. I continue to serve on the La Plaza board and help raise funds for programs focused on the arts and cultures of Mexico. The overall planning to develop enterprises and other revenue streams to support La Plaza is still ongoing.

CASA CULTURA SAYBROOK

Along with my continuing support of the educational programs at La Plaza, I support Casa Cultural Saybrook in East Los Angeles. Casa Cultural Saybrook is a nonprofit that helps bring the arts to neighborhoods by partnering with local hospitals, after-school programs, and surrounding cities and local organizations where it is needed most. Students at Casa Cultural Saybrook

are exposed to other cultures through the arts, crafts, and music. Participating children also attend field trips to arts and cultural events in and around Los Angeles. I serve on Casa Cultural Saybrook's board and have been very impressed with what they are able to achieve through their programming for children.

I continue to work for children's social causes in Los Angeles and support Casa Cultural Saybrook and La Plaza because I don't want to wait another 150 years to have another Latino mayor. I want to see more Latinos in leadership positions, and it starts with early education. I have spent most of my life helping the children in my own family and now I hope to help others so that they have the same opportunities I had. I am passionate about creating educational opportunities for Latino children living in poverty in both inner cities and rural areas. I do what I can by serving on boards and raising funds for educational programs that will assist these young people in making the transition out of poverty so that they can go on to receive a higher education. I see these future graduates making a significant contribution to society in the future. I feel very strongly that by supporting these organizations in their efforts to introduce our youth to art and culture that both will continue to play an important role in people's lives and that through these efforts the world will be a better place.

20

BUILDING OUR PERSONAL COLLECTION
AND A MUSEUM

T HESE DREAMS OF A LATINO museum accomplished, I set my north star on making another dream come true: to open a museum in Oaxaca. A special mission in my life was to find a woman who would share my dreams. For over fifty-five years, I have enjoyed that special someone at my side, who has shared my love of museums and my passion for collecting Indigenous folk art and jewelry. While Ronald, Ellen, and I were working together in the mid-1960s, we traveled to several villages conducting our market research. This is when Ellen and I started seriously collecting.

During the early years of our collecting, Ellen and I bought and traded for what we could, since we didn't have much money. Because of our limited means, we were very selective in what we acquired. In order to purchase these unique items, it was not unusual for us to sleep on church floors with our petates or in hammocks. We often paid a peso to sleep at some of these places, all with the idea of saving money for our purchases. We first bought some textiles to wear ourselves, and then they eventually became part of the collection. Ellen wore every one of these textiles and the huipiles at one point or another. She wore many of the huipiles to work during her thirty-two years as a social worker for Los Angeles County. The fruits of our labor throughout these expeditions accumulated in our home. For many years we've practically

lived in our own personal and intimate museum. Every piece has its own story, and I have fond memories of how we acquired each one.

SOME OF OUR COLLECTING TRIPS

On a research/collecting trip in the mid-1960s, Ellen, Ronald, and I traveled to Ixtlán de Juárez, in the mountains. Our Jeep got stuck in the mud passing through the entrance of the village. The villagers who came to help us asked if we were Evangelists, to which we responded no and that in fact, we were devout Catholics. We decided to tell them we were Catholic because we heard music coming from the church in the village, and we assumed everyone was Catholic. They helped pull the Jeep out of the mud, and we left it by the residence of one of these helpers, who turned out to be an Evangelist. I asked him if there was an inn in town, and he replied that there wasn't one, and to ease our concerns he offered us a place to sleep in his church after the prayers and hymns were finished.

The next day the three of us headed out toward San Bartolomé Zoogocho when suddenly we were greeted by a group of feral dogs showing us their ferocious fangs. We stood there waiting for the villagers to come out to call off the dogs. We stayed in San Bartolomé Zoogocho for two weeks while visiting nearby villages and collecting census and economic data as part of the UCLA project. We also purchased folk art and textiles for our personal collection.

One of the most impressive textiles we saw belonged to a young man who showed us four of his family's huipiles. I asked him which one he thought was the best, and he gave me a philosophical monologue, stating that there was no such thing as a "best" huipil. He argued that they were all the best, just as the chiles he planted were the best ones in the region. One day we told him we wanted to go to the market of Talea de Castro to do some research and to buy food and any folk art we might come across. He pointed out that the only way to get there was by a cargo truck. The owner of the truck told us we could sit in the back, so, after a bumpy ride, we arrived at Talea de Castro with sore bottoms. That didn't stop us from enjoying the town though. We bought necklaces, some with silver crosses and amulets, from an antique dealer who had a little grocery store in the market area in San Pedro Quiatoni.

FIGURE 35. The opening gala at the Belber-Jiménez Museum with Antonia Hernandez, Ali MacGraw, Ellen, and Gloria Molina cutting the ribbon, 2008. Courtesy of the Belber-Jiménez Museum, Oaxaca.

FIGURE 36. Arcelia Yañez at the opening of the Belber-Jiménez Museum, 2008. Courtesy of the Belber-Jiménez Museum, Oaxaca.

When it was time to return, we saw that the back of the truck was filled with sacks of avocados. We asked the driver where we should sit, and he told us that Ellen could sit in the cab, and Ronald and I could sit in the cargo area. Ellen didn't want to ride in the cab with two men she didn't know, so she joined us on top of the avocado sacks. As the sun was setting and the truck started on its way back to San Bartolomé Zoogocho, we were repeatedly smacked by tree branches. We joked about the avocados underneath us turning into guacamole with all our bouncing around. We finally arrived safe and sound and quite content after our journey. In the end, we dropped in total exhaustion after such a long day and uncomfortable ride.

Throughout the years, we have visited numerous remote towns and villages throughout Mexico and the American Southwest and always attempted to bring some sort of memory home with us. It was the handcrafted pieces that we cherished the most, along with the life experiences that we had in those places and the people we met along the way. These keepsakes aren't just for our collection, but rather they dwell in our hearts and minds. Unbeknownst to us at the time, our collection would eventually grow to become one of the most important comprehensive collections of Mexican Indigenous jewelry, textiles, and traditional costumes in the world. As our collection grew, Ellen and I started dreaming of having our own museum.

EL MUSEO BELBER-JIMÉNEZ, OAXACA

It would be many years before Ellen and I realized our dream of opening a museum in Oaxaca. In 2007 we purchased the Casa Azul (Blue House) on the corner of Matamoros and Tinoco y Palacio in the historic district of the City of Oaxaca. As you might recall, this was the home of one of my teachers, profesora Mariela Morales, and I used to clean her floors on Saturdays for five pesos. Ellen and I created our museum over the next six months and opened El Museo Belber-Jiménez on Saturday, May 21, 2008.

We were lucky to find this eighteenth-century house for our museum, as it was appropriately laid out to display our collections. The purpose of our museum is to educate the public, as well as schoolchildren, about the artistic traditions of Oaxaca and Mexico that represent the roots of our Indigenous cultures. Our goal is to preserve the rich heritage of the Indigenous peoples of Mexico for future generations. Here, I provide you a brief walking tour of

the Belber-Jiménez Museum to give you an idea of the scope of the collections and how they are displayed.

As one enters the museum, there is a library to the right of the lobby area, which holds books that tell the history of Mexican folk art, textiles, and jewelry. As one leaves the library, one enters a small room with an exhibition featuring two women artists, Frida Kahlo and Margot de Taxco. On the right side are photos of Frida Kahlo and a display that includes a necklace inscribed with a dedication from El Zapo (Diego Rivera). It is said that Frida was wearing this necklace when she passed away in 1954. Included are pre-Hispanic necklaces that allegedly had been worn by Frida as well. On the other side are pieces by Margot de Taxco, who was known for exquisite enamel work in her jewelry designs.

The next room to the right showcases pre-Hispanic jewelry, the majority of which came from my childhood town of Tututepec. Much of this jewelry was made from shell, amber, jet, amethyst, rock crystal, jade, pearls, turquoise, and gold. Some of these I found as a child while walking around the countryside, and others were discovered when we were repairing my grandfather's house. One piece is a traditional gold bead necklace that my grandmother Nabora purchased at a religious celebration on one of the Fridays of Lent at Guaspaltepec. The significance of this necklace is that it has one pre-Hispanic gold pendant with three eagles, representing her line in the Mixtec noble class. There is also a large necklace made of caracol shell that was used for the Fire Ceremony in Tututepec. They came in the chest that my parents brought with them when they moved to Oaxaca. As the eldest son, I inherited these family heirlooms, and they have been in my collection for as long as I can remember.

In the same room, we included necklaces made of glass beads and silver crosses from the colonial period, dating from the sixteenth and seventeenth centuries. These were brought by the Spanish to trade for gold objects from the Aztecs and Mixtecs. These necklaces and other items were also brought by the Spanish to Mexico to Christianize the Indigenous peoples. The Dominicans, Franciscans, and Jesuits in the sixteenth century required items to be made for the churches they were building, and an artisan from Salamanca, Spain, came with them to teach the Indigenous Mixtecs how to make these religious items along with silver filigree jewelry. Oaxaca was already an important area for the early production of silver filigree jewelry. The techniques were similar to what the Mixtecs had already mastered in

gold for their pre-Hispanic religious practices. Now they were forced to make items for the church and Spanish royalty.

As one moves to the next gallery, the focus is on the modern period. This first room has a large collection of silver work by William Spratling. The collection includes jewelry, a tea service, candlestick holders, creamers, spoons, necklaces, silver boxes, and so on. Born in 1900 Spratling was an American silver designer and artist, best known for his influence on twentieth-century Mexican silver design. He was a professor and lecturer on architecture at Auburn University and Tulane University. In 1931, Spratling decided to move to Mexico and establish a silver industry in Taxco, which was a site of silver mines but had no native silver-working industry. He started designing works in silver based primarily on pre-Hispanic and traditional motifs, and he hired local goldsmiths and silversmiths to produce those designs in Taxco. Spratling was the primary designer for his workshop, Taller de las Delicias, and was insistent that only high-quality materials and techniques be used in production. He received widespread notoriety as a result of his development of what many considered to be a model handwrought industry. His influence reached as far north as Alaska.[27]

This gallery also includes a framed Tina Modotti photograph of William Spratling that he dedicated to the artist Fred Davis. Spratling designed two sarapes that were made in Taxco, and we have one in our collection, hanging in this gallery. We also showcase the work of Antonio Piñeda, the internationally renowned Mexican silversmith.[28] A Taxco native, Piñeda was among the most prominent of the many silversmiths to emerge in the 1930s and became one of the major modernist silversmiths of the 1950s, 1960s, and well into the 1970s.

To the right, one enters a small gallery dedicated to Matilde Poulat, better known as Matl. Poulat was an educated artist and designer from Mexico City, who started designing and making jewelry in 1934. She is known for her uniquely detailed style, and her work is considered among Mexico's best. This is the most important and comprehensive collection of her work in the world. She trained her nephew Ricardo Salas, and after her death in 1960, he

27. Penny Morrill, *William Spratling and the Mexican Silver Renaissance: Maestro de Plata* (New York: Abrams, 2002).

28. Gobi Stromberg and Ana Elena Mallet, *Silver Seduction: The Art of Mexican Modernist Antonio Piñeda* (Los Angeles: Fowler Museum at UCLA, 2008).

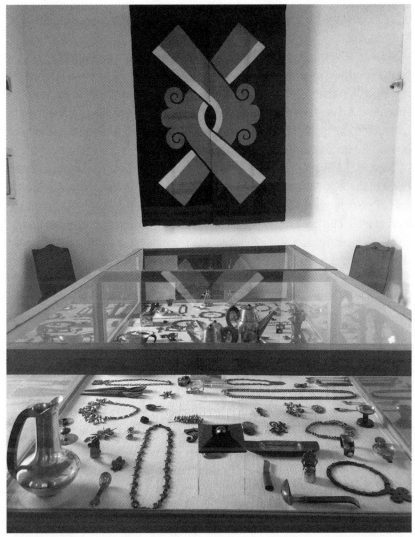

FIGURE 37. Exhibit case with collection of William Spratling silver work and one of the sarapes he designed. Courtesy of the Belber-Jiménez Museum, Oaxaca, Mexico.

continued to create pieces in the Matl style for many years thereafter. When he died, his daughter sold me their private collection of Matilde Poulat's work.

Leaving this gallery, one crosses the third patio to the right and enters a gallery of Southwest Native American art. Ellen and I viewed the American Southwest as an extension of Mexico and collected textiles, jewelry, pottery,

baskets, and other arts from the different Indigenous groups in Arizona, New Mexico, and California. In this gallery, we have on display Navajo jewelry, including silver and turquoise bracelets and squash blossom necklaces; Navajo textiles, including a Second Phase Chief blanket and a Germanton rug; pueblo pottery, both historical and contemporary; Hopi and Zuni katsinas; and baskets from the Apache and some of the California tribes. I have included some of the silver jewelry pieces I have made that were influenced by Native American designs in this gallery.

Next is the Spanish colonial gallery, with Saltillo sarapes dating from the 1850s to the 1880s on the back wall. Tinwork from Oaxaca, which was mostly made in Xochimilco during the colonial period, can be seen hanging on the wall as well. Pottery from Oaxaca and handmade furniture dating to the seventeenth century are also on display. We included two saddles that demonstrate the extraordinary skill of the saddle makers of the nineteenth century.

The next room displays a collection of folk art carvings by Manuel Jiménez Ramírez from San Antonio Arrazola in the Valley of Oaxaca. He was the first, and the most famous, wood carver in Oaxaca at the time and is credited as the originator of the Oaxacan version of *alebrijes*, animal creatures carved in wood and painted in strong contrasting colors with intricate designs. A Mexican flag from 1909 that was presented to President Porfirio Díaz when he came to Oaxaca for the opening of the Teatro Macedonio de Alcalá is hanging on the wall to the left. This gallery also displays old toys and ceramics from Guadalajara, as well as religious art and tinwork. We also included some Talavera and Majolica pieces as well. One of the Majolica dishes that has a Picasso-like design was used by my grandmother Nabora.

The museum tour ends with what Ellen and I consider our favorite part of the collection—the textile room. This room includes a comprehensive collection of over one hundred complete traditional Mexican costumes representing different Indigenous communities in Mexico. Over the past century, many cultural changes have been brought on by contact with Western cultures, resulting in a gradual transformation of cultural values. Ellen and I focused on putting together this collection of traditional textiles to preserve a part of Oaxaca's cultural heritage as well as other Indigenous cultures throughout Mexico and Mesoamerica.

In addition to the colorful costumes worn by women and men from throughout Mexico, the exhibit includes handwoven cotton textiles that my grandmother Nabora made for my grandfather Adrián. One of the most

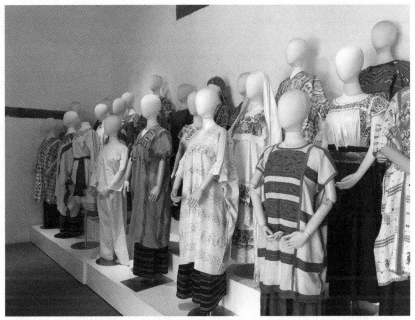

FIGURE 38. Textile room with examples of traditional clothing from Oaxaca, as well as from other Indigenous cultures throughout Mexico and Mesoamerica. Courtesy of the Belber-Jiménez Museum, Oaxaca.

significant and highly regarded pieces that is part of my grandfather's attire is his sash with dyed caracol and cochineal designs and fringe. The sash is representative of his elite status as an important principal among the Mix-tecs in Tututepec. We also included my grandfather's shoulder bag made of natural brown cotton with caracol dyed designs. I recall him carrying his tortillas in it.

There is additional gallery space for exhibitions on the ground floor, and the patios are used for events. We also built and furnished a one-bedroom apartment on the second floor. We built the apartment for visitors, research-ers, guest artists, and hopefully, one day to accommodate a full-time museum director. We also created a space opposite the library at the main entrance for my brother Juan to manage our shop, where we sell jewelry, paintings by local artists, textiles from around Mexico, and antiques. I sell my own jewelry in this shop as well.

The museum is currently a private museum that Ellen and I created and support through our own funds. We continue to do this for our love of the

artists and their work, as well as to educate the public about the rich cultural heritage of Oaxaca and Mexico. In April 2017, the Belber-Jiménez Museum gained recognition as an important museum with the donation of 312 textiles and costumes from the collection of Emma Cosío Villegas. The collection includes outstanding examples of costumes from Guerrero, Oaxaca, and Chiapas, with an emphasis on children's clothing. These textiles complement the collection that Ellen and I put together and include some examples of costumes that we didn't have. Occasionally we change our exhibits to rotate the collection, and we plan to exhibit some of these fine examples in addition to our personal collection.

Ellen and I have a home in Barrio de Xochimilco. We travel to Oaxaca several times a year to be with family and friends and to celebrate the holidays. We always go for Easter, in late June or early July, for Día de los Muertos in late October/early November, and for Christmas and to bring in the New Year. It is important that we continue to maintain our ties to both the country and the people we love.

Our museum is dedicated to my family and the numerous people who helped me throughout my life, from my childhood in Tututepec and my youth in Oaxaca City to my success in the United States. It is also representative of the journey my life has taken, and it is this legacy that I give to the world. My life has been full of the unexpected. Every time I was faced with a challenge or an obstacle, I never let it stop me, but instead, I worked hard to find potential opportunities and solutions. It was never easy, but through my resolve, and maybe even at times my own naïveté, I carved out a life that took me from a small town along the Pacific coast of Oaxaca in southern Mexico to a successful life in Southern California in the United States. I draw strength from my Indigenous heritage and the role models and mentors who helped me along the way. I hope my story inspires young people today who are facing similar struggles. With both courage and the belief in oneself, it is possible to reach for the stars and make your dreams come true. I know mine did.

BIBLIOGRAPHY

Ávila B., Alejandro de. "Bleeding Threads: Cochineal in Mexican Textiles." In *A Red Like No Other: How Cochineal Colored the World*, edited by Carmella Padilla and Barbara Anderson, 118–33. New York: Skira Rizzoli, 2015.

Beals, Ralph L. *The Peasant Marketing System of Oaxaca, Mexico*. Berkeley: University of California Press, 1975.

Beverley, John. *Subalternity and Representation: Arguments in Cultural Theory*. Durham, NC: Duke University Press, 1999.

Cook, Scott, and Martin Diskin, eds. *Markets in Oaxaca*. Austin: University of Texas Press, 1976.

Diskin, Martin. "The Structure of a Peasant Market System." In *Markets in Oaxaca*, edited by Scott Cook and Martin Diskin, 49–65. Austin: University of Texas Press, 1976.

Drucker-Brown, Susan. "Cultural Cross-Dressing in Rural Mexico: The Case of Jamiltepec, Oaxaca." *Cambridge Journal of Anthropology* 23, no. 3 (2003): 18–38.

Henderson, Sandra. "Latin American *Testimonio*: Uncovering the Subaltern's Gender, Race, and Class." *Ex Post Facto* 10 (Spring 2001): 83–84, https://history.sfsu.edu/sites/default/files/images/2001_Sandra%20Henderson.pdf.

Goldschmidt, Walter, ed. *The Social Anthropology of Latin America*. Los Angeles: Latin American Center, UCLA, 1970.

Joyce, Arthur A. "Formative Period Social Change in the Lower Río Verde Valley, Oaxaca, Mexico." *Latin American Antiquity* 2(1991):126–50.

Joyce, Arthur A. "Interregional Interaction and Social Development on the Oaxaca Coast." *Ancient America* 4, no. 1 (1993): 67–84.

Joyce, Arthur A., Andrew G. Workinger, Byron Hamann, Peter Kroefges, Maxine Oland, and Stacie M. King. "Lord 8 Deer 'Jaguar Claw' and the Land of the Sky: The

Archaeology and History of Tututepec," *Latin American Antiquity* 15, no. 3 (2004): 273–97, https://www.jstor.org/stable/4141575.

Klein, Kathryn, ed. *The Unbroken Thread: Conserving the Textile Traditions of Oaxaca*. Los Angeles: Getty Conservation Institute, 1997.

Levine, Marc N. *The Tututepec Archaeological Project (TAP): Residential Excavations at Yucu Dzaa, a Late Postclassic Mixtec Capital on the Coast of Oaxaca, Mexico*. Los Angeles: Foundation for the Advancement of Mesoamerican Studies, 2007. https://famsi.org/reports/05031/05031Levine01.pdf.

Morrill, Penny C. *William Spratling and the Mexican Silver Renaissance: Maestro de Plata*. New York: Abrams, 2002.

Spores, Ronald, and Andrew K. Balkansky. *The Mixtecs of Oaxaca: Ancient Times to the Present*. Norman: University of Oklahoma Press, 2013.

Street-Porter, Tim. *Casa Mexicana: The Architecture, Design, and Style of Mexico*. New York: Stewart, Tabori and Chang, 1918.

Stromberg, Gobi, and Ana Elena Mallet. *Silver Seduction: The Art of Mexican Modernist Antonio Pineda*. Los Angeles: Fowler Museum at UCLA, 2008.

Tisdale, Shelby J. *Fine Indian Jewelry of the Southwest: The Millicent Rogers Museum Collection*. Santa Fe: Museum of New Mexico Press, 2006.

Waterbury, Ronald. *The Traditional Market in a Provincial Urban Setting: Oaxaca, Mexico*. Ann Arbor, MI: University Microfilms, 1968.

Waterbury, Ronald. "Urbanization and a Traditional Market System." In *The Social Anthropology of Latin America*, edited by Walter Goldschmidt, 126–56. Los Angeles: Latin American Center, UCLA, 1970.

Winter, Marcus. *Oaxaca: The Archaeological Record*. Mexico City: Editorial Minutiae Mexicana, 1992.

ABOUT THE AUTHOR AND EDITOR

Federico Jiménez Caballero is of Indigenous Mixtec and mestizo heritage from Tututepec, a small town in coastal Oaxaca, Mexico. He came to the United States as a researcher at the University of California, Los Angeles, in the late 1960s. Over the years he became a well-known and successful jewelry artist and gallery owner in Santa Monica, California. As philanthropist he serves on museum and nonprofit boards and has opened a museum in Oaxaca.

Shelby J. Tisdale is the director of the Center of Southwest Studies at Fort Lewis College and is an award-winning author. Her book *Fine Indian Jewelry of the Southwest: The Millicent Rogers Museum Collection* (Museum of New Mexico Press, 2006) received two book awards. Her latest book, *Pablita Velarde: In Her Own Words* (Little Standing Spruce Publishing, 2012), is a full-length biography of this famous American Indian painter.